Office Furniture Design

ROCKPORT

Copyright © 2006 by LOFT Publications

First published in the United States of America by
Rockport Publishers, a member of
Quayside Publishing Group
33 Commercial Street
Gloucester, MA 01930-0589
Telephone: (978) 282-9590
Fax: (978) 283-2742
www.rockpub.com

ISBN-13: 978-1-59253-274-2
ISBN-10: 1-59253-274-8

Editor:
Oscar Asensio

Text:
Montse Borràs

Translation:
Jay Noden

Art Director:
Lorena Paula Damonte

Layout:
Judit G. Barcina, Zahira Rodríguez Mediavilla

Editorial project:
2006 © LOFT Publications
Via Laietana 32, 4th Of. 92.
08003 Barcelona, Spain
Tel.: +34 932 688 088
Fax: +34 932 687 073
loft@loftpublications.com
www.loftpublications.com

Printed in China

Office Furniture Design

GLOUCESTER MASSACHUSETTS

ROCKPORT PUBLISHERS

CONTENTS

RECEPTION

01

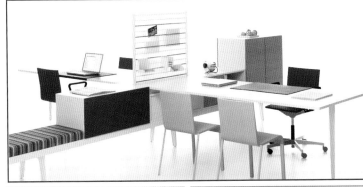

02

CONTENTS

03

04

INTRODUCTION

o This volume is a compilation of some of the most innovative and attractive office furniture to come from the world of industrial design in recent years. There is no mistaking the technological changes that objects have been through, in terms of both function and material. This is also the case with the design of work spaces conceived for the needs of the user and to integrate with surroundings. The design suits the individual as a house is adapted to the owner, and not the owner to the house.

Versatile objects, which unite different functions in a single item, furniture that folds away or can be extended, and mobile cabins and offices are some of the examples of a change that reflects the life of an individual in relation to his work. The tendency of the working world, at least in developed regions, is to spend less time in the workplace, thanks to the facilities that new technology offers us. Trips, meetings, and information exchanges, far from becoming less effective and less productive, have a decisive influence on the distribution of today's offices, creating new, transitional layouts capable of absorbing changes and being adapted to temporary needs.

The progressive transformation of the home into a partial or complete work place is also reflected here. In this way, office furniture designers are creating more versatile items, perfectly apt both for the home and the office.

On the other hand, well-being is no longer a synonym for inefficiency. In countries like the United States, a lot of offices have spaces designated for relaxation and sport, and the rest of the world assimilates the notion of comfort with an incentive to improve productivity. The laws of ergonomics are a new challenge in the design of contemporary furniture: designing objects that adapt to the body, to its different postures and needs, without abandoning the search for new objects regarding shapes and materials. There is also a transformation in how the needs of workers influence the creation of new products, instead of people adapting to what is already available.

This book brings together examples that reflect these tendencies, from well-established names and studios, such as Jean Nouvel, Antonio Citterio, and Vitra a COR, to emerging creators such as Bram Boo. All these items and proposals show the growing desire and interest in the world of design to improve well-being where people spend a large part of their lives.

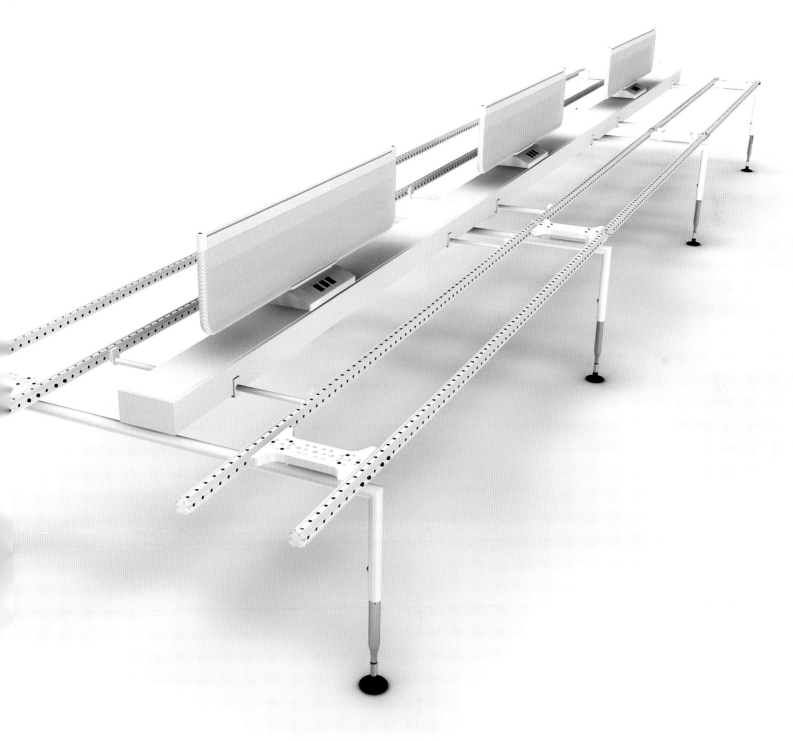

RECEPTION

WORK PLACE

MEETING ROOMS

OFFICE

01

o The access space to any building or office is the first to establish communication with a visitor or a user. In the same way as the hallway of a house gives a first impression and creates an atmosphere, the reception space has a representative role of "public relations" for the company or institution where it is located. In recent years, the need to accentuate the personality of these areas has increased, and depending on the available space, opportunities are taken to use them for other functions than merely circulation and reception.

From the classical reception desk, which has evolved due to the needs created by the use of technology, to small, tranquil meeting spaces, designed for fast business exchanges, there are growing possibilities for furniture and accessories. These include comfortable vanguard sofas, fine rows of seats for smaller spaces, or attractive modules that integrate a variety of functions. The goal is for the reception space to personify the spirit of the company, its functions, and the team behind it.

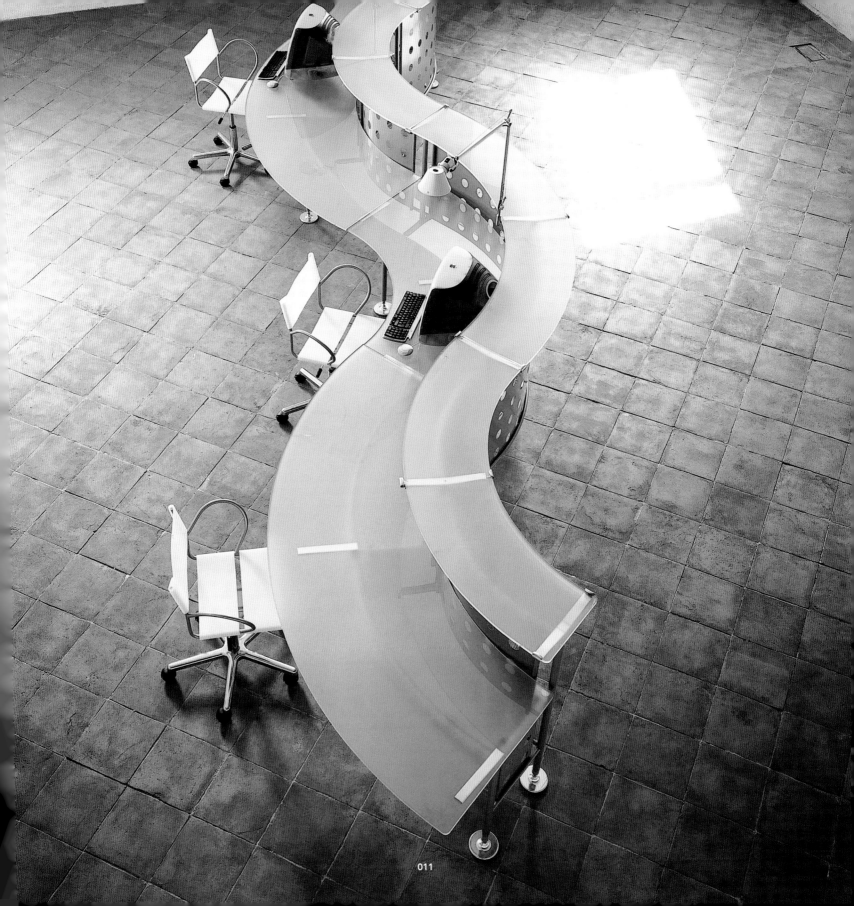

Marengo Tables Design and Manufacture: Studio D'Urbino Lamazzi

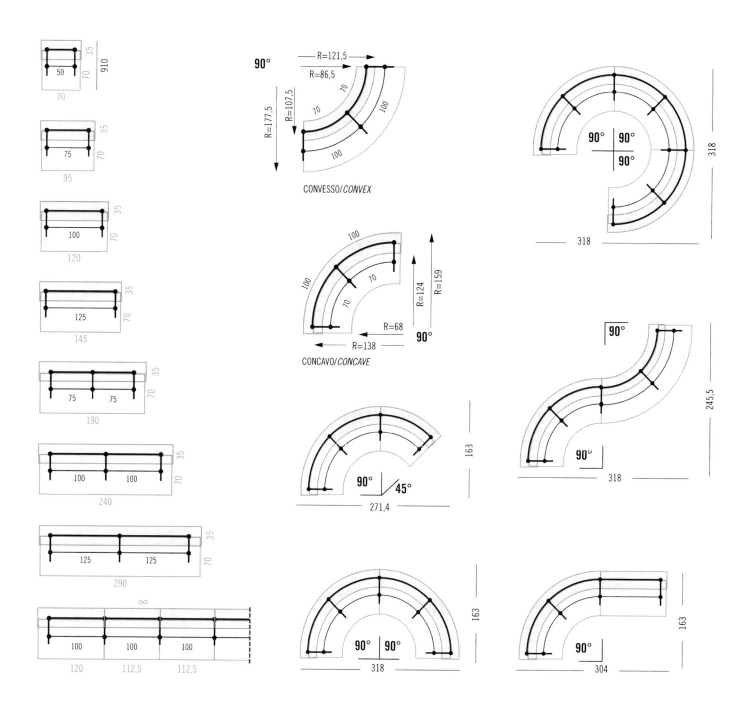

CONVESSO/*CONVEX*

CONCAVO/*CONCAVE*

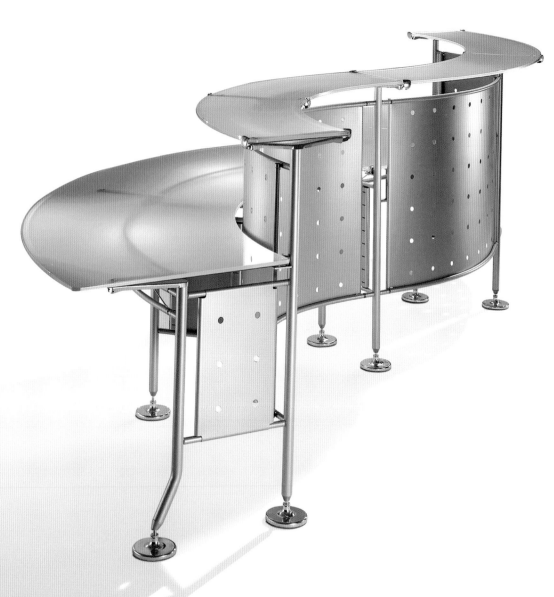

○ This concept for a computer table is presented as a wide range of modules with steel structures and aluminum finishes, and elegant surfaces of translucent glass. The independent modules, of one or two levels, can be combined in varying ways, creating straight, concave, convex, or twisting lines, depending on the desired function: reception desk, work space, or even a meeting room.

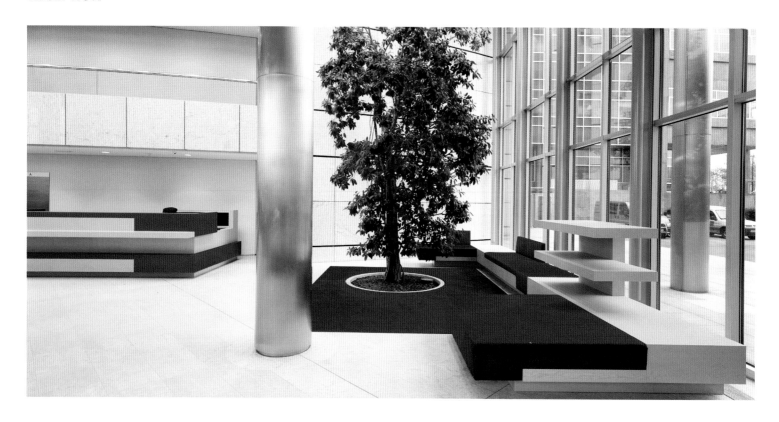

Public ING Design and Manufacture: i29

○ For this reception area, furniture was created in accordance with the scale, shape, and color of the space. The light furniture unites different functions in a single piece: a reception desk is joined to a bench with an integrated display case. The chosen materials—oak wood and deep, red upholstery—go perfectly with the natural stone and glass which are predominant in the construction of the building.

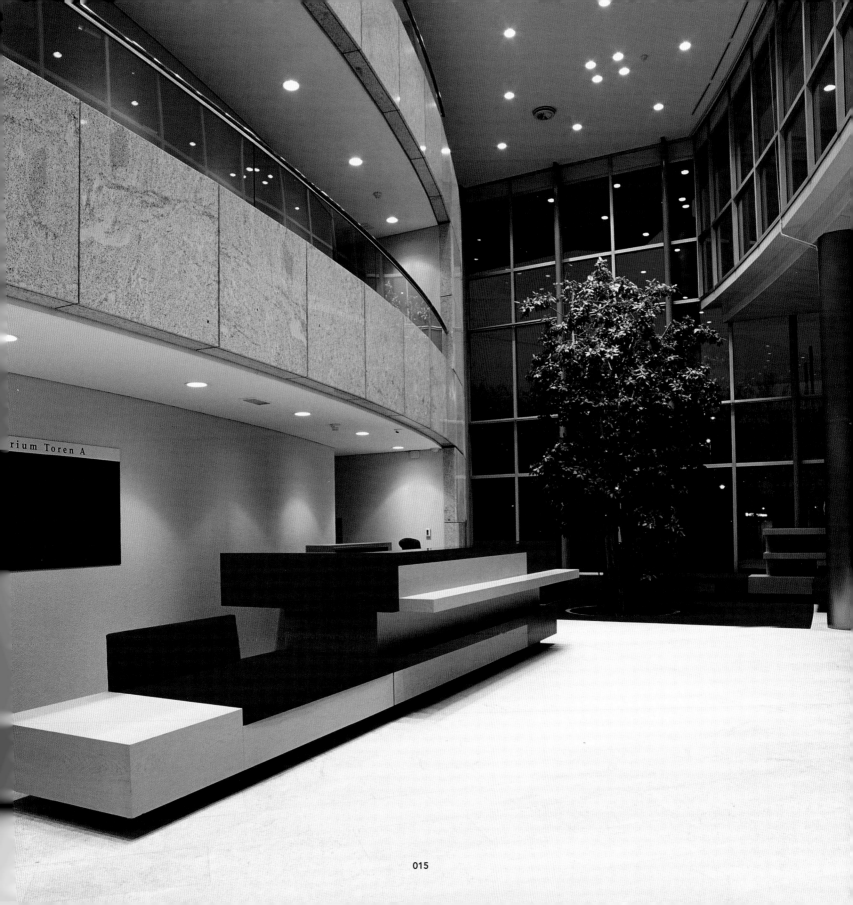

rium Toren A

Seat Series Design: Matthew Butler Manufacturer: Bluesquare

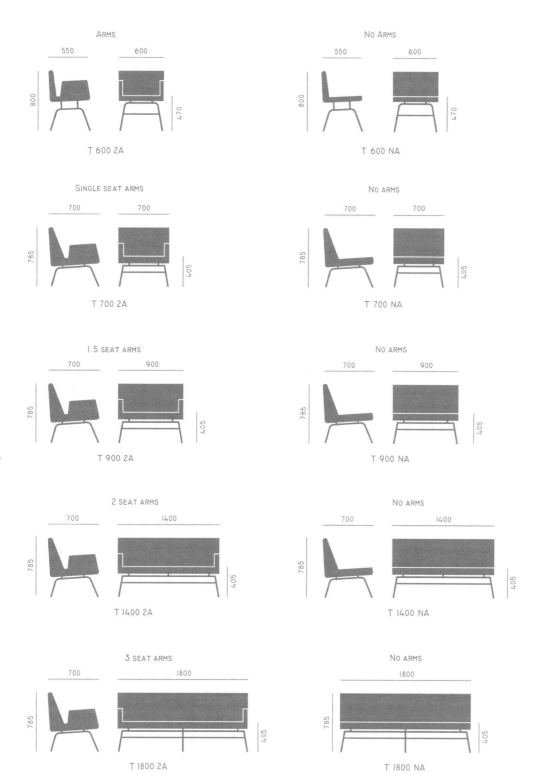

ARMS

550 600

800 470

T 600 2A

No ARMS

550 600

800 470

T 600 NA

SINGLE SEAT ARMS

700 700

785 405

T 700 2A

No ARMS

700 700

785 405

T 700 NA

1.5 SEAT ARMS

700 900

785 405

T 900 2A

No ARMS

700 900

785 405

T 900 NA

2 SEAT ARMS

700 1400

785 405

T 1400 2A

No ARMS

700 1400

785 405

T 1400 NA

3 SEAT ARMS

700 1800

785 405

T 1800 2A

No ARMS

1800

785 405

T 1800 NA

○ The T Series was designed by Mathew Butler for the Olympic games in Sydney. The collection of sofas, seats, armchairs, and tables achieves elegance and simplicity, and is perfect for diverse reception spaces due to comfort and durable style. The seats can have a circular base or four legs, and the variety of colors allow for multiple combinations, guaranteeing adaptability to diverse environments.

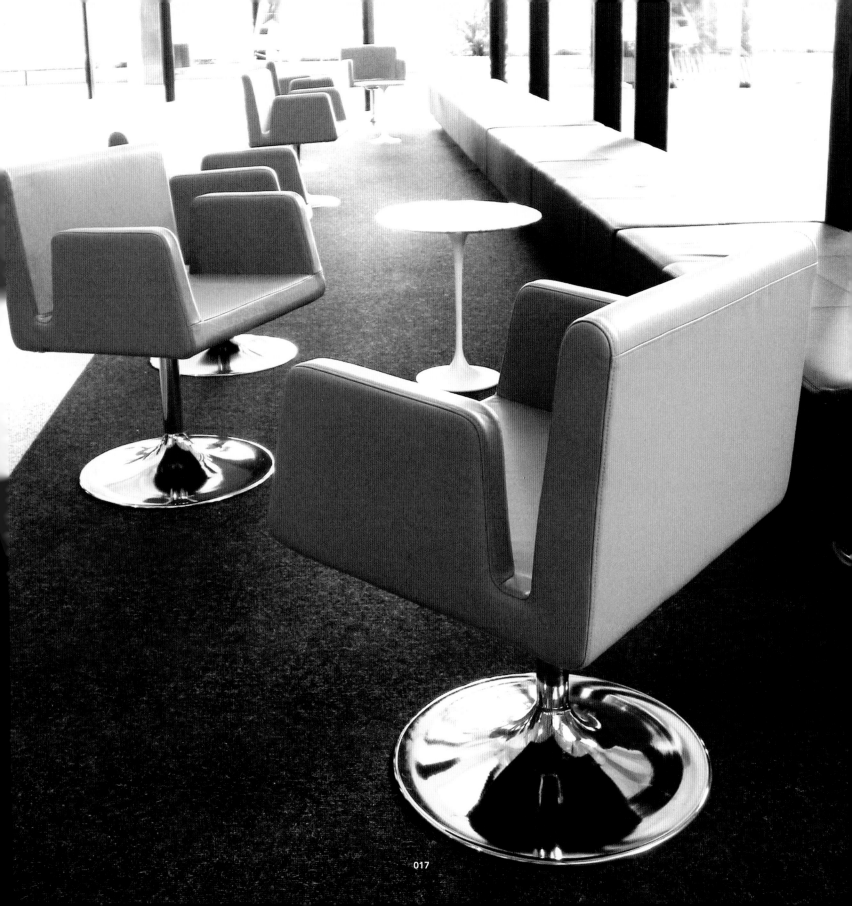

Sea Bench Design: Johnny Sorensen

∘ This two-seater bench, with its reversible and changeable seat, is ideal for places where the furniture must comply with regulations of resistance and flexibility, thanks to the beech or maple wood laminated with cherry panels. The seat has a back, which can be added when desired. To balance the wear, the seat rotates 180°, and thus the back section can easily become the front. The wooden chair can be replaced by an upholstered one and vice versa.

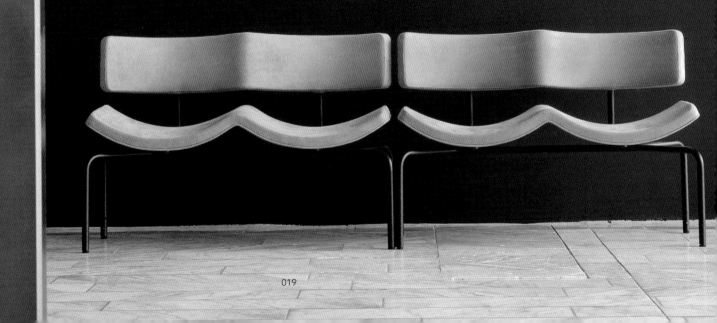

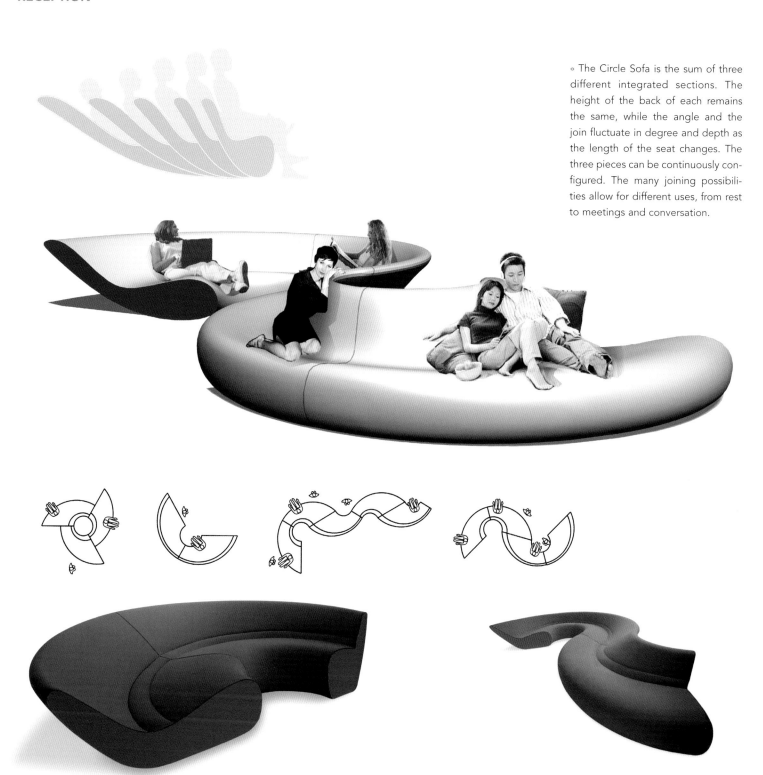

○ The Circle Sofa is the sum of three different integrated sections. The height of the back of each remains the same, while the angle and the join fluctuate in degree and depth as the length of the seat changes. The three pieces can be continuously configured. The many joining possibilities allow for different uses, from rest to meetings and conversation.

Circle Sofa Design: UN Studio Manufacturer: Walter Knoll

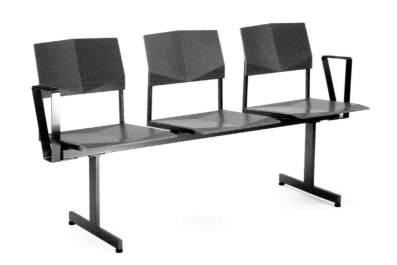

Office Furniture Design

∘ The Kide seats form part of a series of multi-functional seats, stools, arm-chairs, and chairs. The wood has been curved and compressed in a new way to reflect light and shadows. Thanks to its unique appearance, this design is a fresh option for a wide range of public spaces. The seat and back are made from birch plywood with melamine laminate. Chairs can be piled with an optional annex piece.

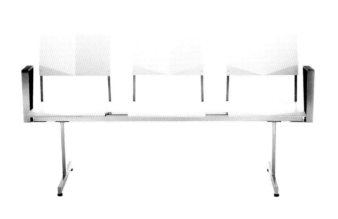

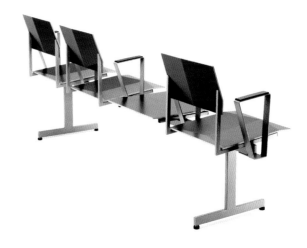

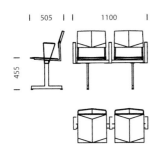

505 1100

455

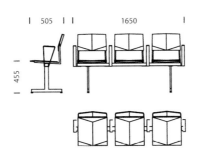

505 1650

455

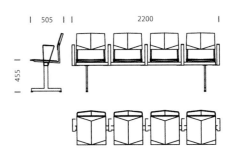

505 2200

455

Kide Series Design: Mikko Paakkanen Manufacturer: Avarte Oy

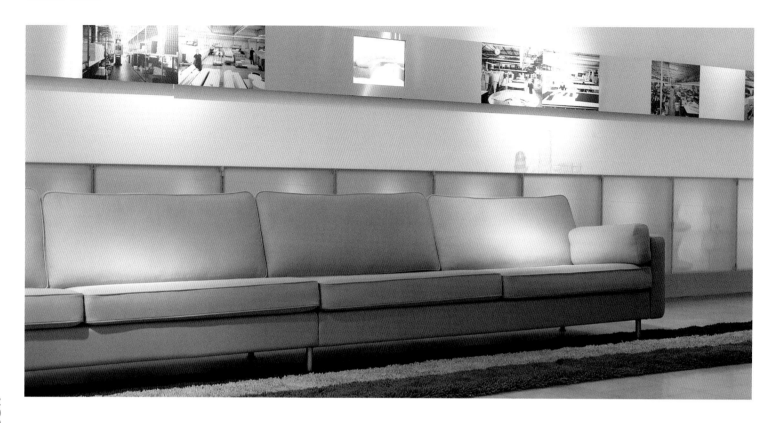

Conseta Sofa **Design:** Friedrich-Wilhelm Möller **Manufacturer:** COR

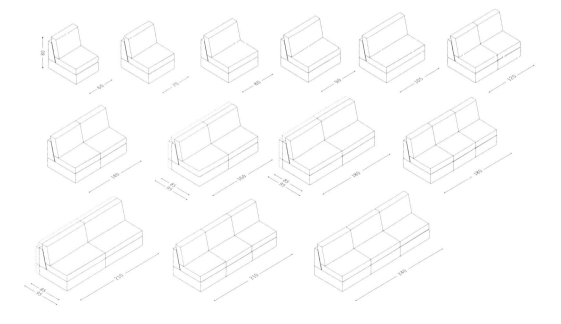

∘ A classic in design, this sofa was named after the Latin "con sedere," which means "to sit with," and is as flexible and adaptable as a chameleon. Its simplicity allows it to resist styles and fashions and to fit perfectly in diverse environments. With its elegant lines, it creates a neutral and attractive atmosphere, while fulfilling the requirements of a reception space. It can also be built in different forms, thanks to its connecting elements.

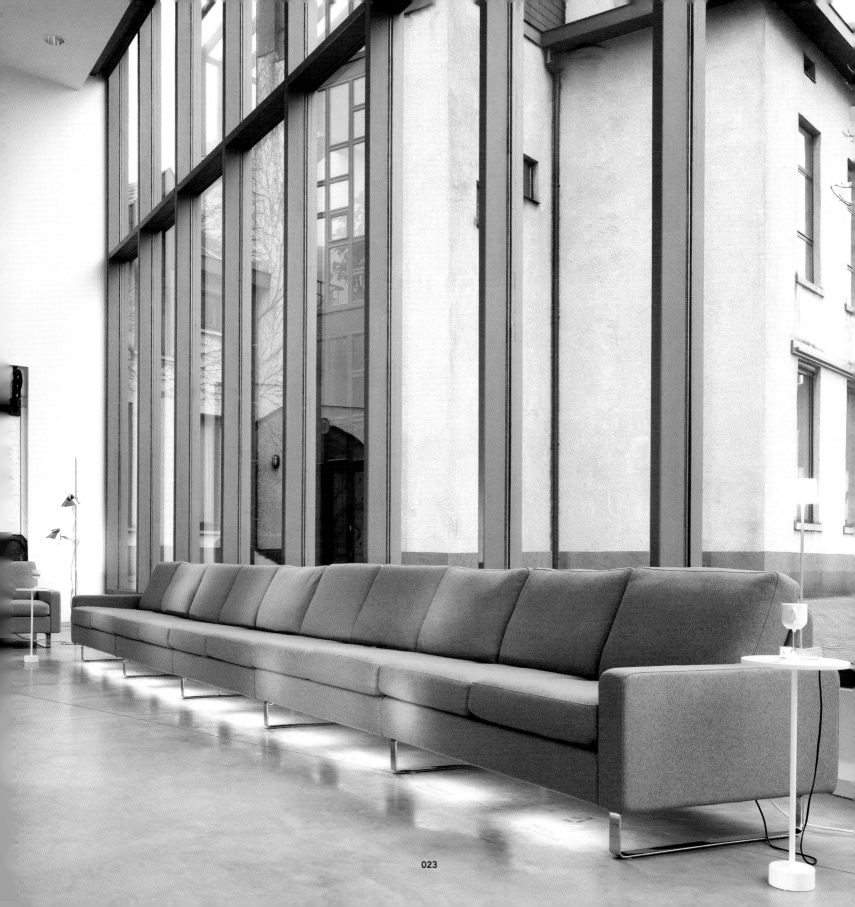

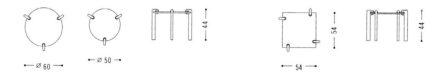

Clou Series Design: Wulf Schneider and Partners Manufacturer: COR

○ Clou is a program of modules and sofas that offer multiple possibilities and simplicity in design. The basic element is a cubic stool. Simple backs can be attached with a single piece. A space fitted with seats, benches, armchairs, and sofas can be combined with tables and surfaces from the series that connect to the furniture.

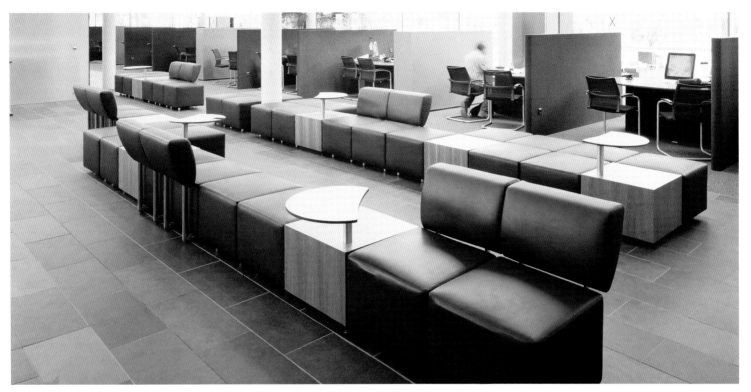

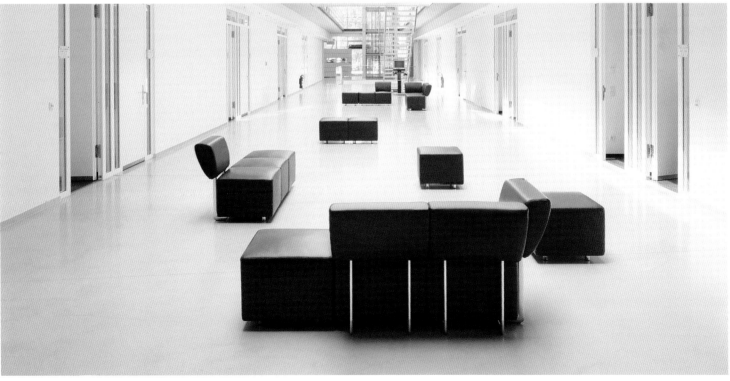

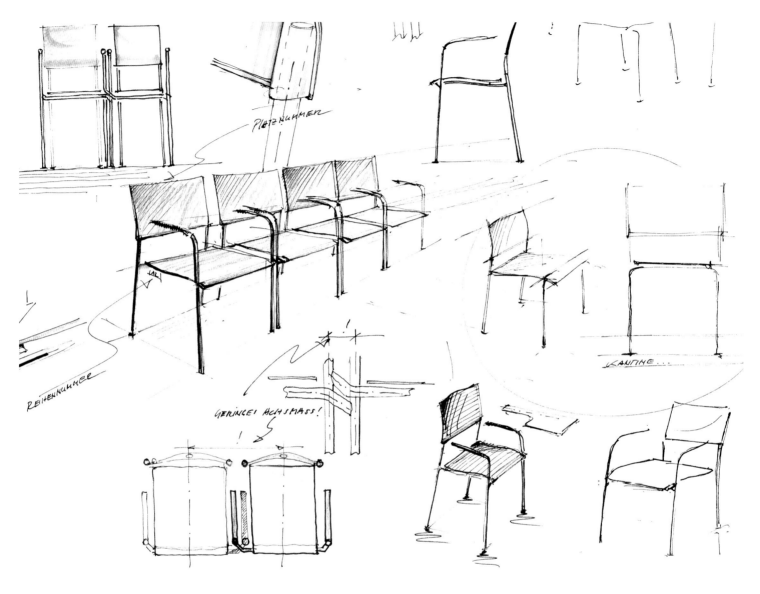

S360 Chair Design: Delphin Design Manufacturer: Thonet

∘ The most ingenious solution for a complicated task: rows of seats whose front legs join with no need for additional elements. The S360 Chair is a large seat with a very low angle, especially designed for audiences. It can be piled, is extremely easy to transport and comfortable to handle, and is stable, light, and flexible. A simple, economical design concept, the chair is also resistant and aesthetically appealing, making it ideal for public spaces.

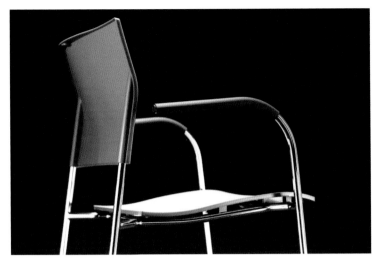

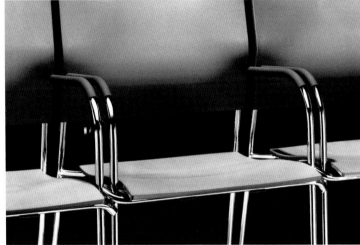

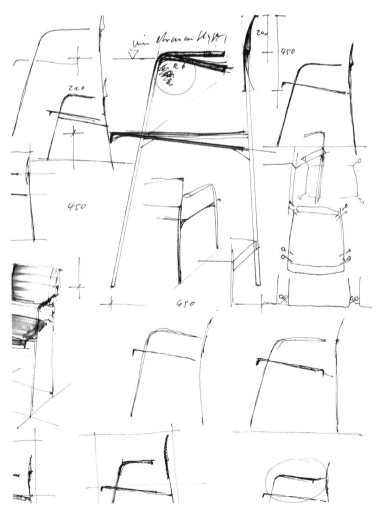

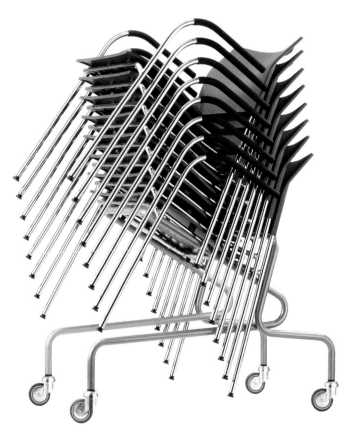

∘ This exquisite piece of furniture, an example of lineal purity that characterizes Scandinavian design, is cheerful and comfortable thanks to the softness of its different-colored cushions, which can be combined with total freedom via a system of Velcro. Thanks to the different modules, straight, angled, or even independent sofas can be created.

Playback Sofa Design: Eero Koivisto Manufacturer: OFFLECCT

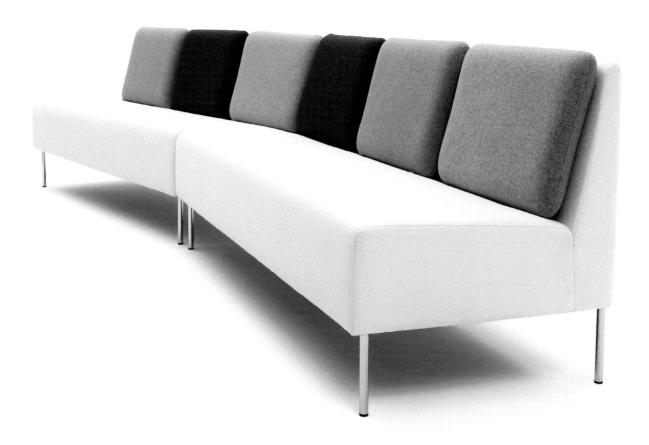

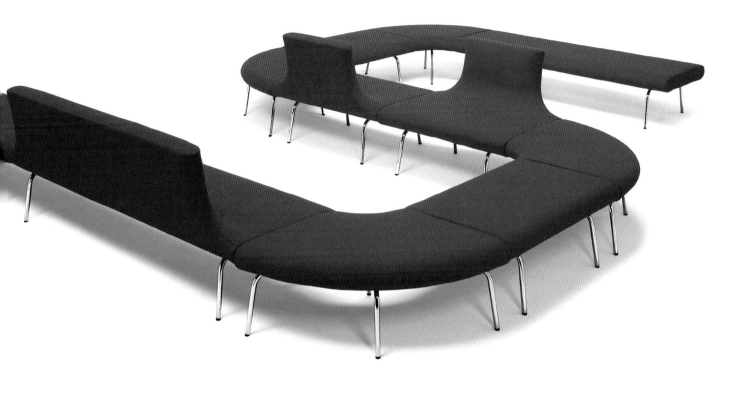

° The Orbit sofa is designed to show off fashionable lines and a modernity without complications. It consists of a series of changeable parts that can be connected, creating a unique layout for each environment. Upholstered in material with a palette of select, bright, and rcfined colors, it creates an elegant, futuristic atmosphere.

Orbit Sofa Design: Eero Koivisto Manufacturer: OFFLECCT

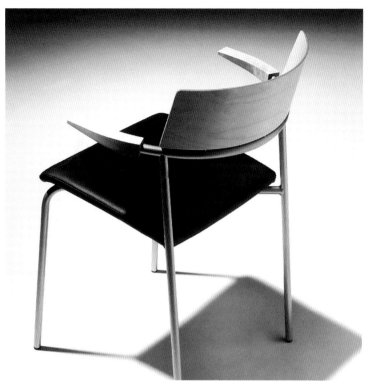

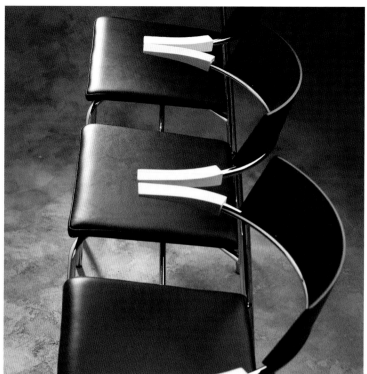

Cirkum Design Troels Grum–Schwensen Manufacturer: Globe Furniture A/S

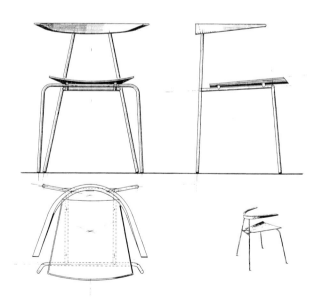

○ Cirkum is an elegant and simple set of furniture that offers a variety of possible applications. The arms (optional) and the back of the chair create a distinctive semicircle that wraps around the body. The combination of colors, textures, and materials complements the lightness of this delicate furniture. The chair can be made combining two tones of wood, and the seats can be upholstered, depending on the needs.

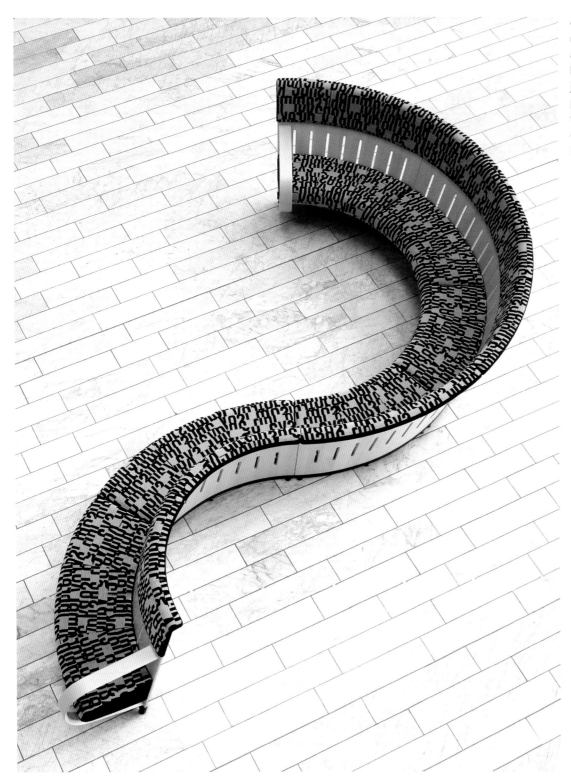

° The Swinger is ideal both for small rest areas and for creating intimate areas in large spaces. The curved back, created when the modules are joined, provides a stability that supports a seat without legs, allowing the floor to be easily cleaned. Swinger comes upholstered, with optional finishes in different types of wood.

Swinger Sofa Design: Rud Thygesen & Johnny Sørensen Manufacturer: Magnus Olesen A/S

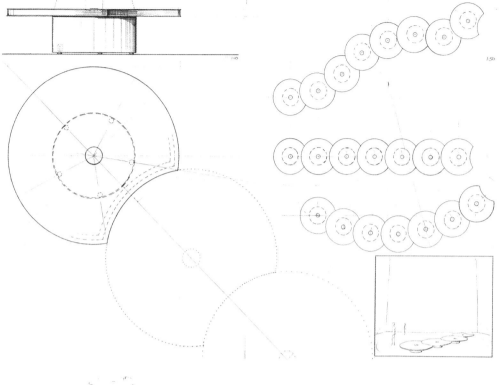

○ Inspired by water lilies, these seats can be positioned apart or joined in a chain, depending on the size of the space. The concave incisions allow a change in direction for each new unit added to the group. The design's minimalism and the bizarre forms that can be created establish different flows of communication, making waiting in reception an architectural experience.

Waterlily Seats Design: Troels Grum–Schwensen Manufacturer: Globe Furniture A/S

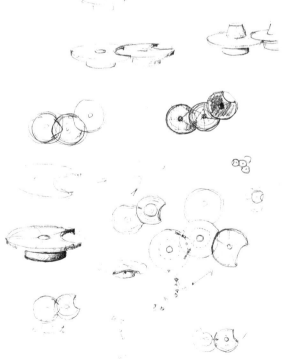

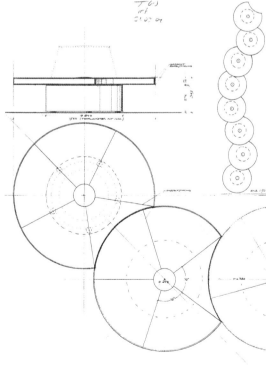

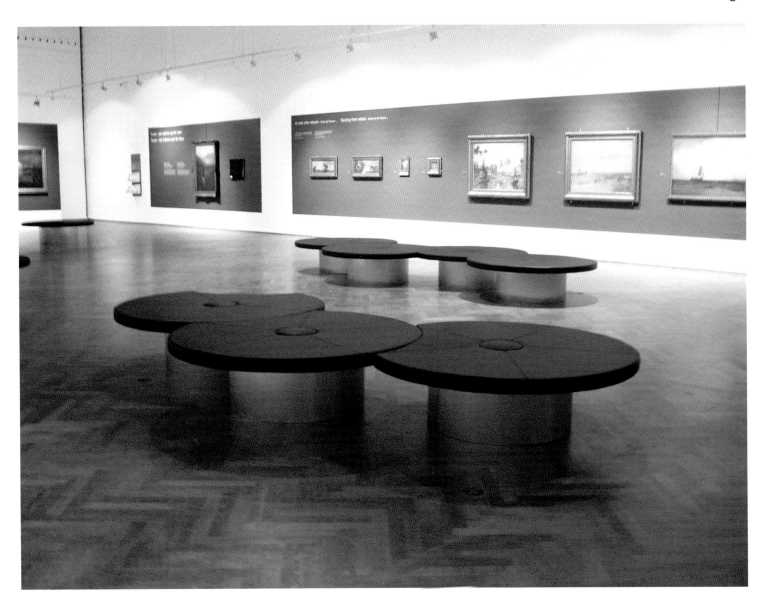

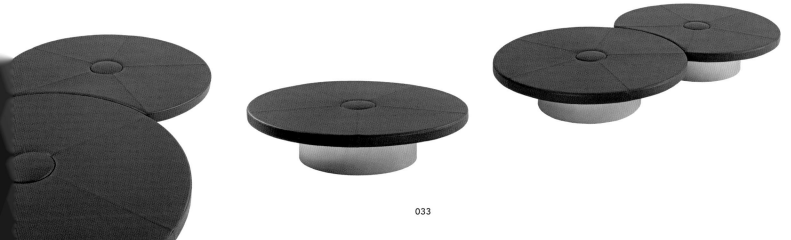

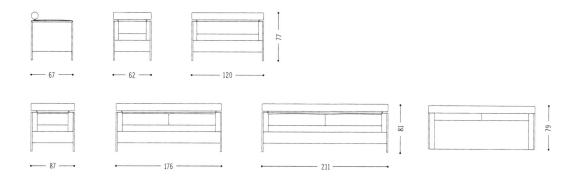

Nemo Design: Peter Maly Manufacturer: COR

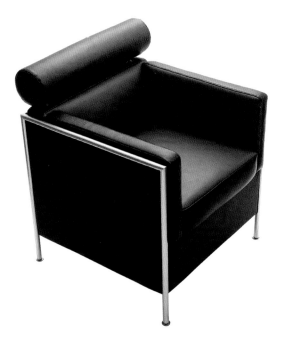

∘ The Nemo modules, in different sizes, allow for groups of seats that harmonize with various interiors. The visible chrome or lacquered tubing emphasizes the clean lines and provides firmness. A compact organization can be chosen using the smaller seat and sofa, or a more sumptuous atmosphere can be created.

034

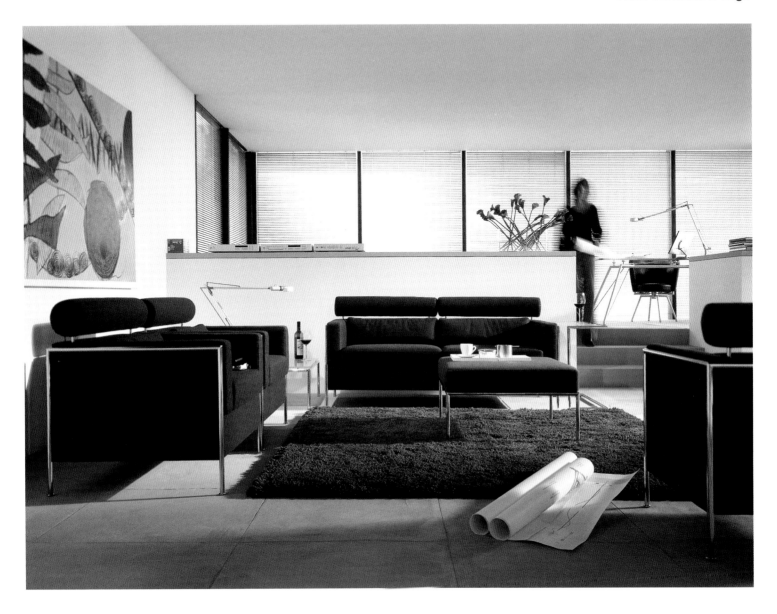

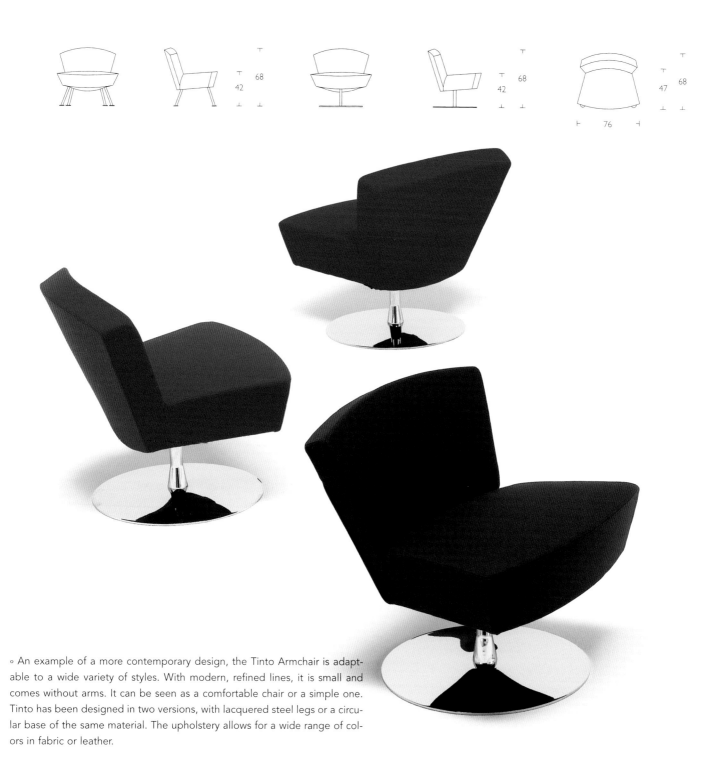

68
42

68
42

47 68

76

Tinto Armchair **Design:** Claesson / Koivisto / Rune **Manufacturer:** OFFECCT

○ An example of a more contemporary design, the Tinto Armchair is adaptable to a wide variety of styles. With modern, refined lines, it is small and comes without arms. It can be seen as a comfortable chair or a simple one. Tinto has been designed in two versions, with lacquered steel legs or a circular base of the same material. The upholstery allows for a wide range of colors in fabric or leather.

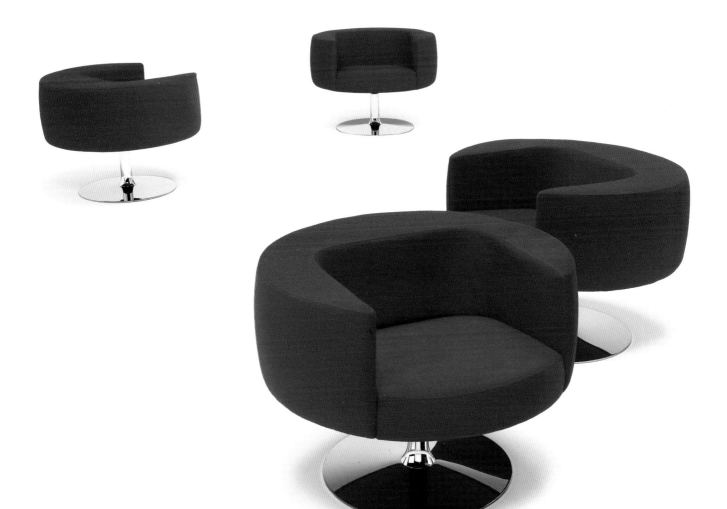

° The Zero Chair, a classical-futuristic piece, combines the sensual curve of its exterior with the straight angles of its interior. The chrome or lacquered metal circular base gives the impression that it is floating. The size of the seat, with comfortable proportions, occupies a large part of the diameter, making it a very functional piece that can be adapted surprisingly to a large number of styles and atmospheres.

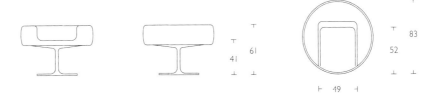

Zero Chair Design: Marre Moerel Manufacturer: OFFECCT

○ The reception of the modern Arnio office building consists of a combination of modules in bright red plastic that serves as a reception desk (straight or angled) and a long bench. The lounge features two modular sofas with straight lines and blue tones. In the center, a large table reinforces the effect of a spatial unit. The comfortable, undulated carpet that covers the floor also covers the entire ensemble.

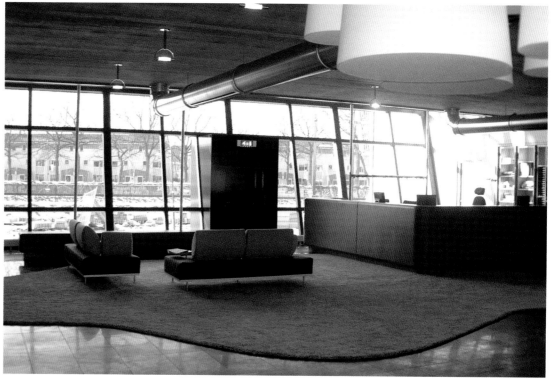

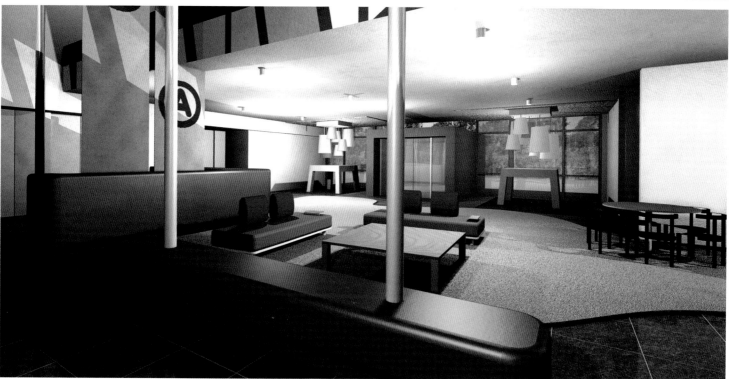

Animatie Entree Design: Yksi Eduard

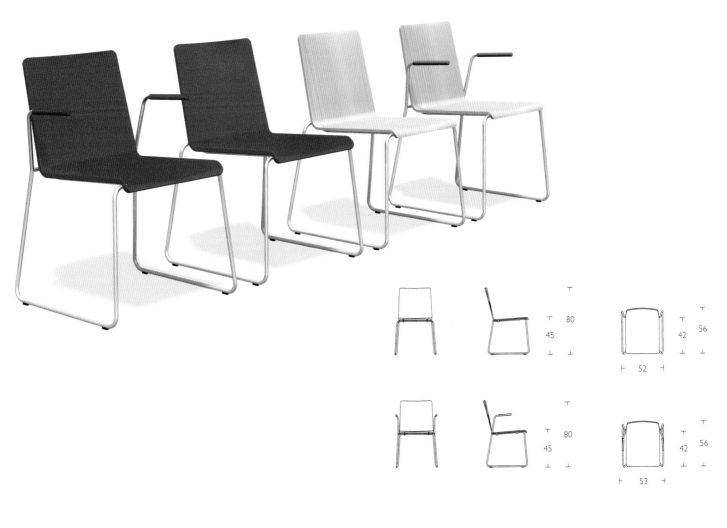

◦ The key concept in the design of this seat is lightness, and the effect is of being suspended in the air, thanks to its fine chrome tubing. The chair has aerodynamic lines in keeping with the gentle curves of the structure. The Monolight chair is ideal for specific corners in large receptions or waiting areas with smaller dimensions, where its simple, light lines contribute to increasing the sense of space.

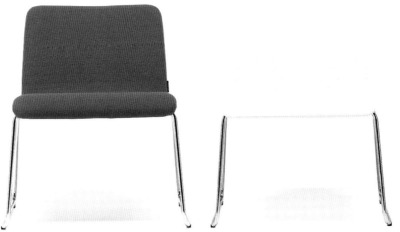

Monolight Chair Design: Ola Rune Manufacturer: OFFECCT

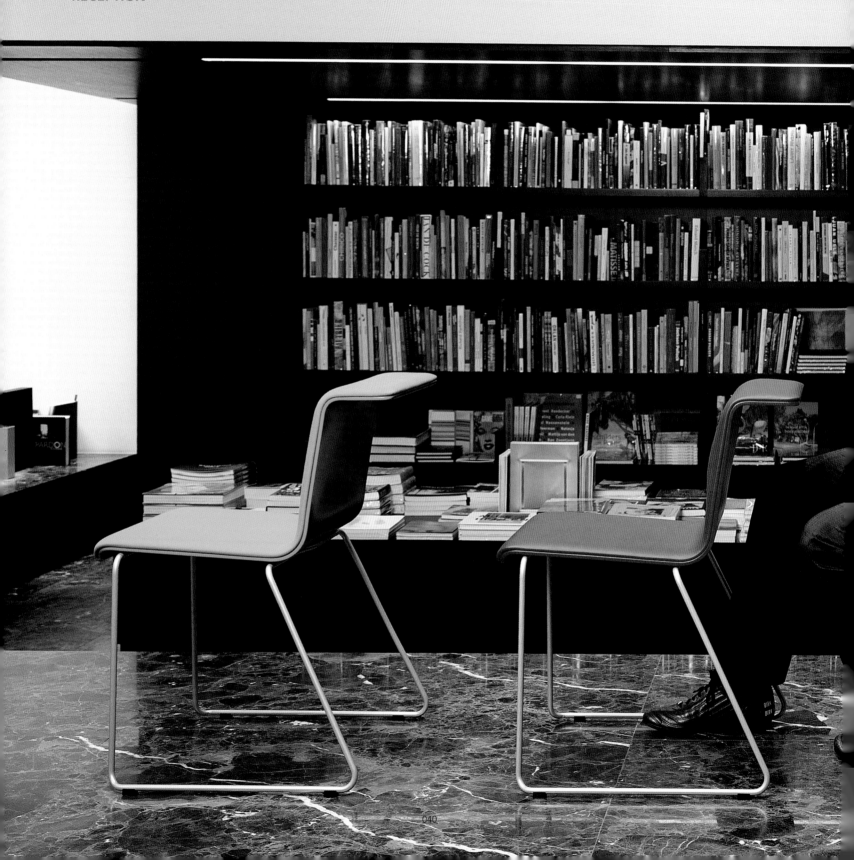

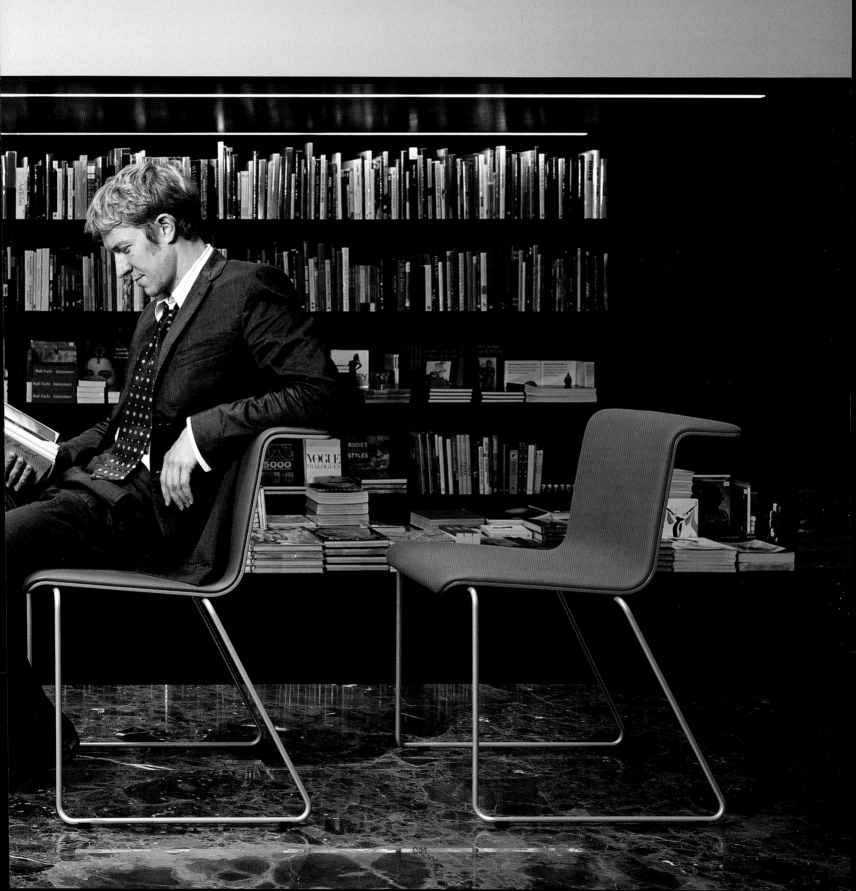

Aline Chair Design: Andreas Störiko Manufacturer: Wilkhahn

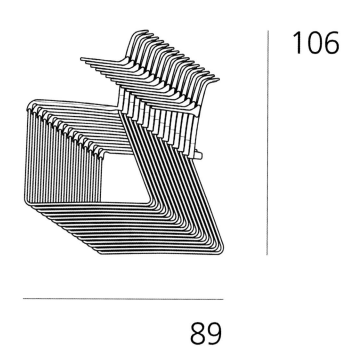

106

89

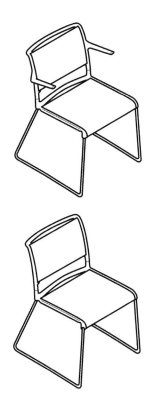

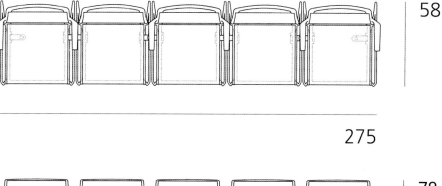

58

275

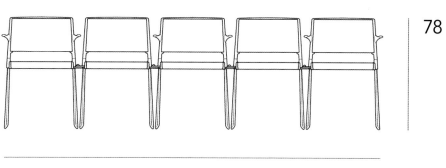

78

275

◦ This is a multi-functional seat that can function alone, or be grouped informally or in rows, thanks to the tubing that can be assembled. Despite its high level of standardization and the low production cost, it allows for a wide variety of applications. Its lightness does not look out of place with the robustness of the materials. The chair and back are made of fiberglass and come in white, gray, or black with optional arms. It can be piled and easily stored.

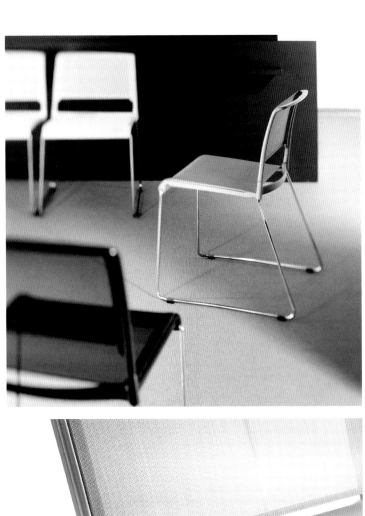

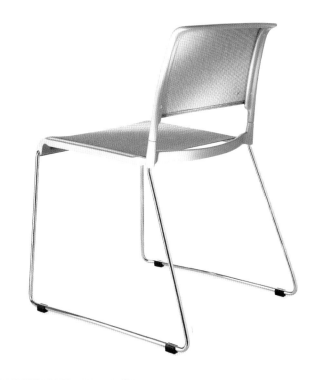

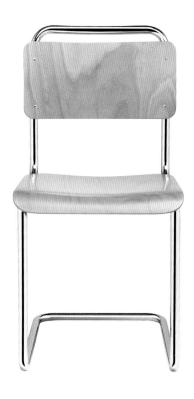

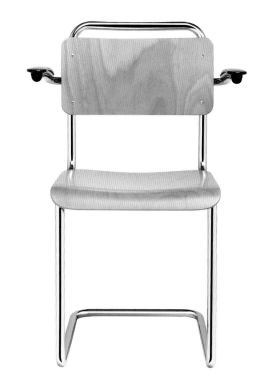

Gispen Chair Design: W. H. Gispen Manufacturer: Dutch Originals

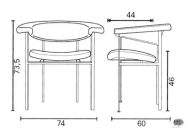

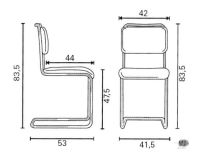

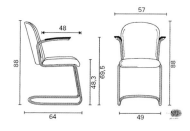

∘ This chair was created in 1931 by W.H. Gispen as one of the first models of tubular seats without back legs. The steel tubular frame follows the elegant line of the varnished plywood seat. There are models with or without gently curved bakelite arms. The Gispen was conceived as a conference seat, although with its elegant, simple lines, it is a classic choice for any space, both public and private.

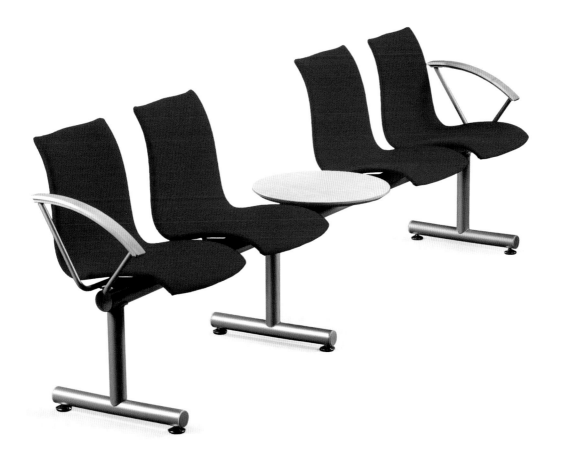

∘ The Bris Bench comes in various versions of two, three, or four seats, and also as a bench in a series of units in rows. The chair and back are well-upholstered and the structure is made of steel, which can be black or epoxy gray. There is also a version with arm supports, and it comes with the Jubilee surface, which can be assembled as a white structure and be used as a table or shelving.

Bris Bench **Design and manufacture:** MNIL Fredrik Torsteinsen

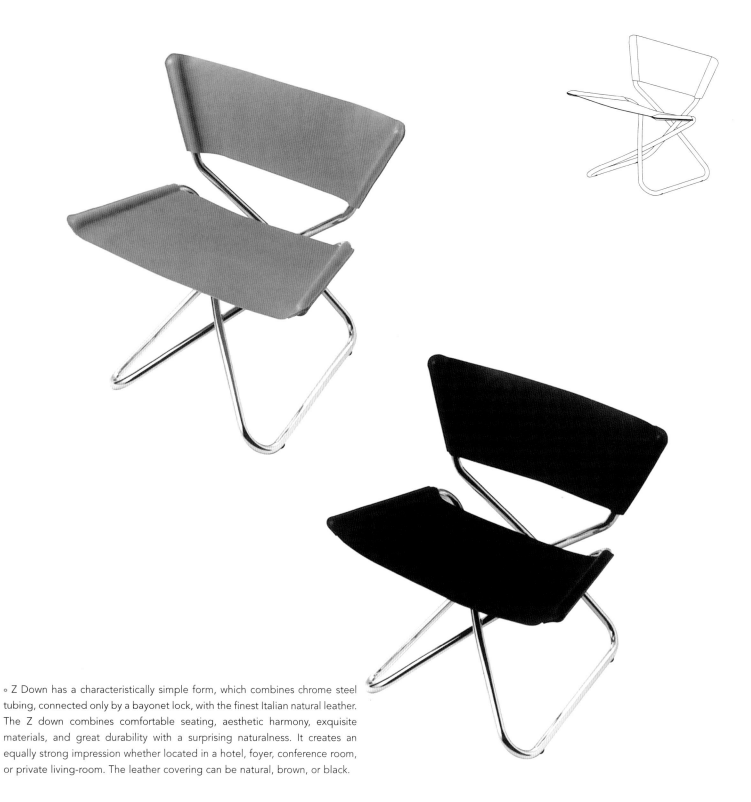

Z Down Design: Eric Magnussen Manufacturer: Engelbrechts

∘ Z Down has a characteristically simple form, which combines chrome steel tubing, connected only by a bayonet lock, with the finest Italian natural leather. The Z down combines comfortable seating, aesthetic harmony, exquisite materials, and great durability with a surprising naturalness. It creates an equally strong impression whether located in a hotel, foyer, conference room, or private living-room. The leather covering can be natural, brown, or black.

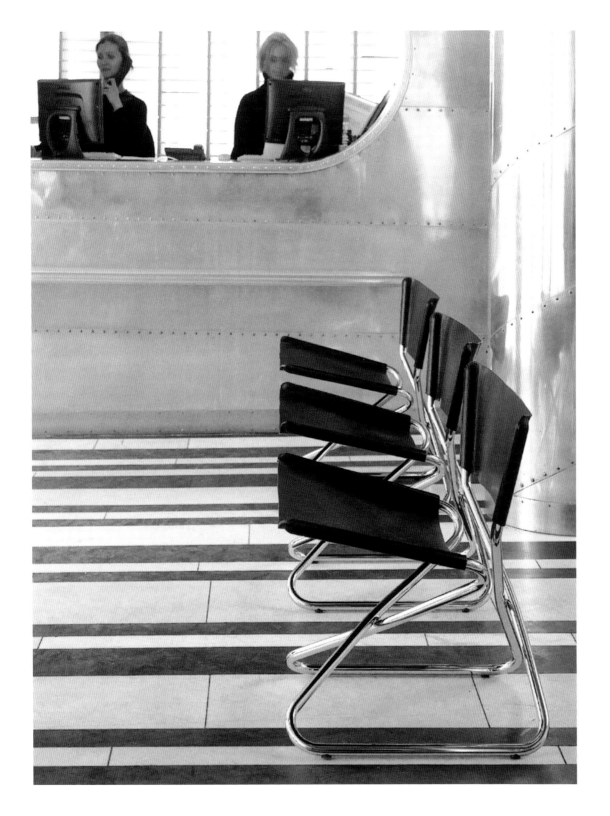

RECEPTION

WORK SPACE

MEETING ROOMS

OFFICE

○ Like the reception area, this is another space that introduces us to the personality and spirit of a company. The place of work is the true nucleus, the space occupied by employees, and plays host to development from the most basic level. It is here where ideas are born, where day-to-day tasks transform into an individual and collective direction. The areas designated for personal work have formally evolved most, due to the use of technology which advances every day. This has created a need for furniture with clear lines, which at the same time houses the host of tools that are being integrated into the workplace. The challenge is to achieve pieces that help to create a clean atmosphere, hiding the cables and connections that are intrinsically linked to the advantages that modern technology brings. Also, perhaps more importantly, the challenge is to achieve environments that encourage concentration as well as fluent communication, in which working efficiently and quickly can be accommodated in a serene space.

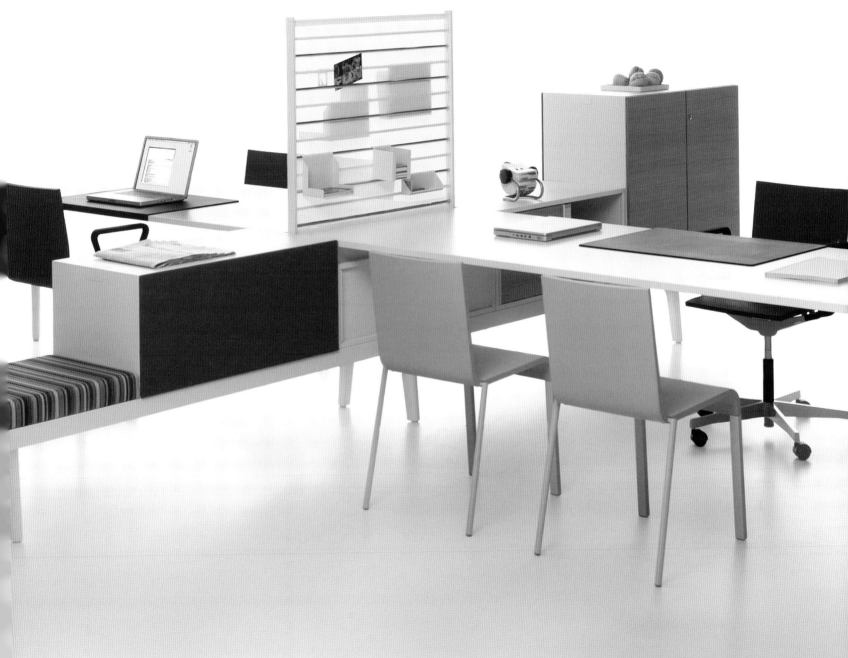

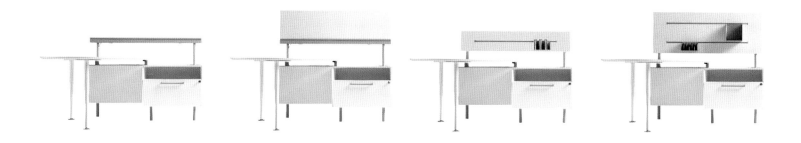

BOS Series Design: Claudio Bellini Manufacturer: Frezza Holland

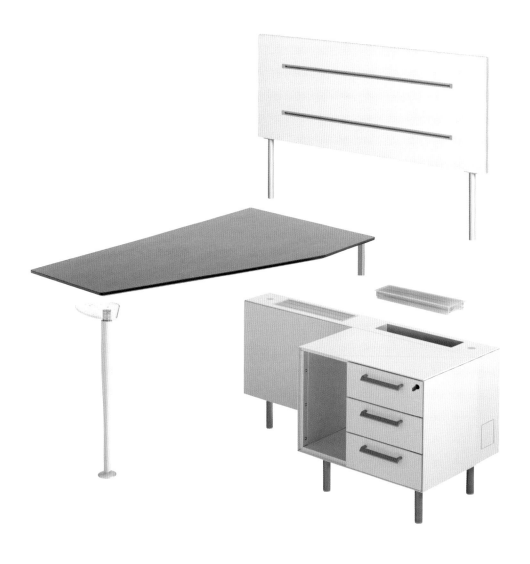

∘ The BOS Series is a program projected for the contemporary office, and allows for a host of layout possibilities for work places both individual and shared. Starting from a central axis-module clad in dust-metal and prepared to house electrical and IT connections, BOS extends practically into infinity, being able to grow horizontally and vertically in accordance with specific needs.

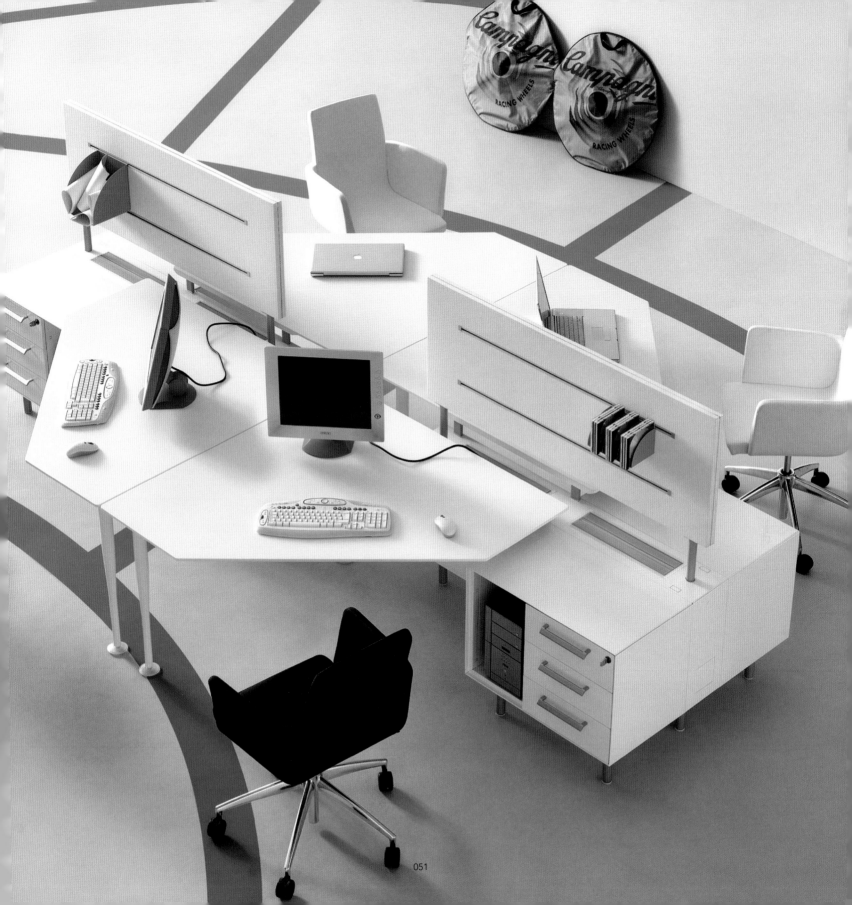

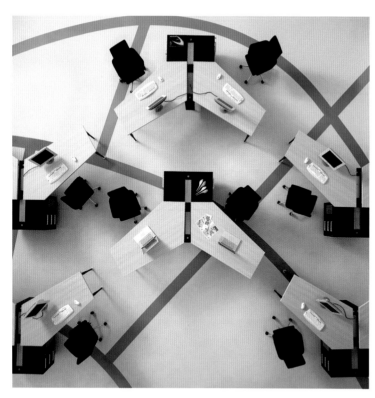

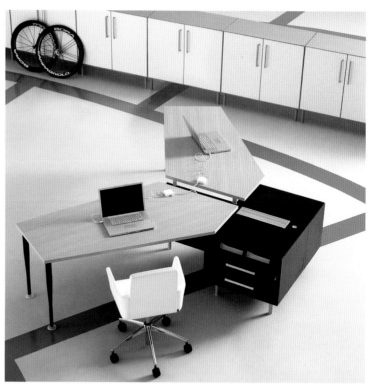

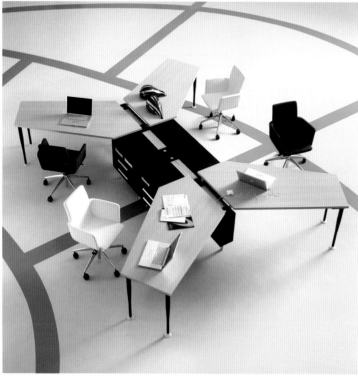

○ Out of all the different layouts that BOS offers, the Y layout is the most complex. Via the triplication of the central axis-module, star-shaped formations can be created which are perfect for operative centers or call-centers. Thanks to the variety of proposals regarding the chromatics and materials, BOS can also be adapted to a wide variety of architectural surroundings.

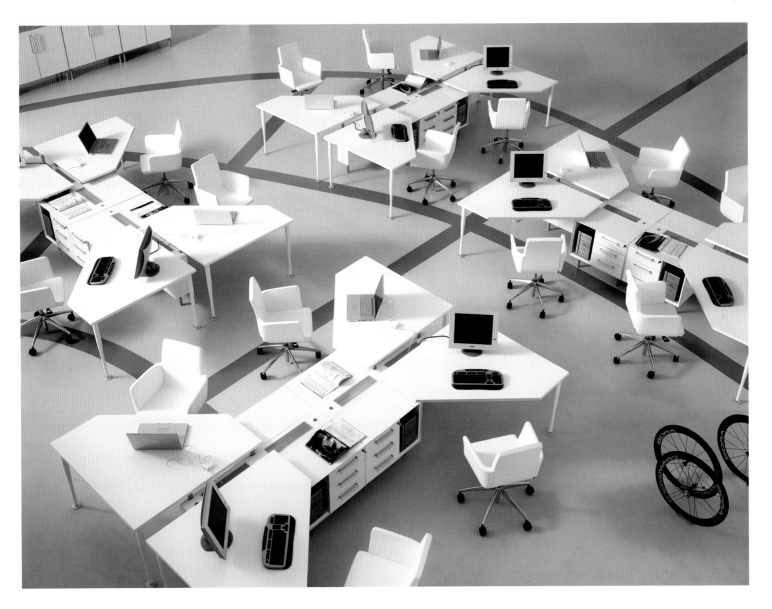

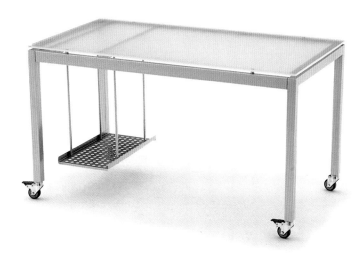

∘ Avantgarde is a practical office desk with an aluminum structure and a semitransparent wood or glass tabletop. The innovation this design presents is in the lower part, which holds the computer's CPU. Wheels can be connected to the legs, and thanks to the brakes incorporated in the wheels, there is maximum adherence.

Avantgarde Table　Design: S.T.C.　Manufacturer: Calligaris

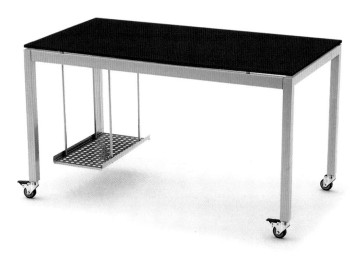

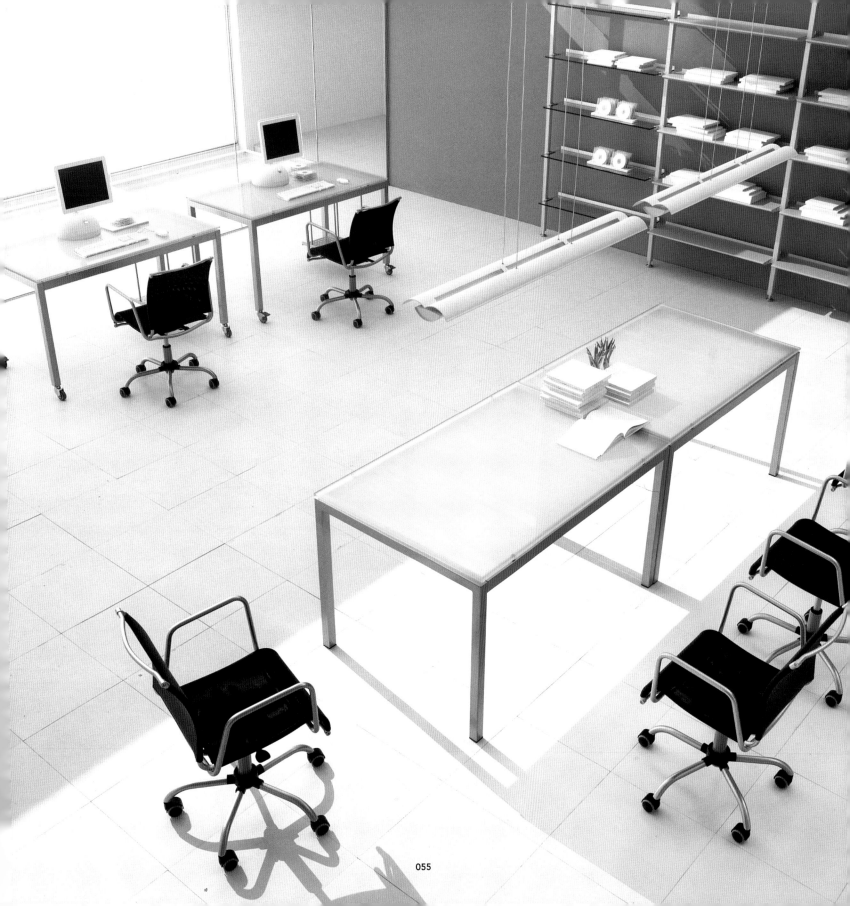

Rack 'n Roll Table Design: Formstelle Studio

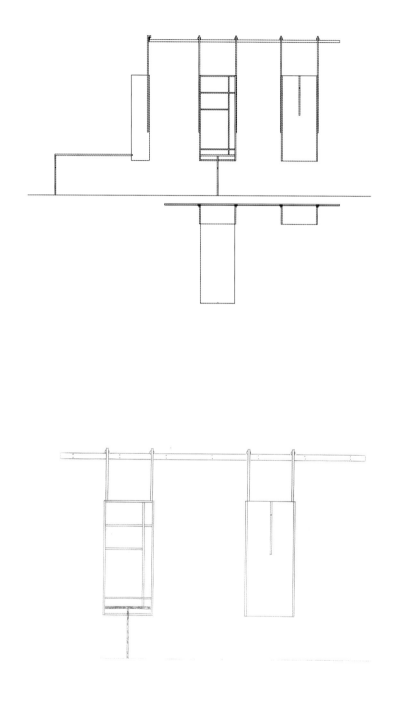

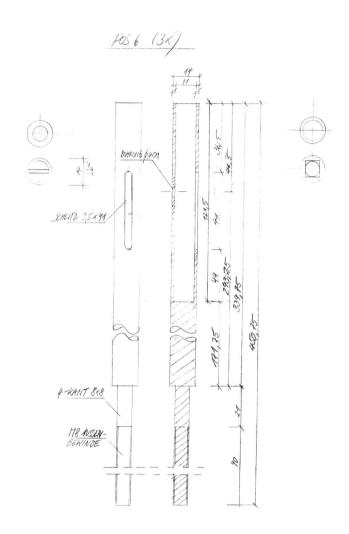

∘ These foldable cubes were designed both for offices and areas in the home designated as studies, especially where it is necessary to optimize the use of space. They are ideal for using with laptops, since when the central tabletop opens and moves downwards, the hanging modules become work desks with incorporated shelving.

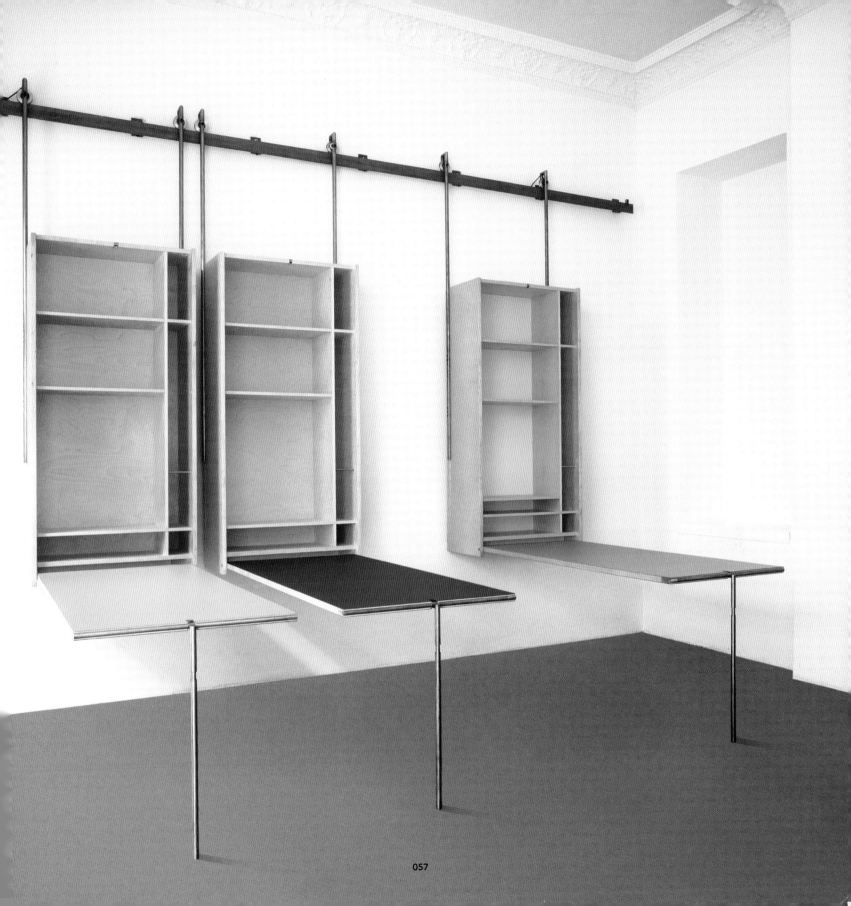

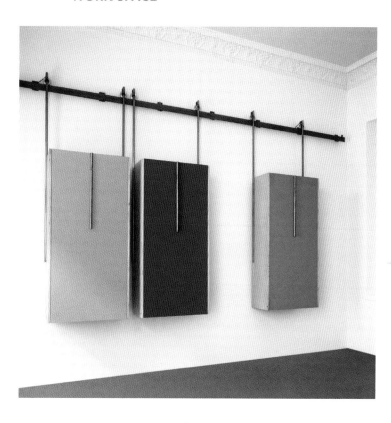

• Thanks to the sliding rail from which they hang, it is possible to move the tables, bringing them closer when needed. An indirect light, situated behind the main body, lights up the surface and the area around the table. Formstelle is presented in diverse colors adaptable to a host of surroundings, providing an identity to each table.

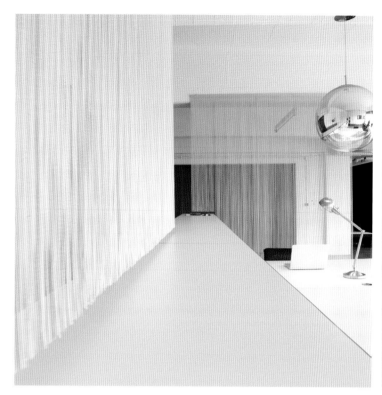
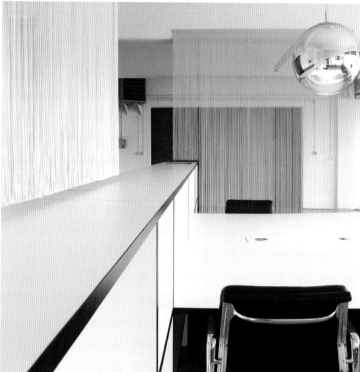

Formstelle Studio Office Design: Calligaris Manufacturer: Calligaris

∘ This is the office of the Formstelle Studio, belonging to architects Claudia Wiedemann and Jörg Kürschner. The base color of the studio is white, suggesting a peaceful environment, ideal for creativity. The tables that compose the room have an aluminum structure and are lined with wood covered in white melamine. The chairs, with their chrome steel structure, are lined with cushioned leather and have rotating legs.

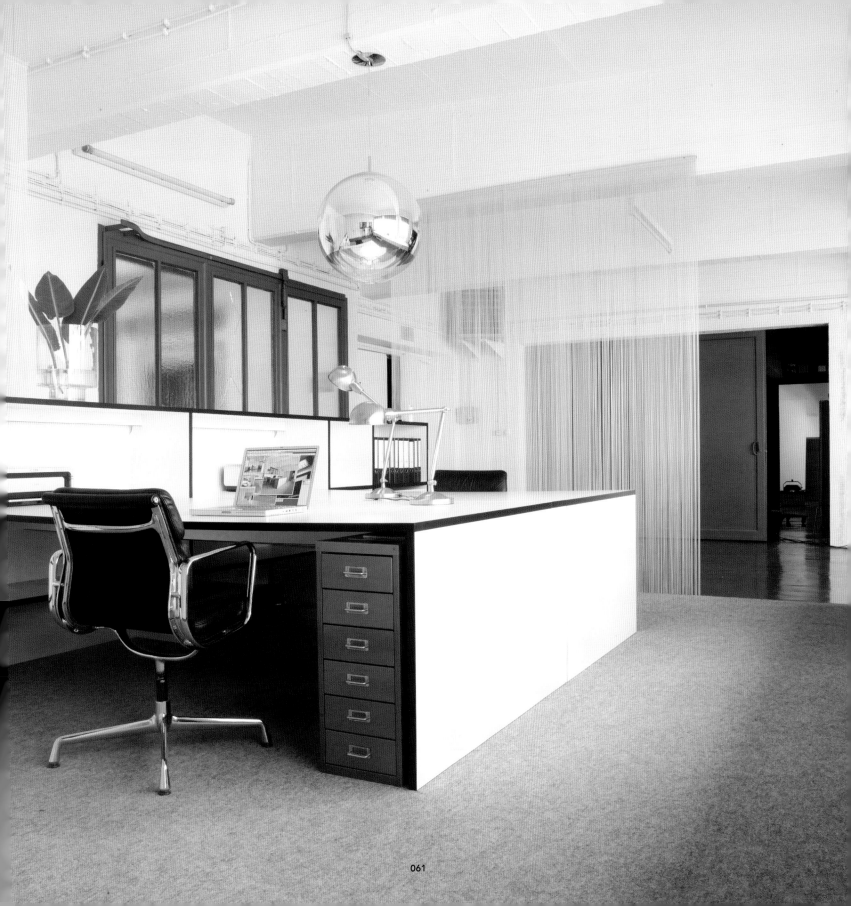

○ One of the most characteristic elements of this space is the separation of the areas using simple fiber curtains, made from thin strips. This means the different work areas can be separated or the visibility between them reduced without impeding the flow offered by open spaces. The spherical lights on the ceiling provide complementary lights to the spotlights on the tables.

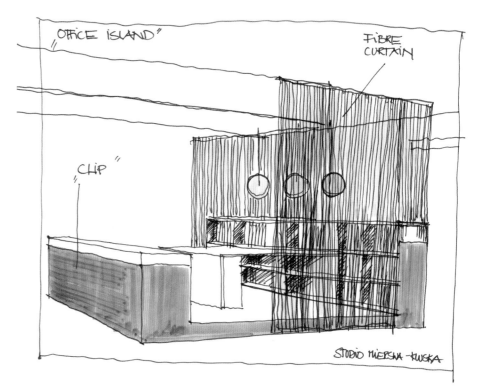

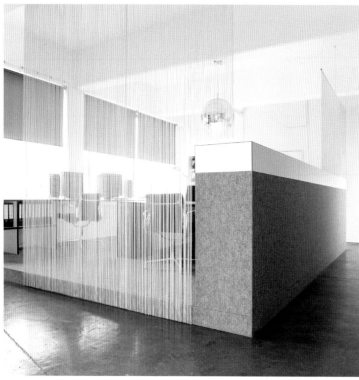

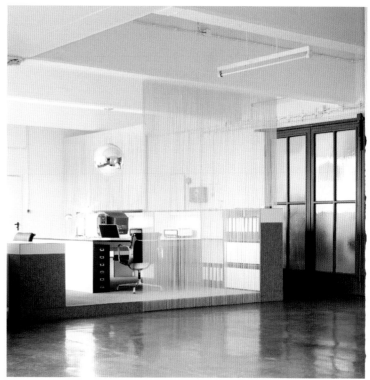

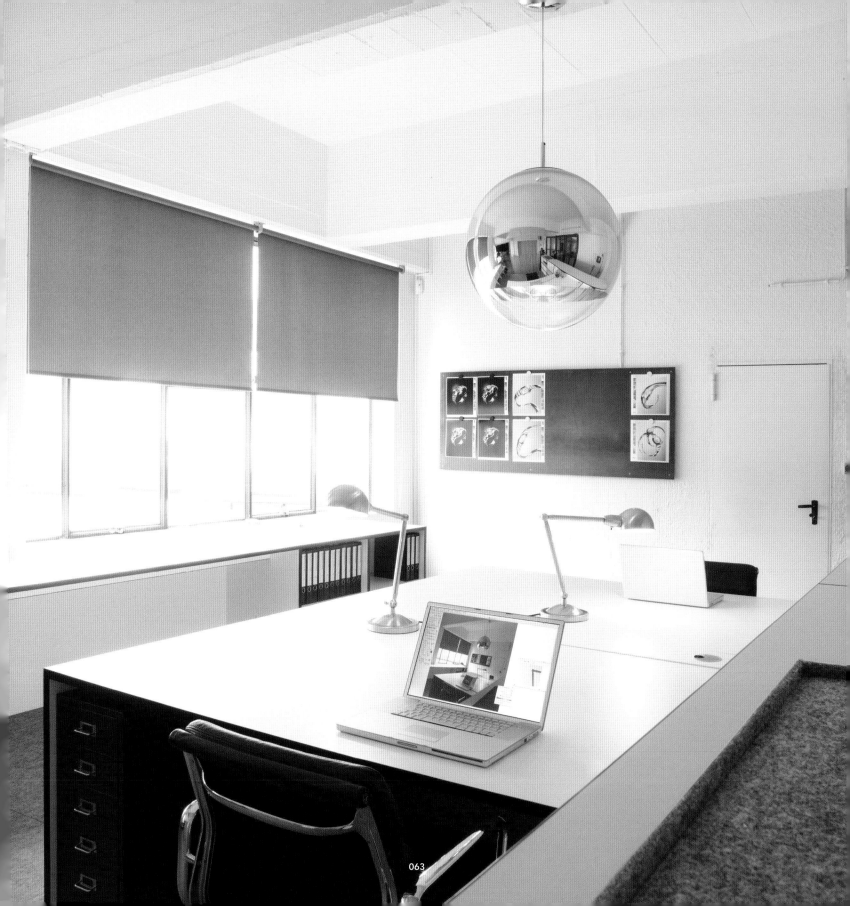

◦ In traditional markets where diverse types of meetings take place, the Space Bench is the natural center of rotation. With its capacity to integrate multimedia, it is appropriate both for entranceways and large spaces: airports, lobbies etc. In a company, it can act as an interactive item of furniture, from which one can obtain information about the company. And in receptions or entranceways, it gives information concerning timetables, news, announcements, etc.

Space Bench Design: Busk and Hertzog Manufacturer: Magnus Olesen A/S

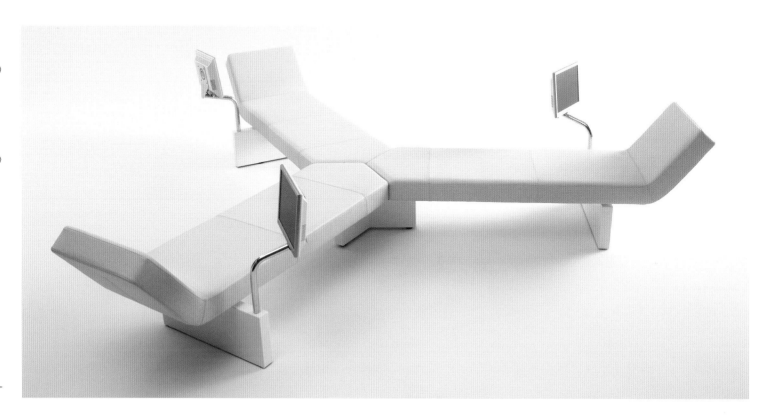

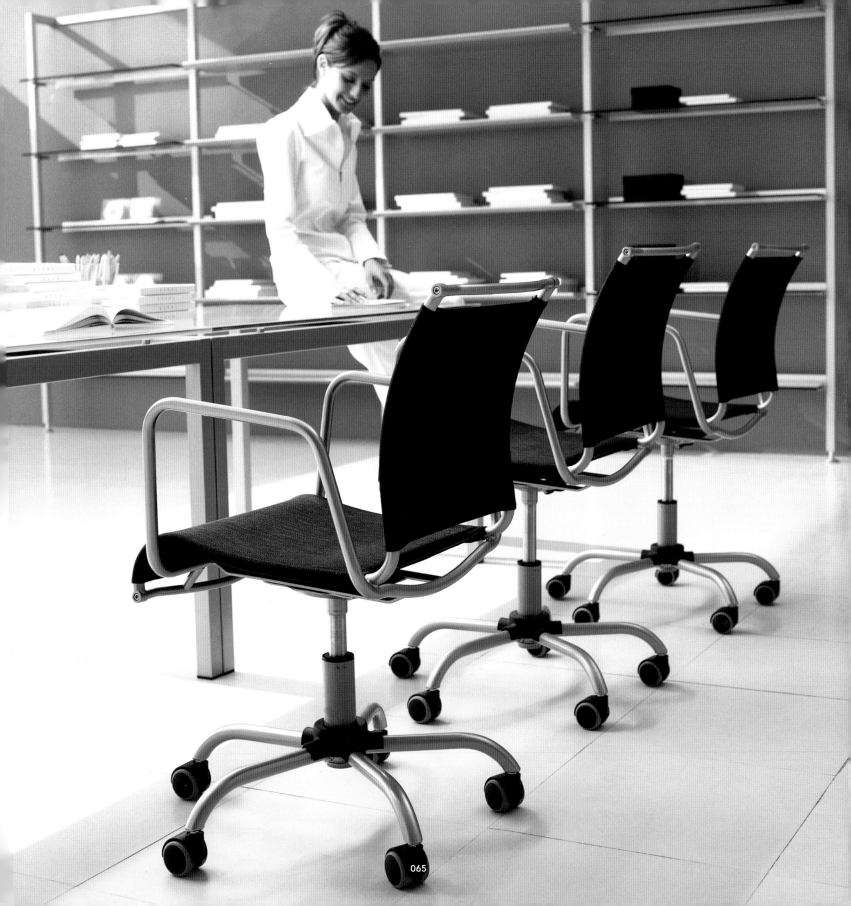

Kant Table **Design:** Markus Boge and Patrick Frey **Manufacturer:** Moormann Möbeln

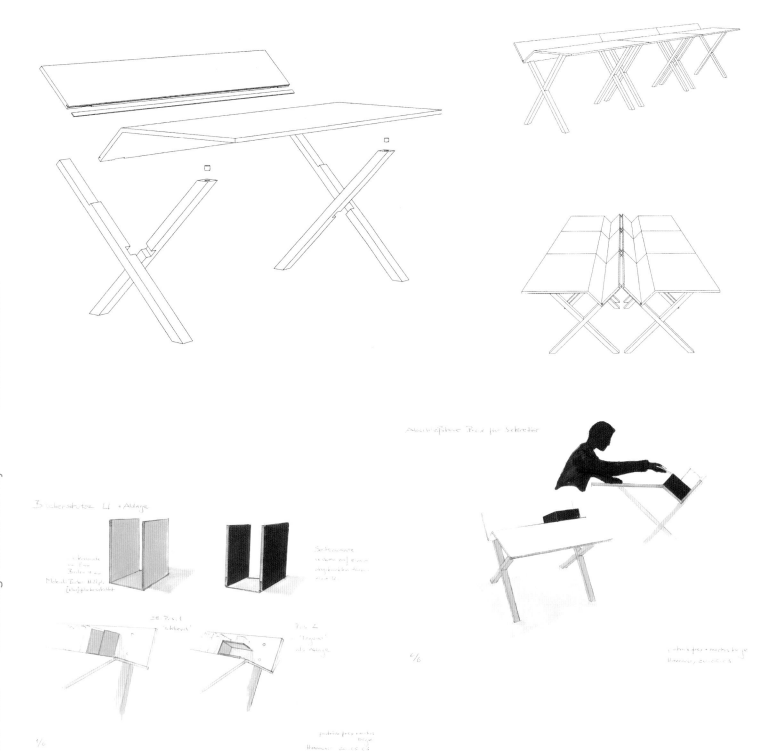

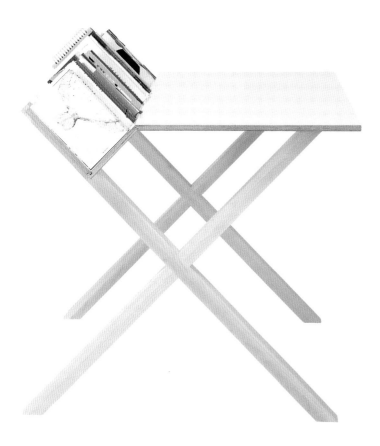

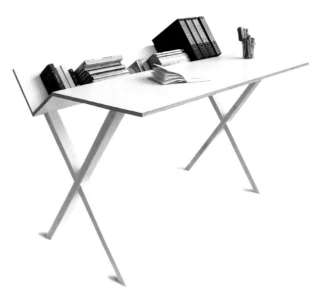

◦ Kant is designed to facilitate the organization of the work desk. Thanks to the L-shape annexed parallel to the table, it is possible to organize the objects used daily in such a way that the table is clear and the objects are accessible. Made from birch wood and covered in white melamine with scissor-shaped legs, its depth comfortably allows for the installation of a computer.

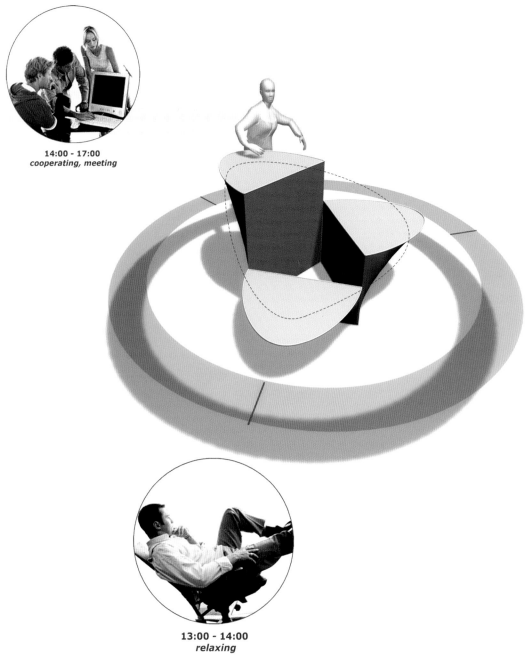

14:00 - 17:00
cooperating, meeting

09:00 - 13:00
concentrated working

13:00 - 14:00
relaxing

SUM Design: UN Studio / Ben van Berkel

∘ Sum is a surprising concept designed for people to work directly on its surface but also around it. Three semicircular pieces at different heights allow the user to work easily in different positions and to occupy the space around his work place. Sum has been made in molten aluminum with surfaces edged with wood.

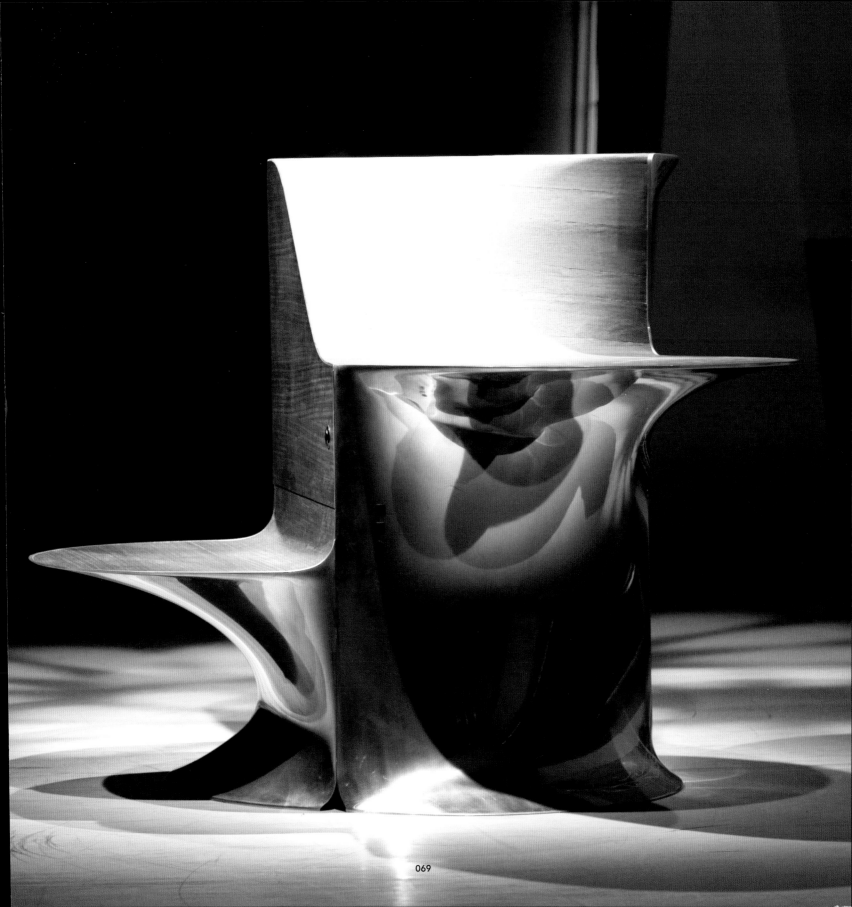

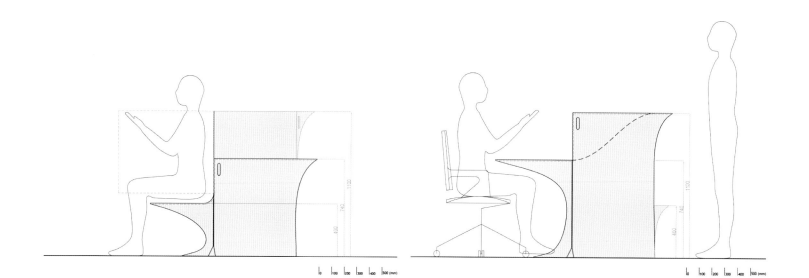

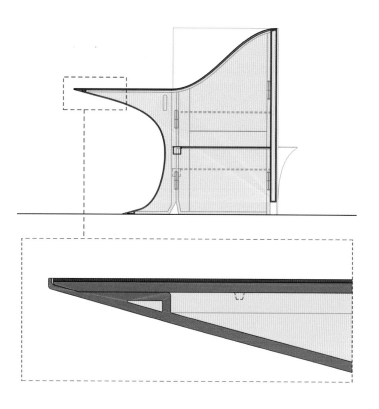

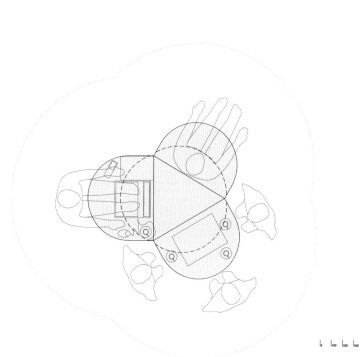

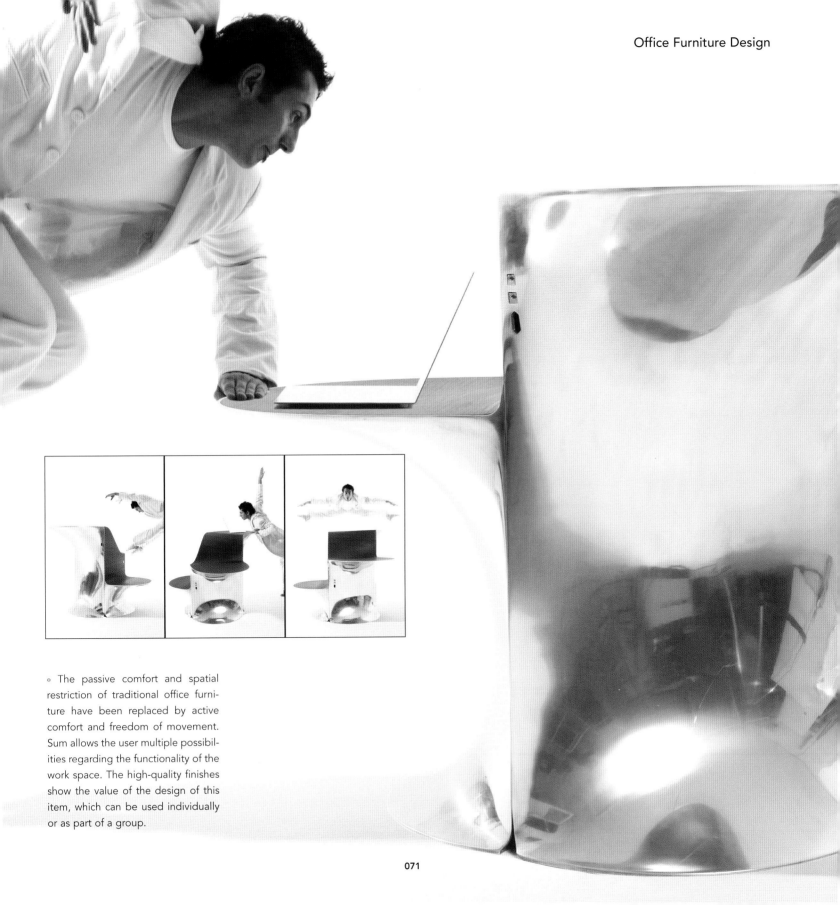

○ The passive comfort and spatial restriction of traditional office furniture have been replaced by active comfort and freedom of movement. Sum allows the user multiple possibilities regarding the functionality of the work space. The high-quality finishes show the value of the design of this item, which can be used individually or as part of a group.

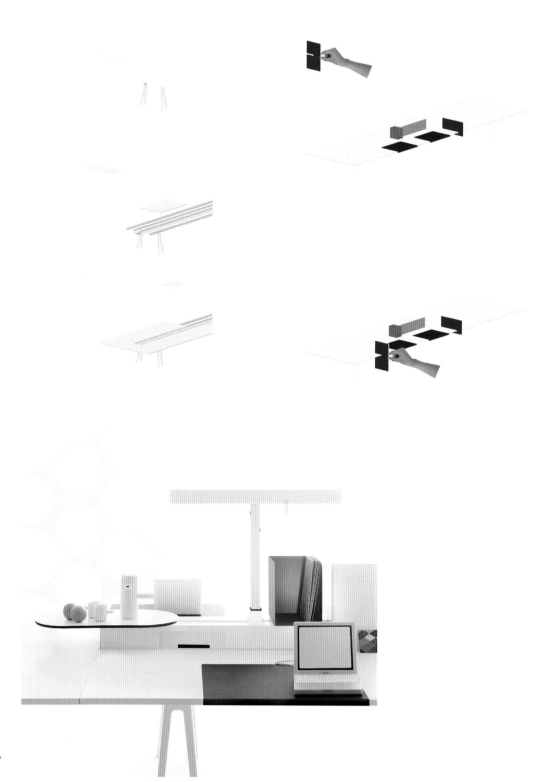

Joyn Series Design: Ronan and Erwan Bourollec Manufacturer: Vitra

○ Joyn is an open system that adapts to diverse work places and increases communication, interconnection, and interaction, breaking existing physical barriers. But more than imposing a method, Joyn favors private work, teamwork, and meetings. Also, the elements of micro architecture offer the possibility of creating isolated areas for specialized tasks.

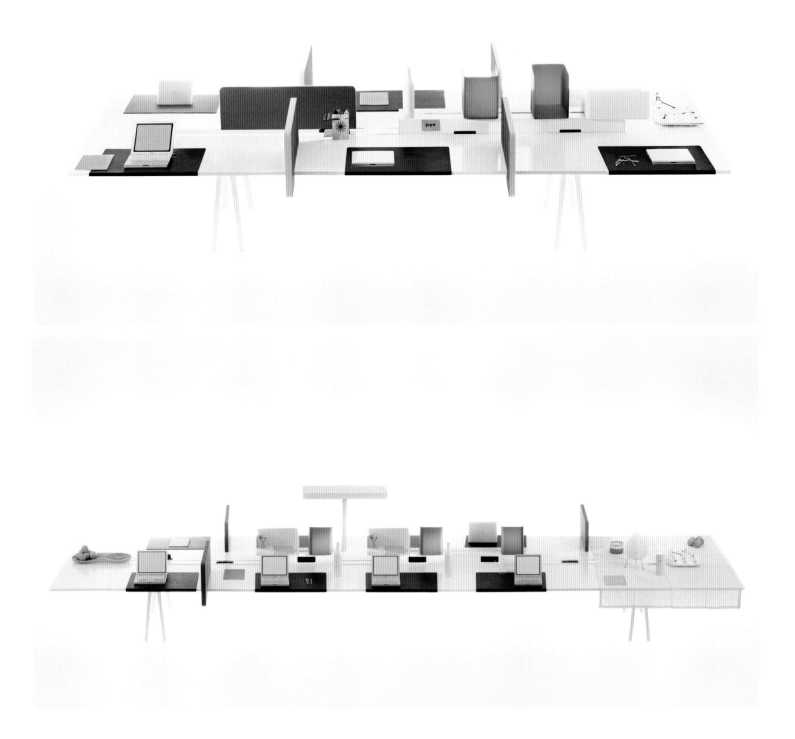

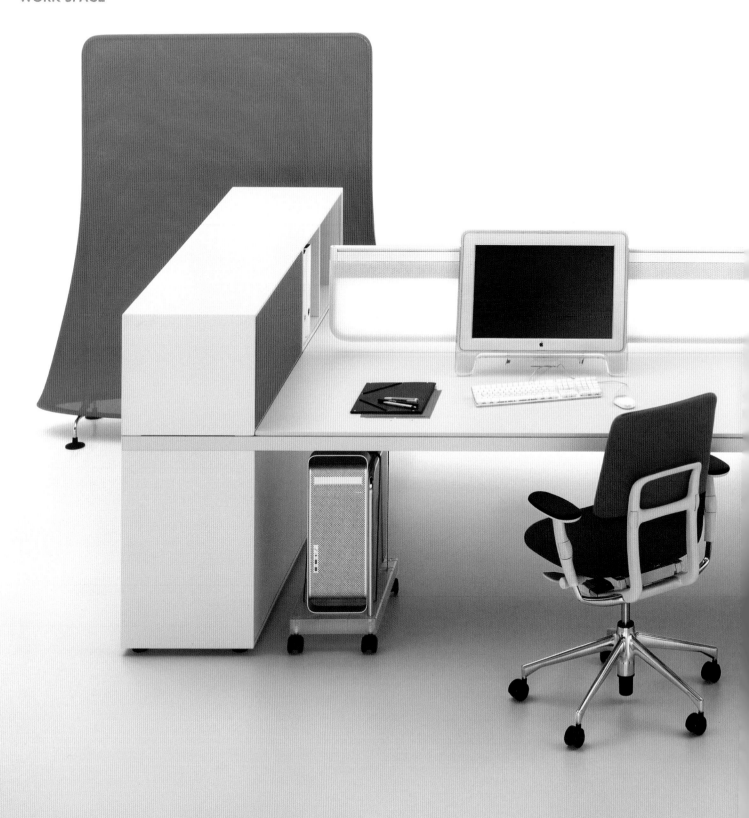

AD One System **Design:** Antonio Citterio **Manufacturer:** Vitra

○ The AD One system of modules for offices adapts to the needs of any company or organization, and has been built following organizational and architectural criteria in a logical and precise manner. It is the perfect system to gain space where needed, due to the surface area, to situate several workstations. Thanks to assembly procedure, it will always create a serene environment and a well-defined aesthetic effect.

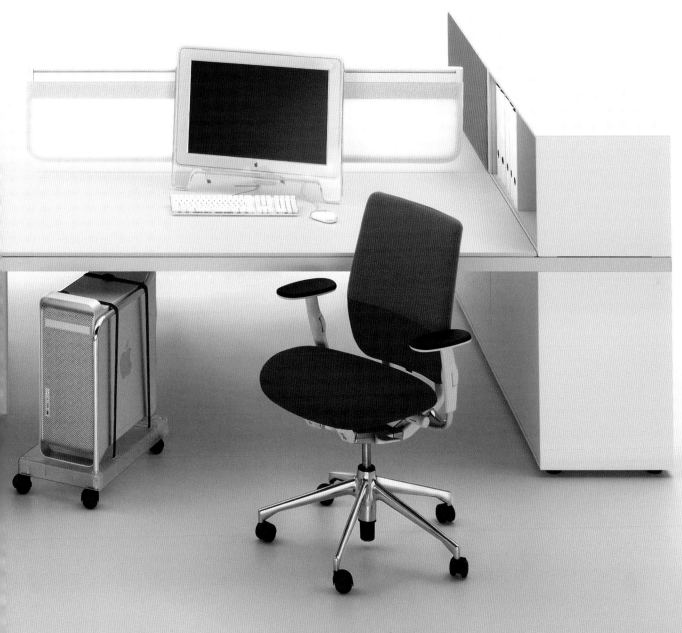

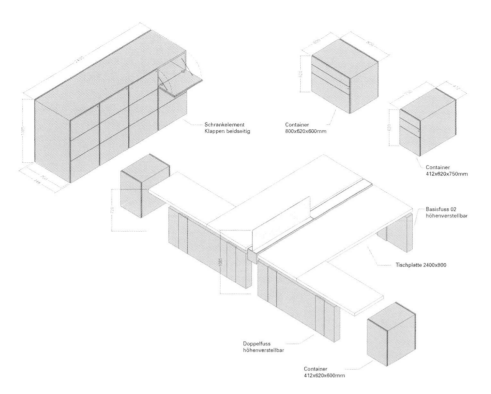

Schrankelement
Klappen beidseitig

Container
800x620x600mm

Container
412x620x750mm

Basisfuss 02
höhenverstellbar

Tischplatte 2400x800

Doppelfuss
höhenverstellbar

Container
412x620x600mm

∘ Double You provides the work place with a new philosophy and new ways of working. A wide variety of modules of different sizes and functions enable the work areas to be established. The pieces with greater height serve to separate the spaces, without blocking visibility, and contain very deep drawers that can be used to store files.

Double You Series Design: Hannes Wettstein Manufacturer: BULO

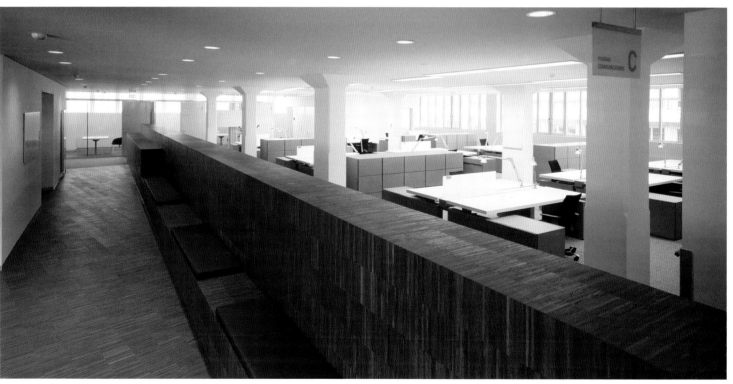

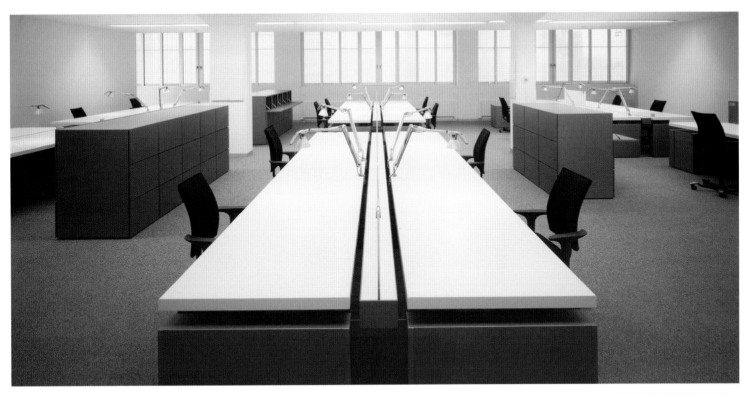

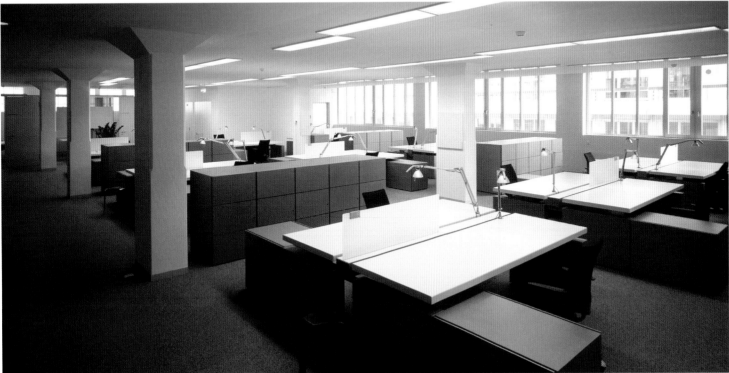

∘ With Double You, straight or angled geometry can be created, supported by the different modules. The base of this system is the central axis to which tables are connected. Situated one in front of the other, they facilitate communication. However, the work can be indivualized thanks to a panel set into the central axis, visually separating the tables from each other.

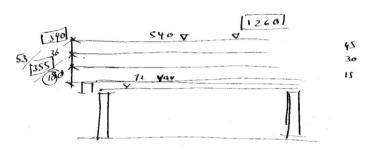

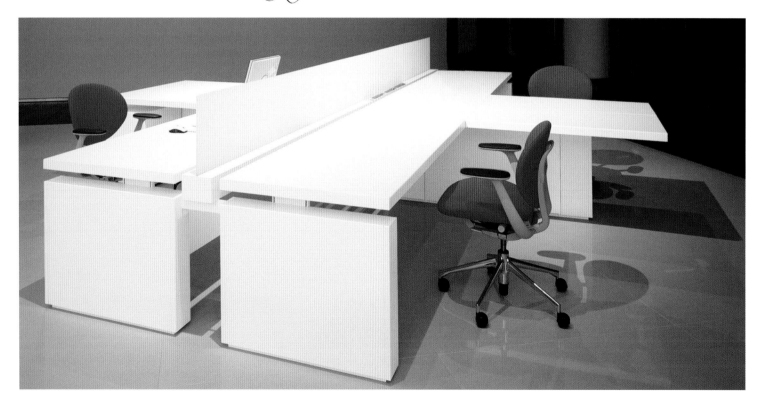

Systemprinzip

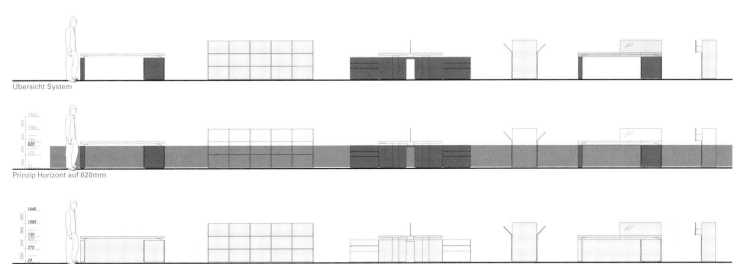

Übersicht System

Prinzip Horizont auf 620mm

Prinzip Abstand je 355mm

Alternative Layouts

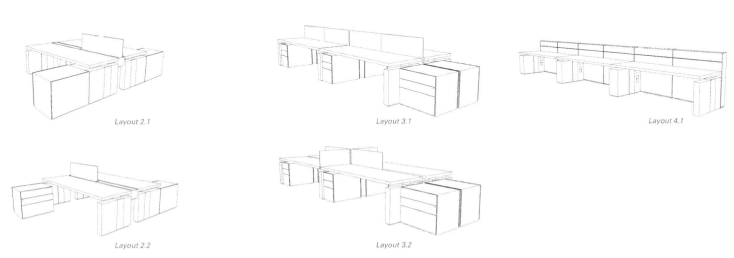

Layout 2.1

Layout 3.1

Layout 4.1

Layout 2.2

Layout 3.2

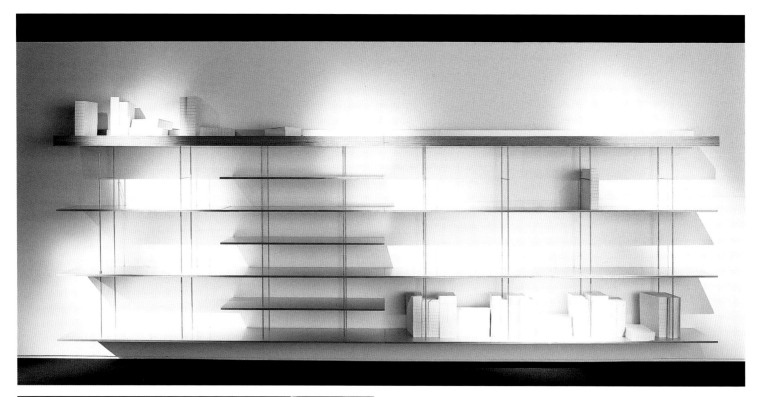

Graduate Shelving Design: Jean Nouvel Manufacturer: Vitra

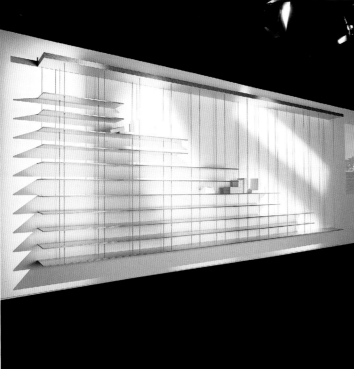

○ Graduate is an almost aerial, well-proportioned, essential shelving. It is fixed to the wall using a plywood table and is made from undulated metal clad in aluminum. The different shelves hang from cables and are separated a meter apart. The basic concept of the Graduate shelving is to minimize where possible the visibility of the shelves, while offering maximum stability and resistance.

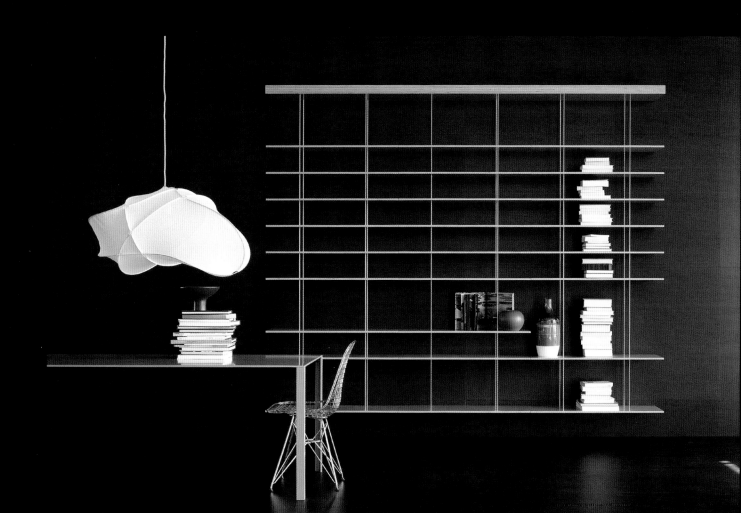

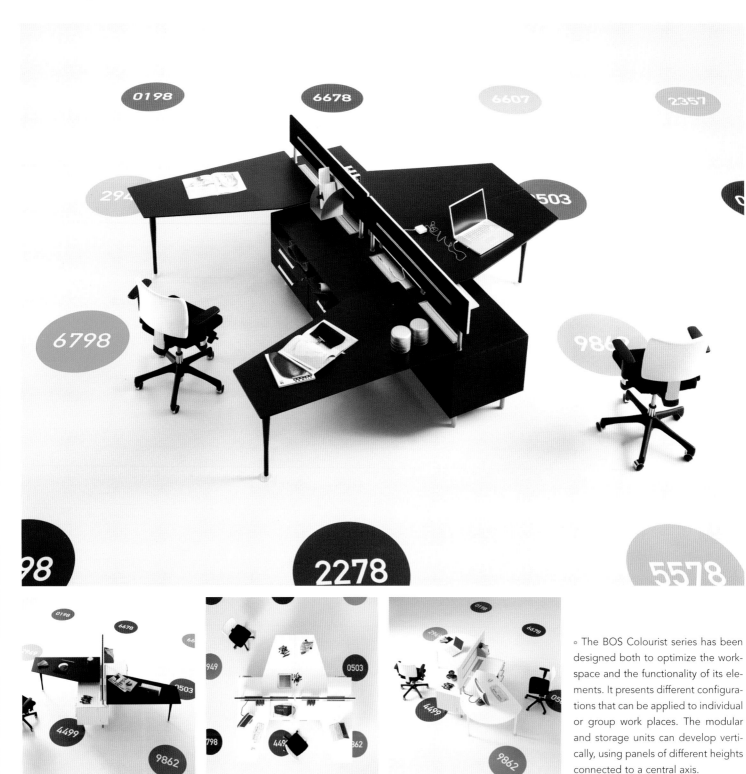

BOS Colourist Design: Claudio Bellini Manufacturer: Frezza Holland

○ The BOS Colourist series has been designed both to optimize the workspace and the functionality of its elements. It presents different configurations that can be applied to individual or group work places. The modular and storage units can develop vertically, using panels of different heights connected to a central axis.

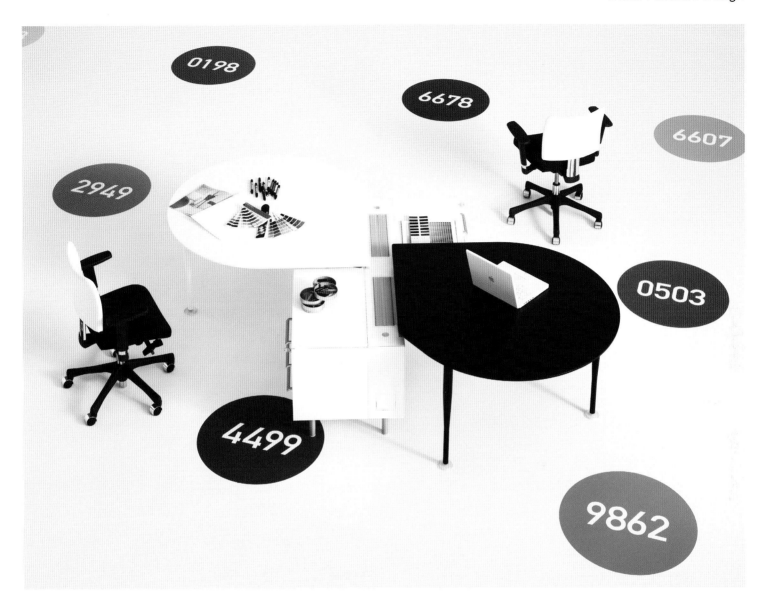

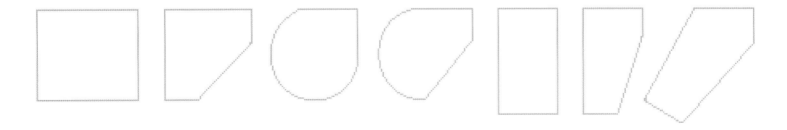

BOS Pharmacy Design: Claudio Bellini

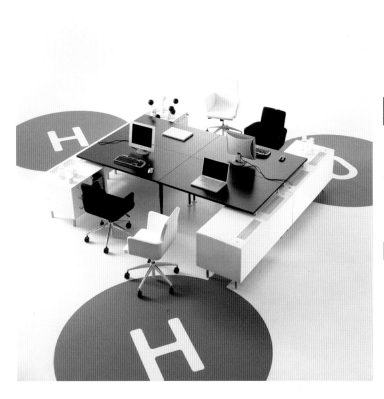

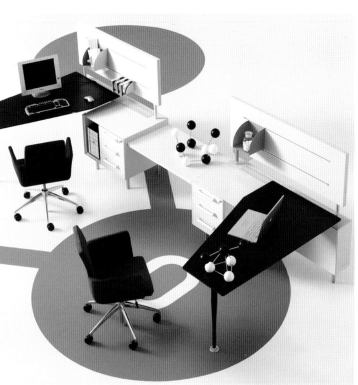

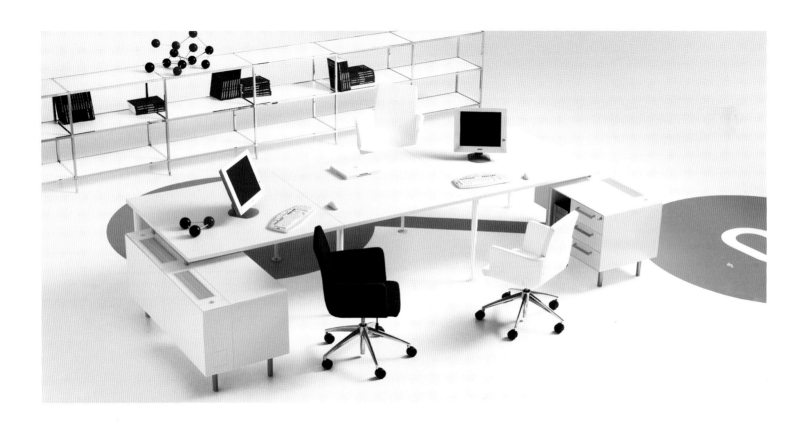

∘ BOS proposes seven basic forms for desktops that offer a high degree of versatility when personalizing work places. The worktables are joined to the axis-module via two spacing elements, and this solution helps to create an aerial impression. The axis-module can replace the support of two legs, which is an important saving of space. Depending on the surface, they can be supported by two legs and the axis-module or on four legs.

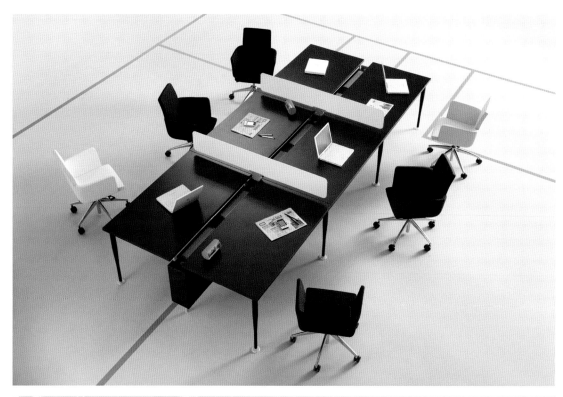

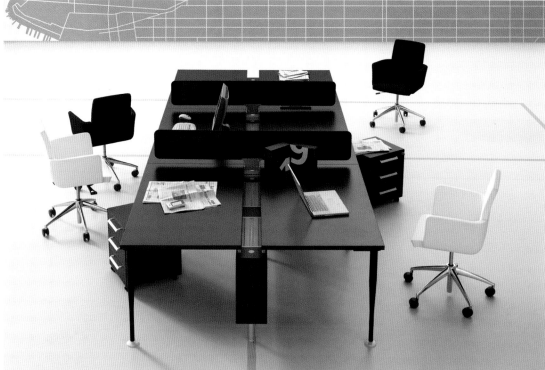

BOS Broker **Design:** Claudio Bellini

∘ The separation screens are made from polycarbonate, and are joined using a bar. This solution provides visual independence and aids concentration. The lower screens are lined with fabric, and thanks to aluminum bars situated on both sides, objects can be fixed to them. The high screens have the same characteristics, but their height guarantees privacy.

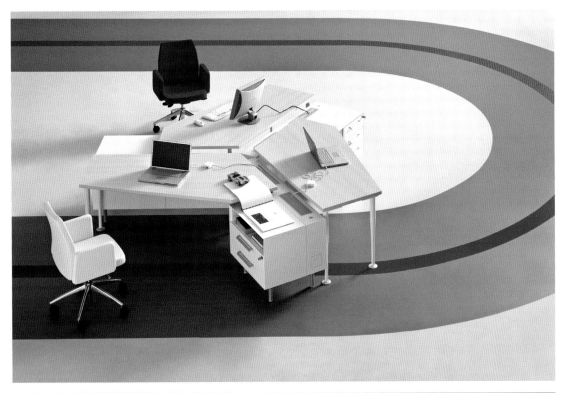

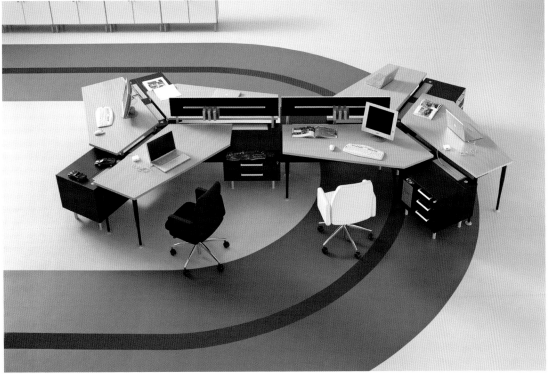

BOS Car Design: Claudio Bellini

○ Stripes proposes a system of bookshelves, desks, and high and low tables, whose surfaces can be distinguished by different series of colored stripes. Studied sequences express concepts of freedom, individuality, surprise, and movement. Considering color as a value added, there are three different possibilities: multicolor, minimalist, and tropical, offering a truly chromatic range. All the panels are made from MDF.

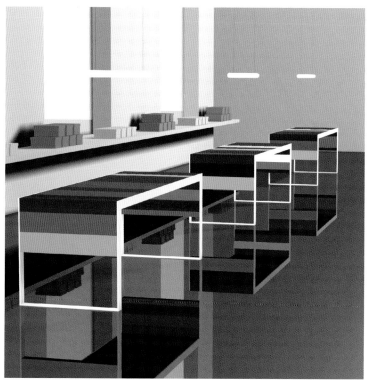

Stripes Collection Design and Manufacturer: Marco Viola

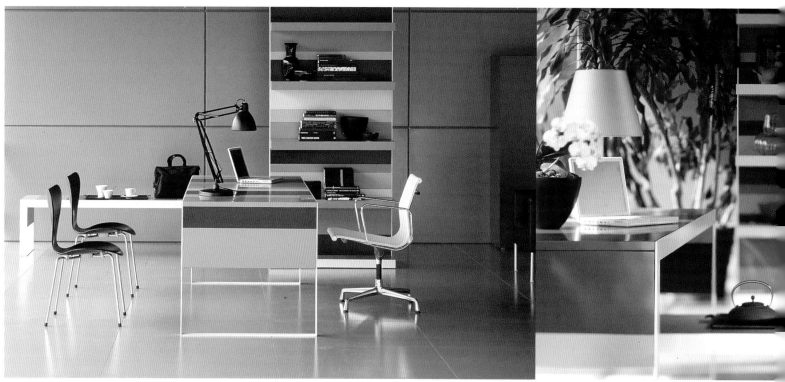

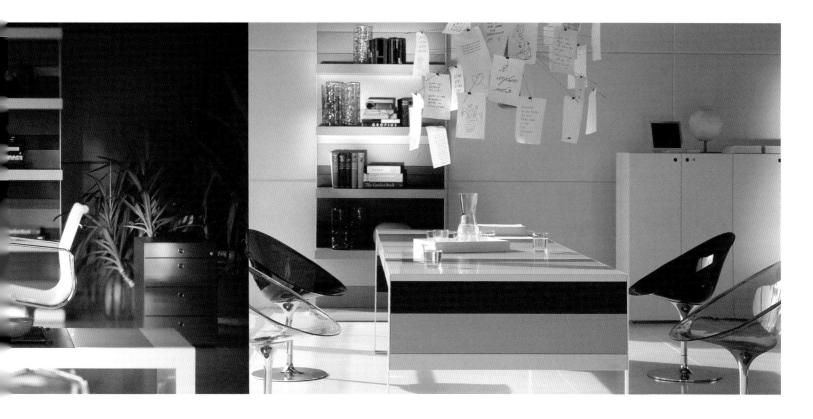

∘ This proposal gives us an architecture oriented towards the object. A table is established as an independent office, since it is capable of meeting all the required functions: desk, organizer, wiring, and storage spaces. This individual piece organizes the space cleanly and clearly. Available in several sizes, the tables are covered in glossy silken white with chrome legs.

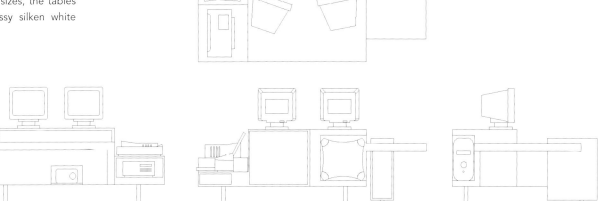

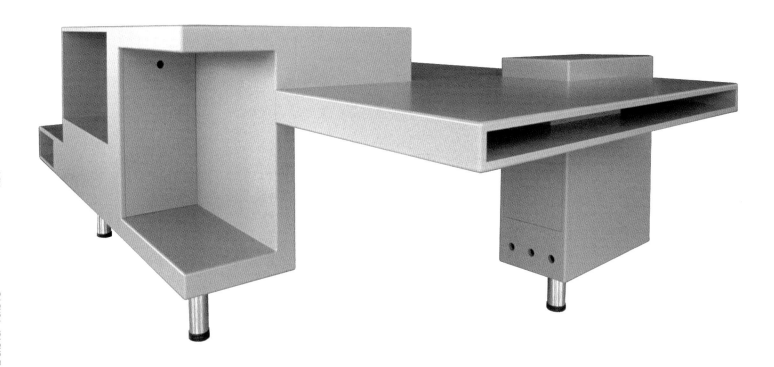

Babla Table Design and manufacturer: i29

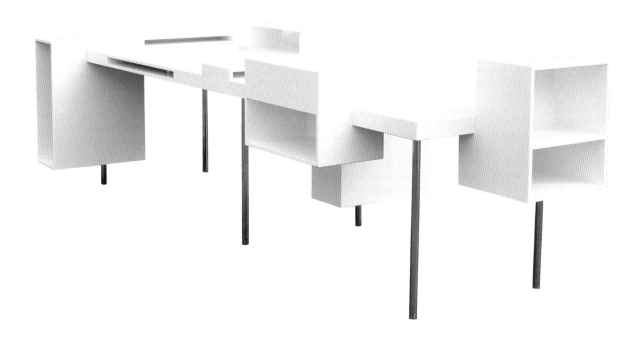

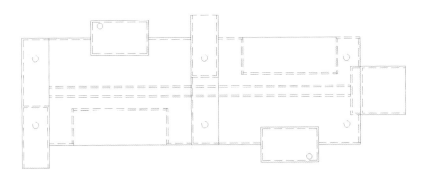

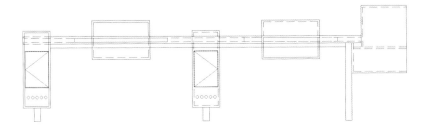

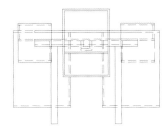

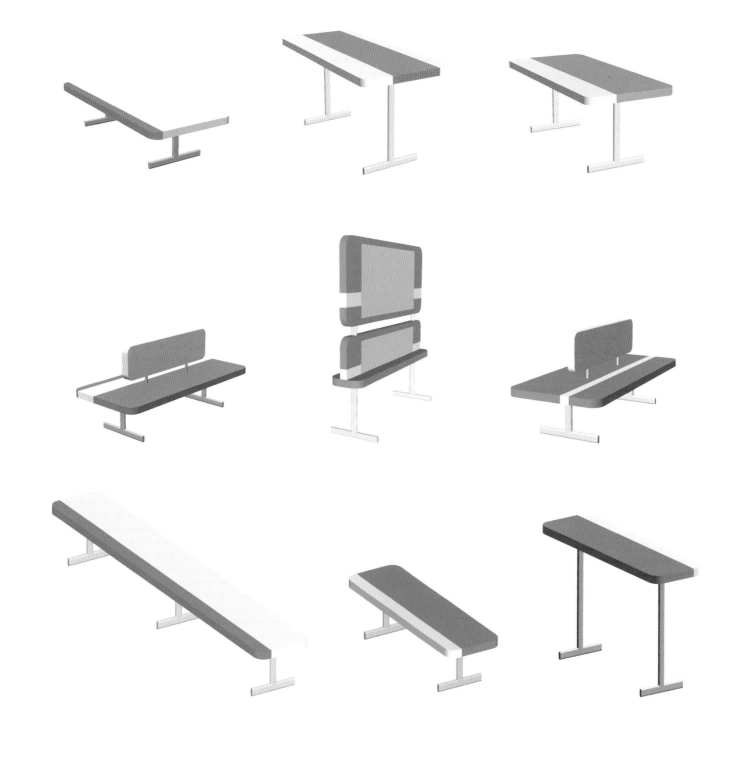

Caland Lyceum Design and Manufacturer: i29

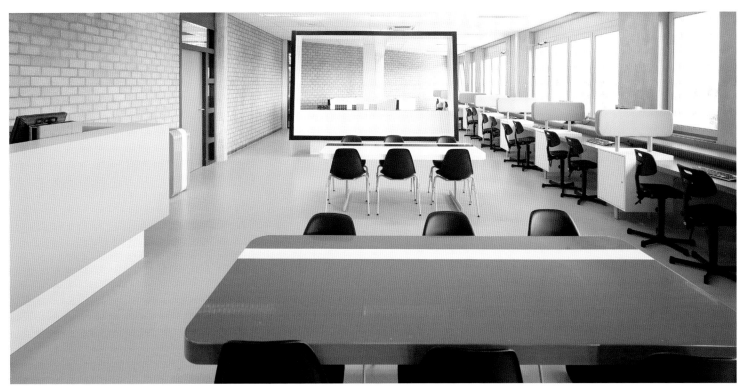

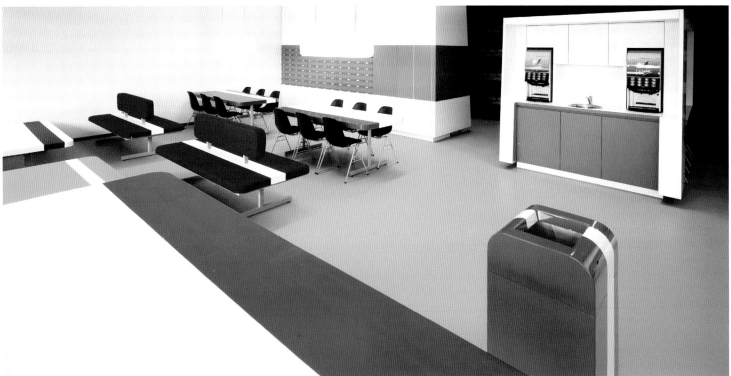

Buzz Wire Design: i29 Manufacturers: Zwartwoud bv

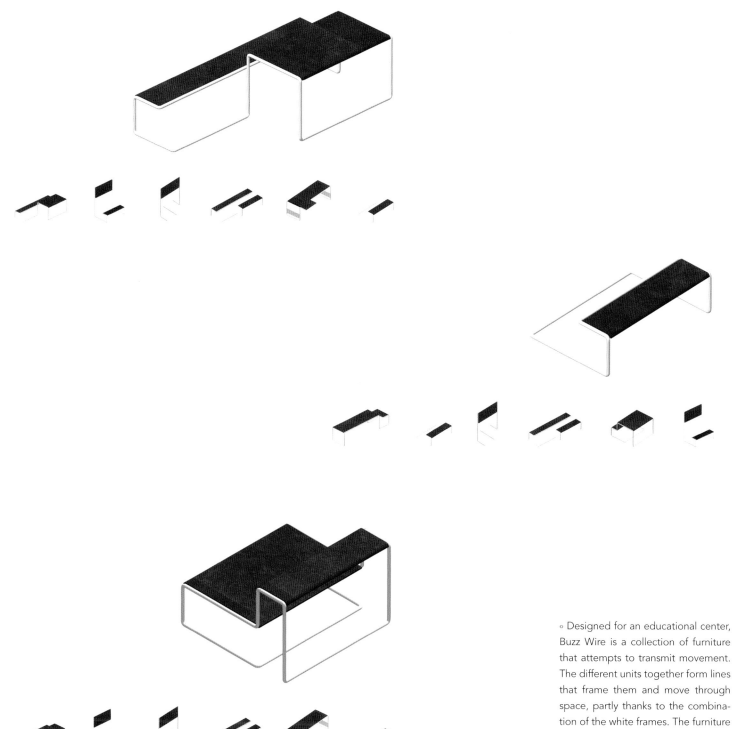

∘ Designed for an educational center, Buzz Wire is a collection of furniture that attempts to transmit movement. The different units together form lines that frame them and move through space, partly thanks to the combination of the white frames. The furniture is made of lino, and the frames are covered in white powder paint.

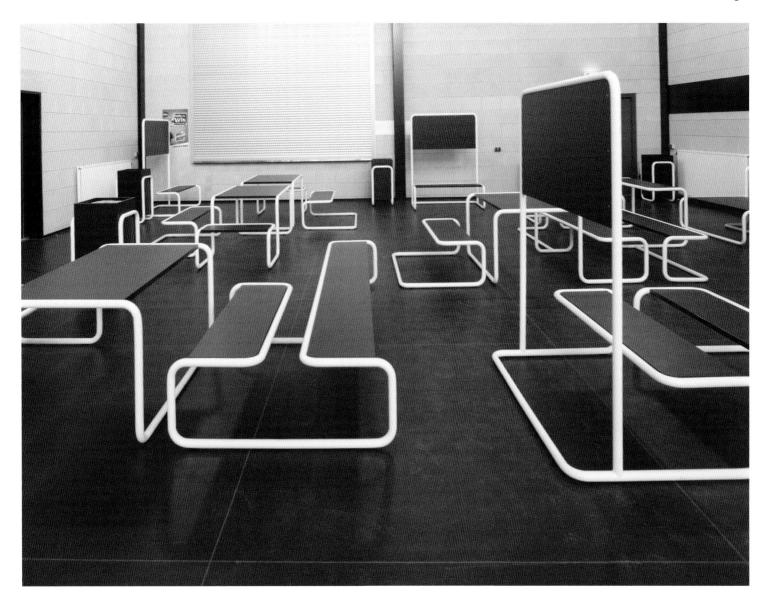

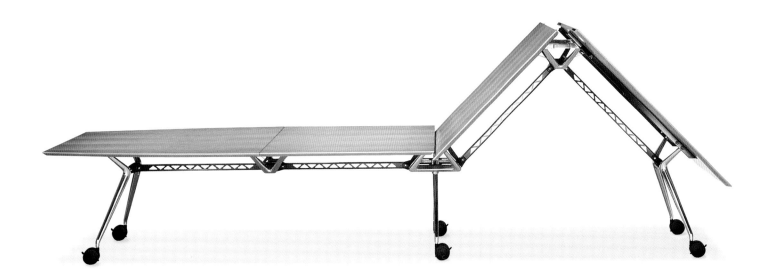

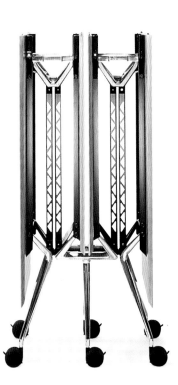

Aspire Table Design and Manufacturer: Konig Neurath Design

◦ Aspire is a flexible, functional, and novel way to improvise a desk or a meeting area. The table is presented with different lengths up to 16 feet, constituted by various tabletops that can be easily folded or unfolded by a single person. Its width allows it to pass standard doorframes without any problem, and once folded, occupies a very small space. It has soft rubber wheels, an aluminum structure, and a beech wood surface.

○ Trolley is a small auxiliary item of furniture with wheels, which is perfect for the office, as a dining table or even a bar. It consists of three boxes within a bigger box that can be covered using a sliding platform, and within which personal objects can be put that are not wanted on the worktop. The lower platform can be taken out. Combined with white, it comes in a neutral gray color or bright green.

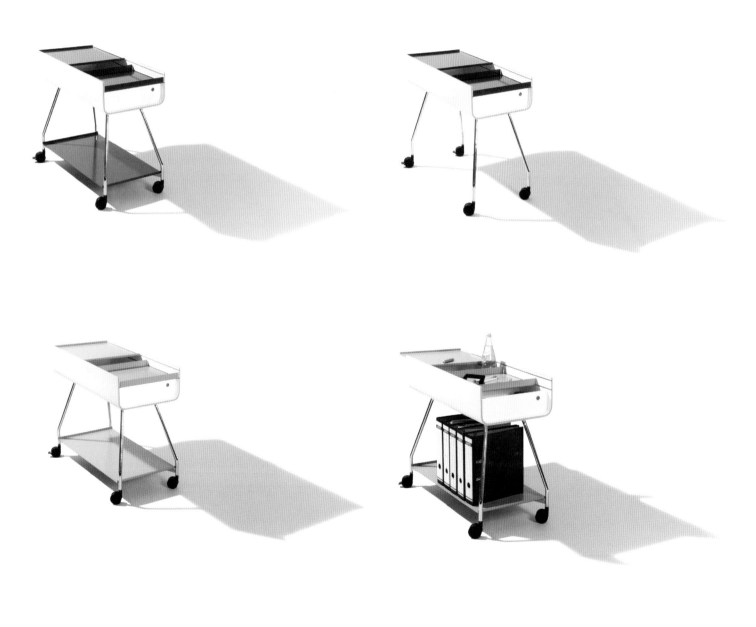

Trolley **Design:** Patrick Frey and Markus Boge **Manufacturer:** Richard Lampert

○ A variation of the original table designed by Egon Eiermann in 1953, this continues to be extremely contemporary thanks to the simplicity of its design and the nobility of its materials. The Lampert studio has designed a practical, demountable version. Seesaw is extremely versatile and can be used in the office, giving it an unconventional appearance. The folded plywood makes it comfortable and flexible. With chrome bases, the chair can be made of birch or upholstered.

Seesaw Chair **Design:** Eiermann Studio / Peter Horn **Manufacturer:** Richard Lampert

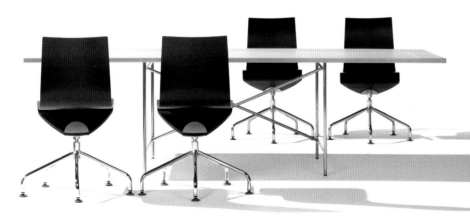

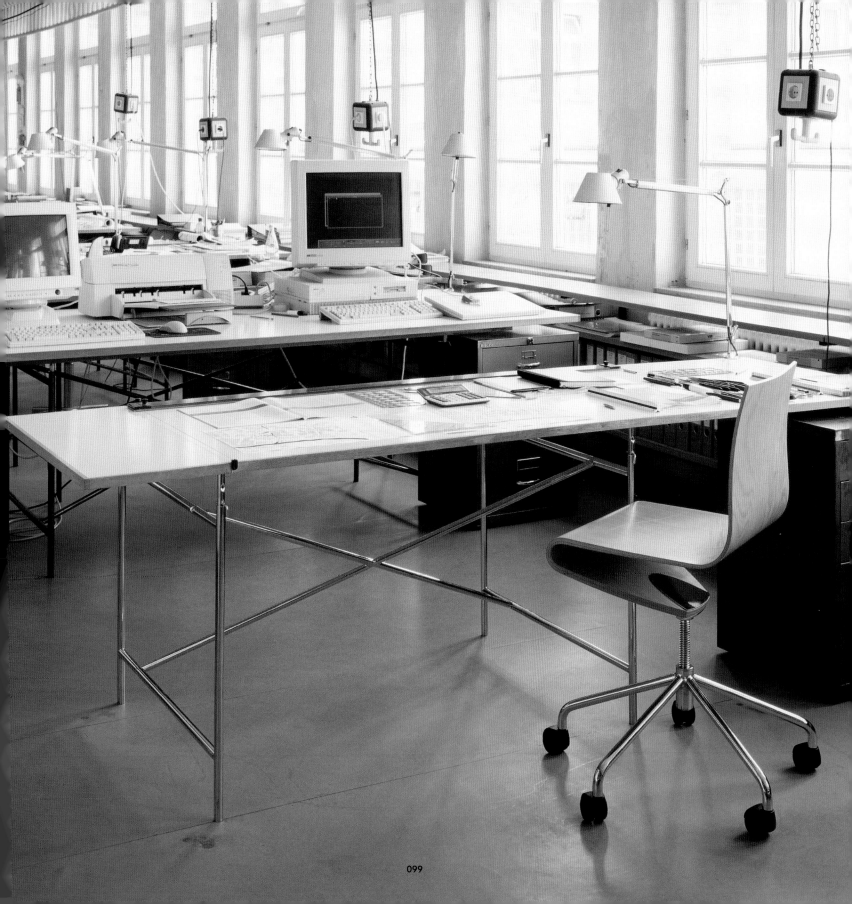

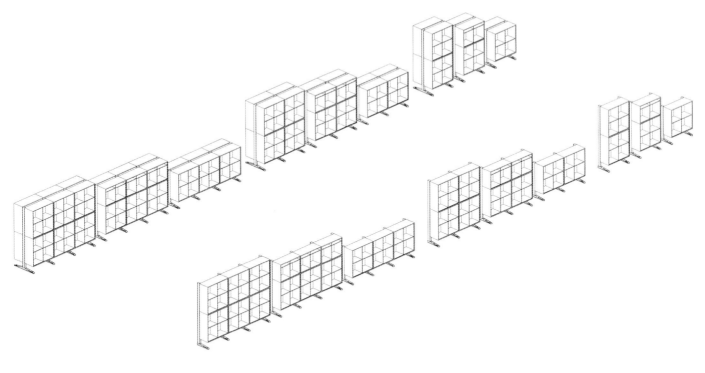

Beam Series Design and manufacturer: Vilhelm Lauritzen

○ This flexible and adaptable furniture lends an incredible freedom regarding the positioning of legs, drawers, or CPU platforms. A series of shelves, tables, and work surfaces offer the opportunity of creating a made-to-measure space, with the continuous aluminum bar as the central nucleus of the system. The shelving unit can be assembled and transformed without tools and serves as a dividing element.

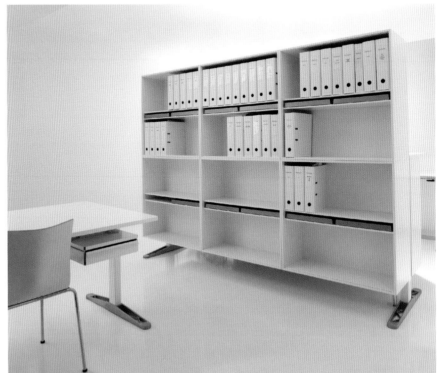

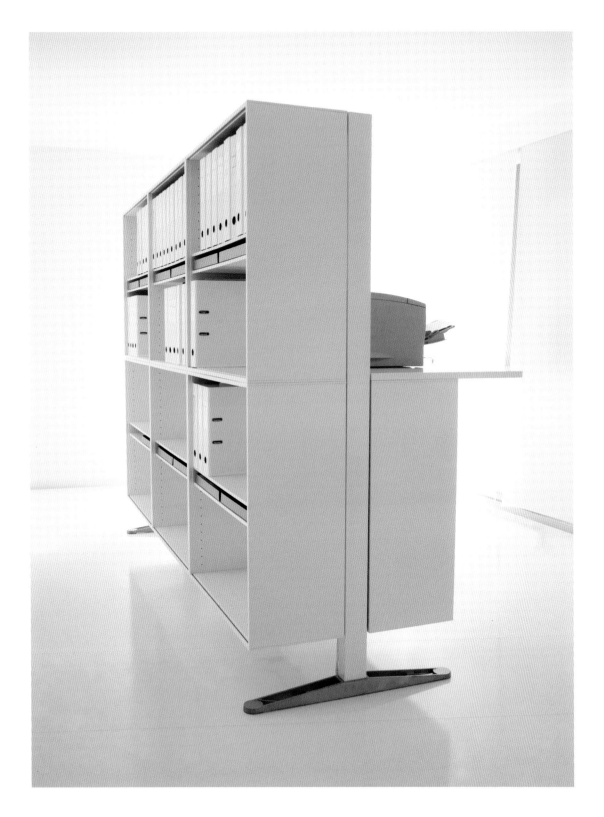

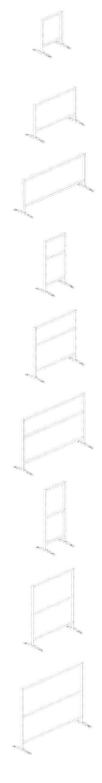

Manufacturer: Engelbrechts

Design: Erik Magnussen, Vilhelm Lauritzen

Plasma Seat and Beam Table

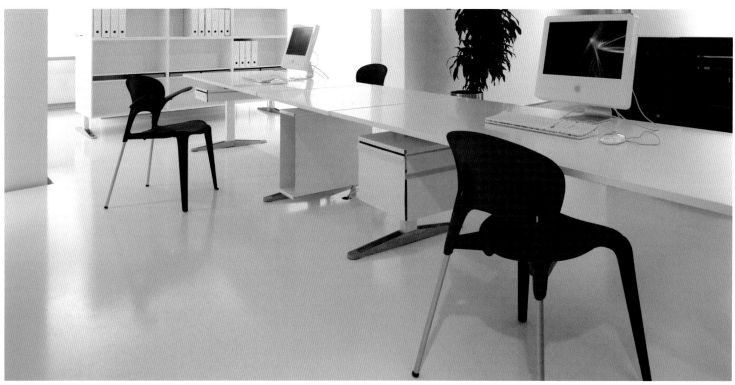

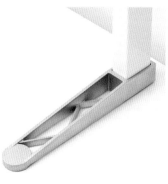

∘ Using a minimum of materials providing maximum quality, this design has a high aesthetical quality, optimum resistance and an exclusive surface, which also lends personality and chromatics to the workspace. An ingenious demountable structure that allows multiple assembly possibilities. The arms can be taken off. In glass reinforced nylon.

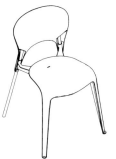
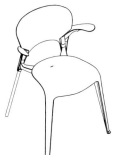

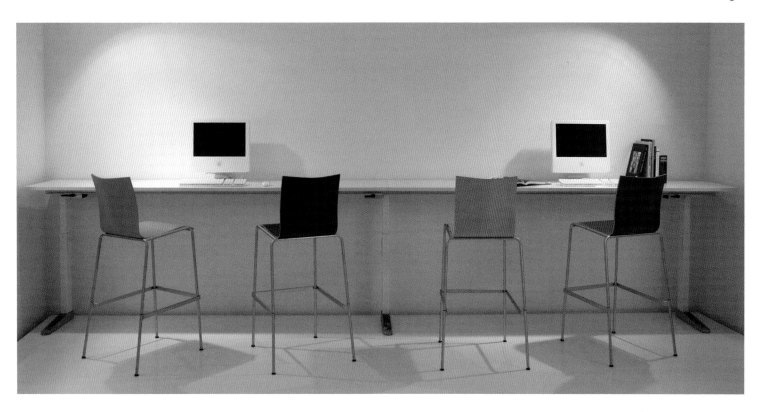

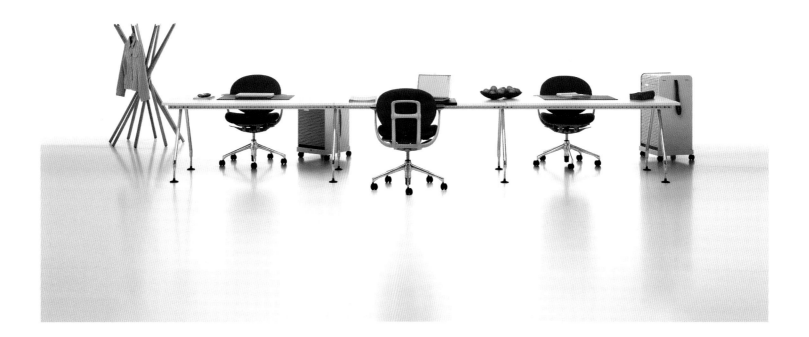

ABC System Design: Arik Levi Manufacturer: Vitra

○ ABC is a system of modular office furniture that adapts to the needs of each individual user. It is a clear design with simple planning and installation. Its various components can be used individually or together, or can be joined vertically and horizontally, forming a defined landscape. The base of the table can be combined with three different tabletops, and the height is adjustable.

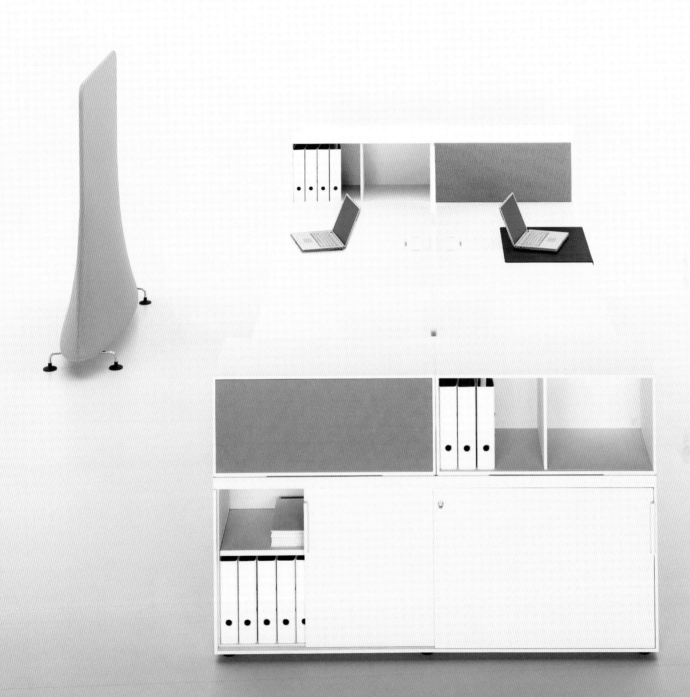

AD One System **Design:** Antonio Citterio **Manufacturer:** Vitra

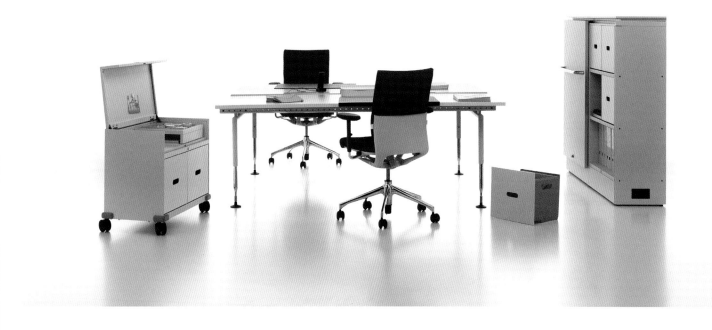

◦ AD One is a modular furniture program ideal for fulfilling the needs of mobility, which are so apparent in today's offices. Thanks to an ample selection of mobile components—dividing screens, trolleys for documents and personal effects, and platforms for CPUs—it can be continually transformed. Components can be added above, beneath, and onto the side of the table, increasing the efficiency of the work surface.

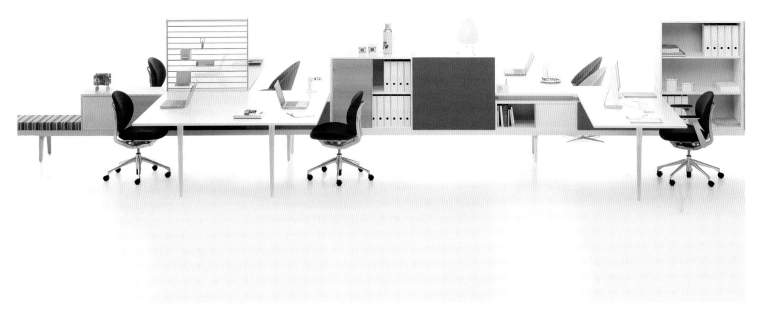

Level 34 System
Design: Werner Aisslinger
Manufacturer: Vitra

○ Level 34 is a concept of modules based on benches, which achieves cheerful, personal and unconventional offices. The system of elegant, extendable furniture creates independent work and rest areas. The base bench incorporates wiring, so the individual spaces, storage areas, waiting rooms, and reception have systems of integrated wiring.

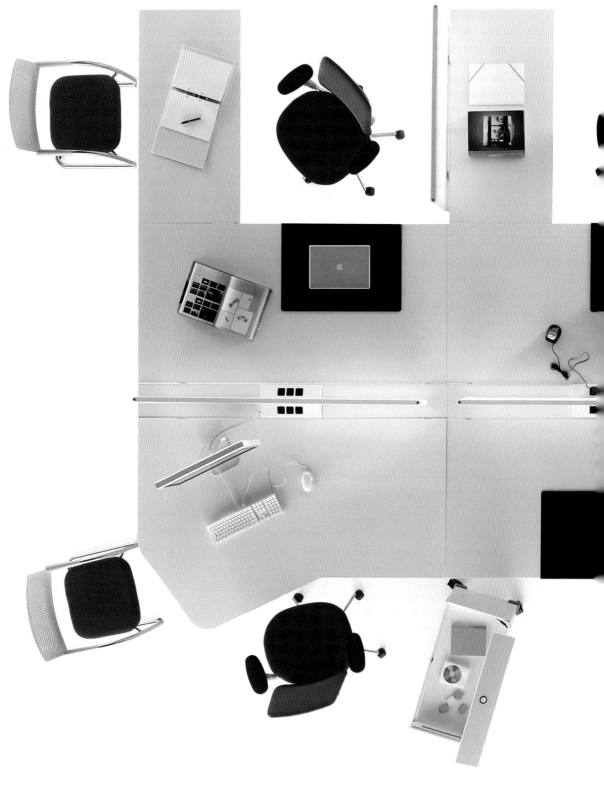

AD One System Design: Antonio Citterio Manufacturer: Vitra

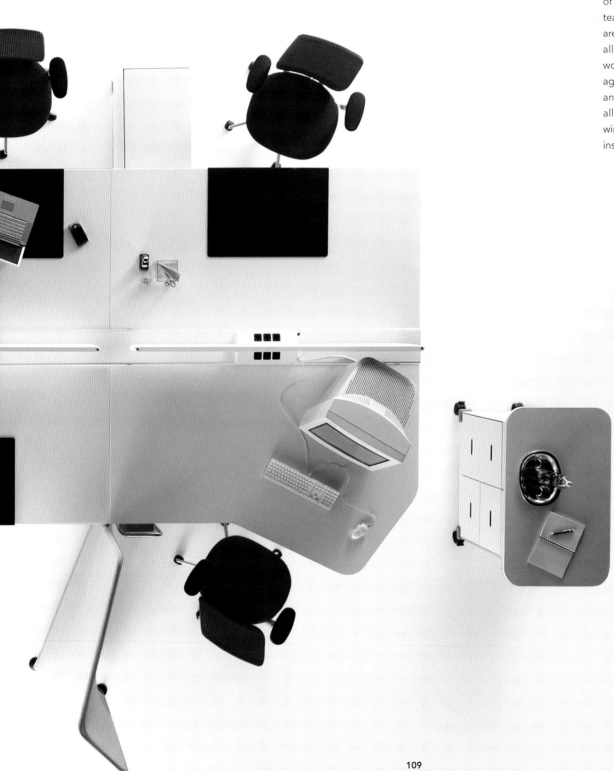

o Ad One is appropriate for any type of office: individual offices for work teams, or offices with large open-plan areas. The variety of its components allows the creation of temporary workspaces that hardly need any storage, or permanent offices for daily and continuous use. The system allows for fast reconfiguration of wiring thanks to a chain of wiring installed under the floor.

○ This system presents a series of modular tables, with a steel structure finished in aluminum powder and surfaces of etched glass, that allow for a variety of assembly possibilities, creating lines that adjust to the environment: straight, concave, convex, or twisting. The modular steel panels can be assembled vertically or horizontally, connected to bars supported by circular bases.

Computer Desk and Panels Design and manufacturer: Studio D'Urbino Lomazzi

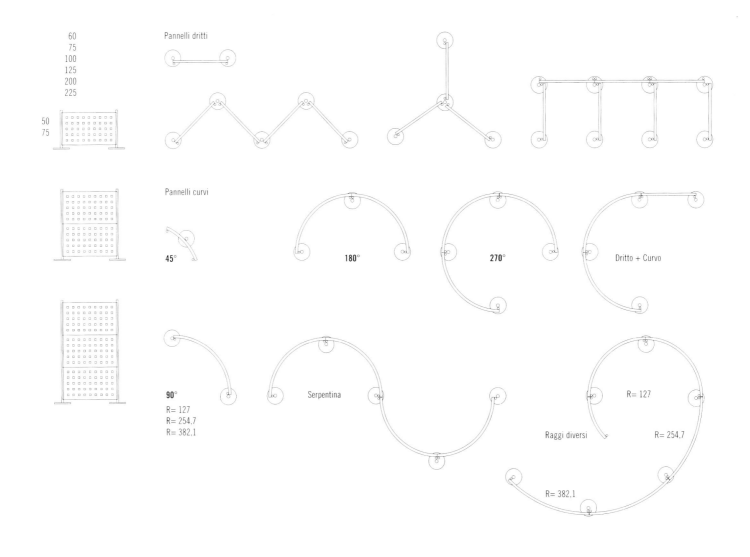

60
75
100
125
200
225

50
75

Pannelli dritti

Pannelli curvi

45°

180°

270°

Dritto + Curvo

90°
R= 127
R= 254,7
R= 382,1

Serpentina

Raggi diversi

R= 127

R= 254,7

R= 382,1

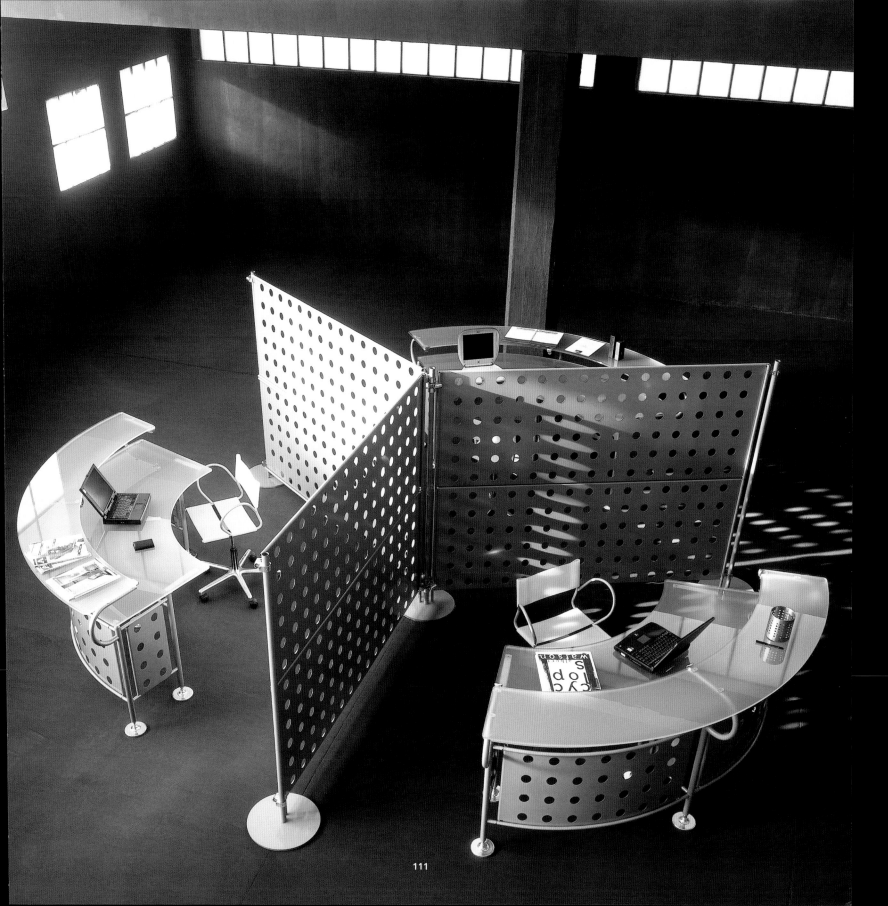

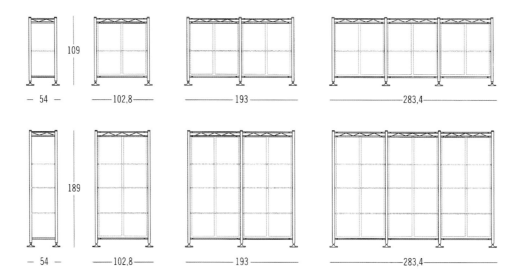

109

— 54 — ——102,8—— ————193———— ————————283,4————————

189

— 54 — ——102,8—— ————193———— ————————283,4————————

Silverglass and Silvergate Systems Design and manufacturer: Studio D'Urbino Lomazzi

∘ Silverglass is a steel storage and shelving system with a matte aluminum finish. The lateral panels and translucent doors transmit the light, creating a visual separation. Silvergate is a shelving system also finished in matte aluminum. The storage pieces have lateral panels and sliding doors in different colors. These systems can be put together in individual or multiple structures, high or low.

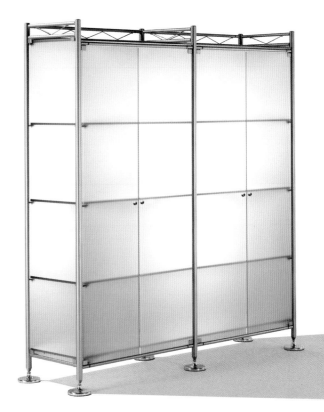

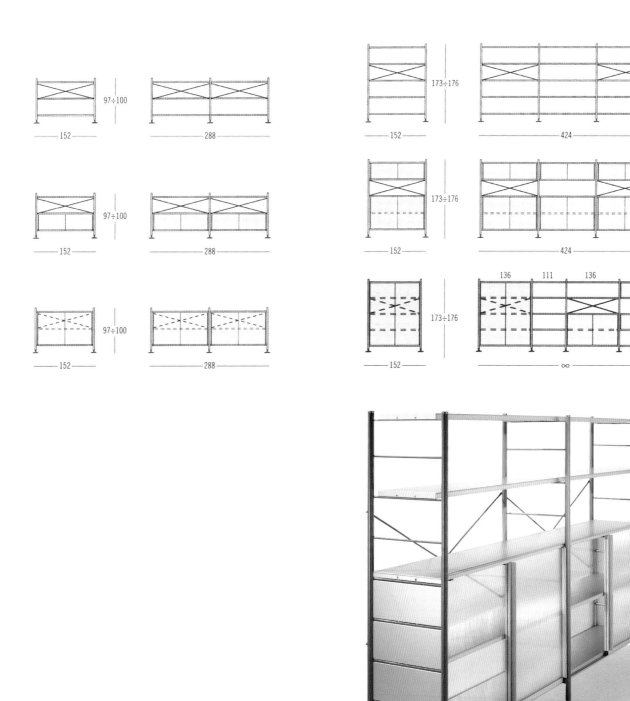

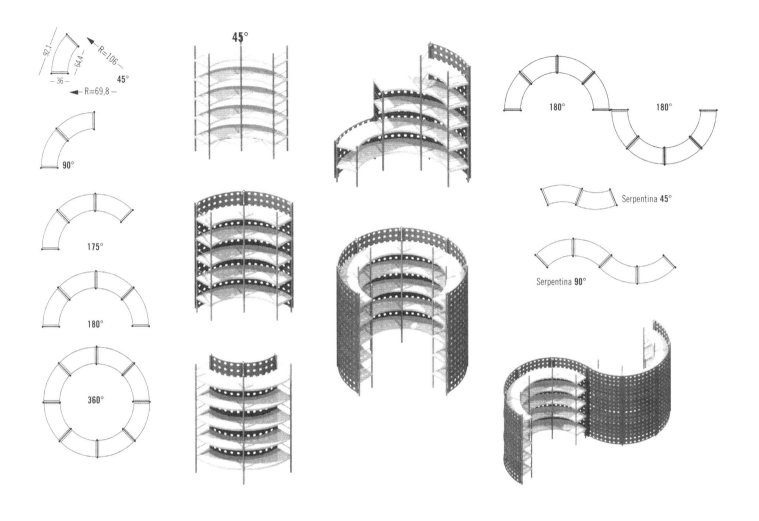

Twister System Design and manufacturer: Studio D'Urbino Lomazzi

∘ Twister is a self-supporting system with curved forms made from steel with matte aluminum finishes. The curved shelves are made from transparent glossy methacrylate, or come in various colors. It can be integrated into a curved wall-panel and accepts configurations in single or multiple structures that may have different heights and lengths, forming concave, convex, or twisting lines and creating either more reclusive or more open work spaces.

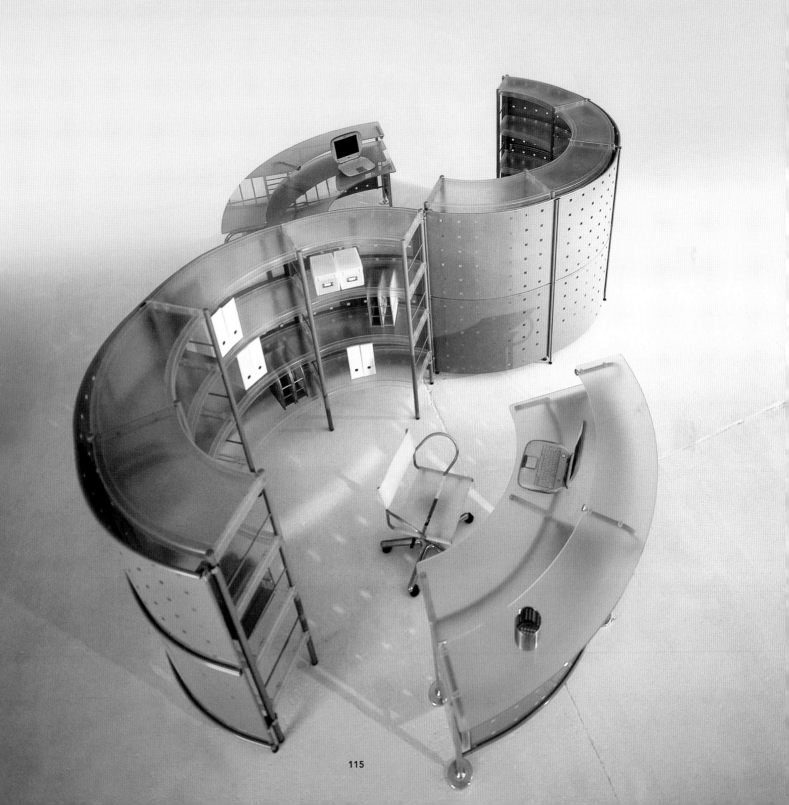

◦ Joyn is an open system that adapts to the diversity of the workplace and increases the communication and interaction breaking existing physical barriers. Joyn favors work done in private, in teams, or meetings. The elements of micro architecture offer the possibility of creating isolated areas and areas for specialized tasks that can be spontaneously reorganized with separating panels and desk protectors.

Joyn System Design: Ronan and Erwan Bouroullec Manufacturer: Vitra

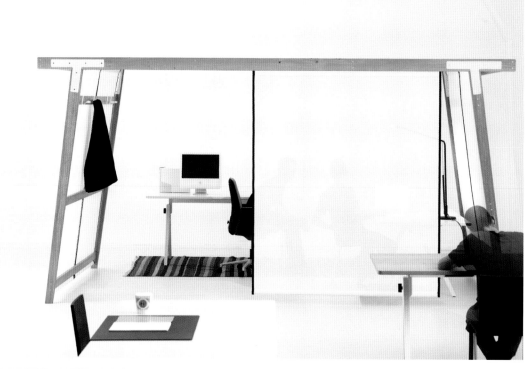

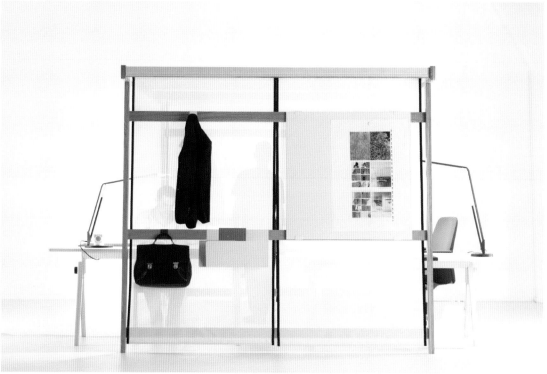

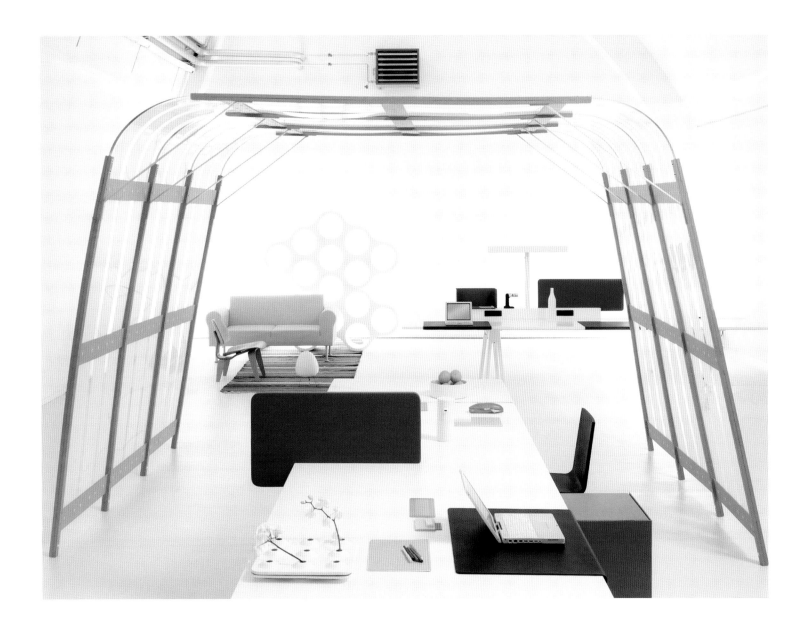

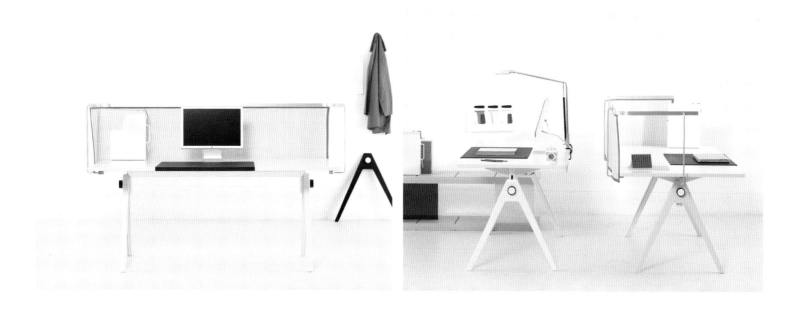

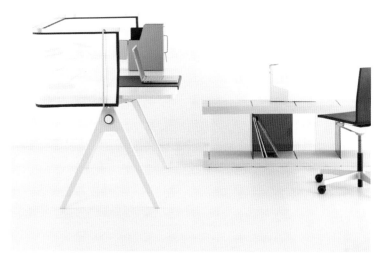

∘ Joyn attempts to match the flexibility of the mobile phone and laptop, creating a dynamic state that adjusts constantly to changes. With no established limits, the workspaces contract and expand easily. The capacity of the rooms, floors, and even the buildings is extraordinarily elastic. The electric and data cables run through a high-capacity central channel as if it were an elevated floor, connecting all the machinery.

102,8

Pianta

84,3

Fianco

84,5

84,3

UN MODULO

102,8

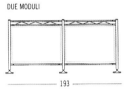

DUE MODULI

193

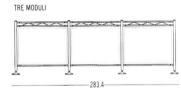

TRE MODULI

283,4

∘ The reading desk is a system of steel tables finished in matte aluminum, with glazed glass sides and top. The desk is equipped to store cables, and can contain a computer, lighting, microphones, and a small shelf. It can function alone or in lines of several units. It is the perfect element for reading areas, but also for spaces of simultaneous translation or for call centers.

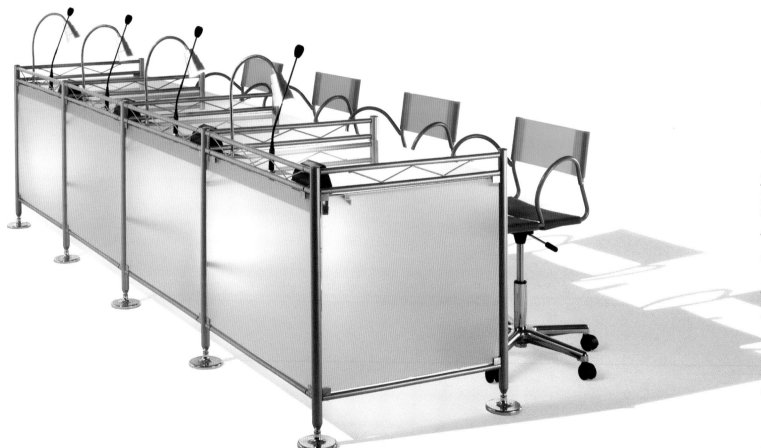

Lecture Desk Design and manufacturer: Studio D'Urbino Lomazzi

DF Shelving System Design: Joan Gaspar Manufacturer: ABR

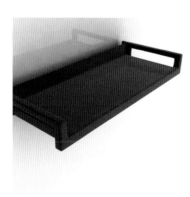

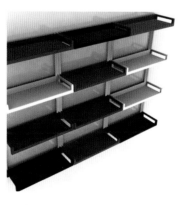

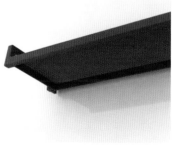

○ This system features plastic modular shelving injected with matte aluminum edging. At any time, the position of the shelves can be regulated and fixed with a bolt. The shelves are made of polypropylene with added fiber for extra resistance, and are treated for protection against UVA rays. Some standard compositions have been proposed, with the added possibility of clients acquiring the lenghts of edging and shelving they need.

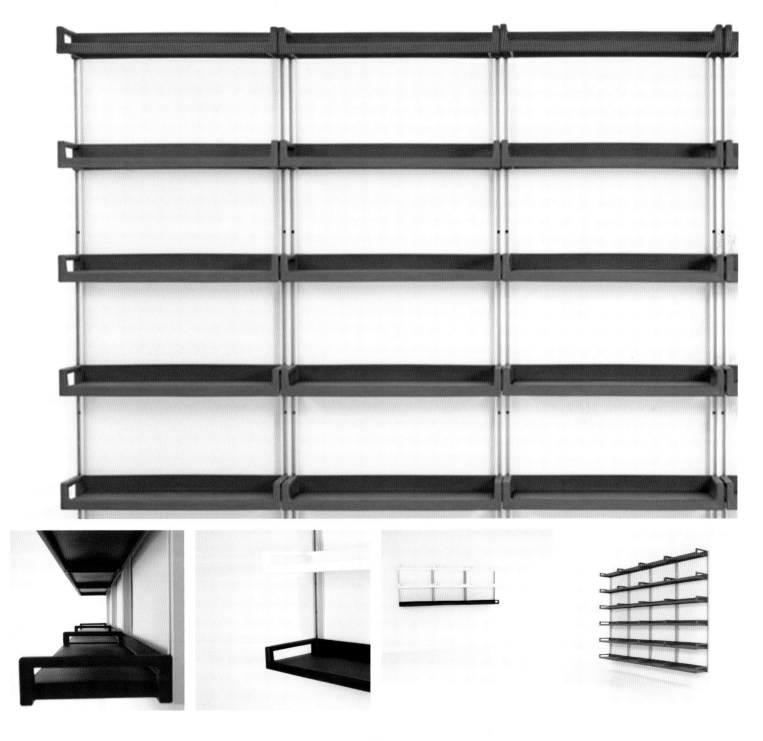

QuietPod Cabin Design and manufacturer: Svein Asbjornsen / Jarle Slyngstad

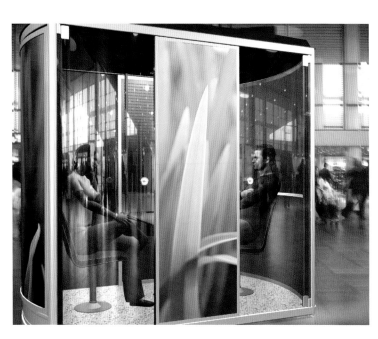
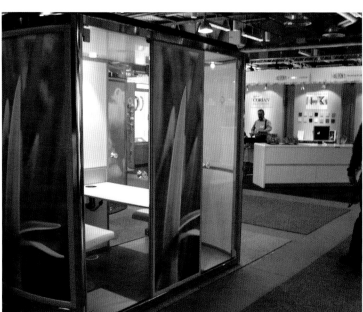
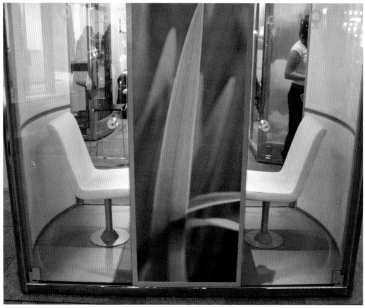

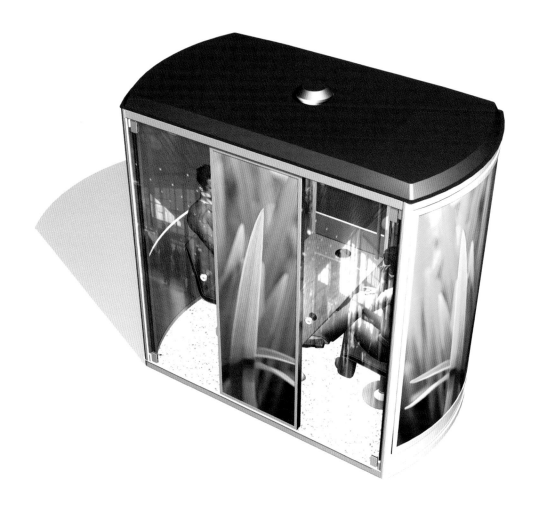

 130

245

∘ QuietPod proposes a solution to the potential need for silence and privacy in an open-plan office. This small and comfortable cabin has a wireless connection to the Internet, a telephone, and sound proofing, facilitating small meetings, confidential calls, or some time to work in silence. It comes in different sizes and designs, which makes it very adaptable to any environment.

Freddy Shelving Design and manufacture: P. Hertel and S. Klarhoefer

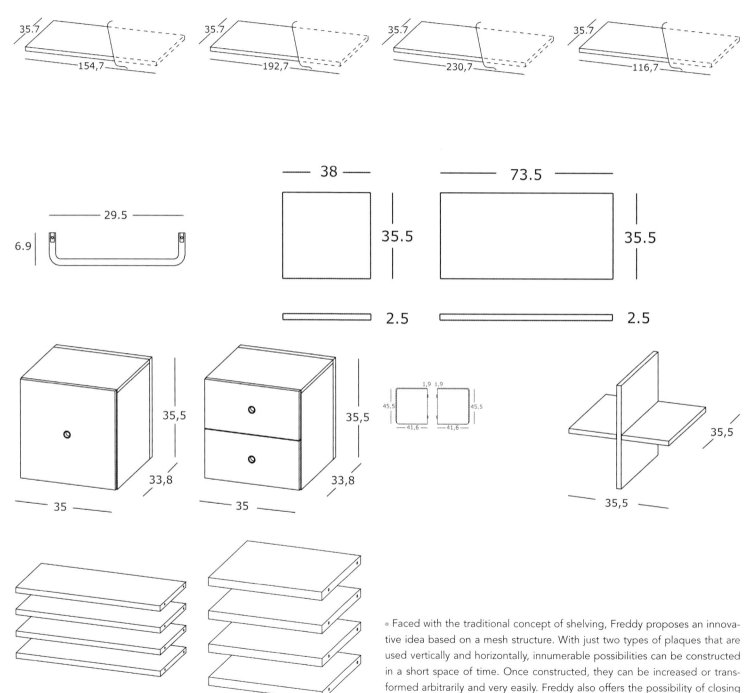

35.7
154,7

35.7
192,7

35.7
230,7

35.7
116,7

38
35.5
2.5

73.5
35.5
2.5

29.5
6.9

35,5
33,8
35

35,5
33,8
35

1,9 1,9
45,5 45,5
41,6 41,6

35,5
35,5

∘ Faced with the traditional concept of shelving, Freddy proposes an innovative idea based on a mesh structure. With just two types of plaques that are used vertically and horizontally, innumerable possibilities can be constructed in a short space of time. Once constructed, they can be increased or transformed arbitrarily and very easily. Freddy also offers the possibility of closing the desired shelves with doors of different colors.

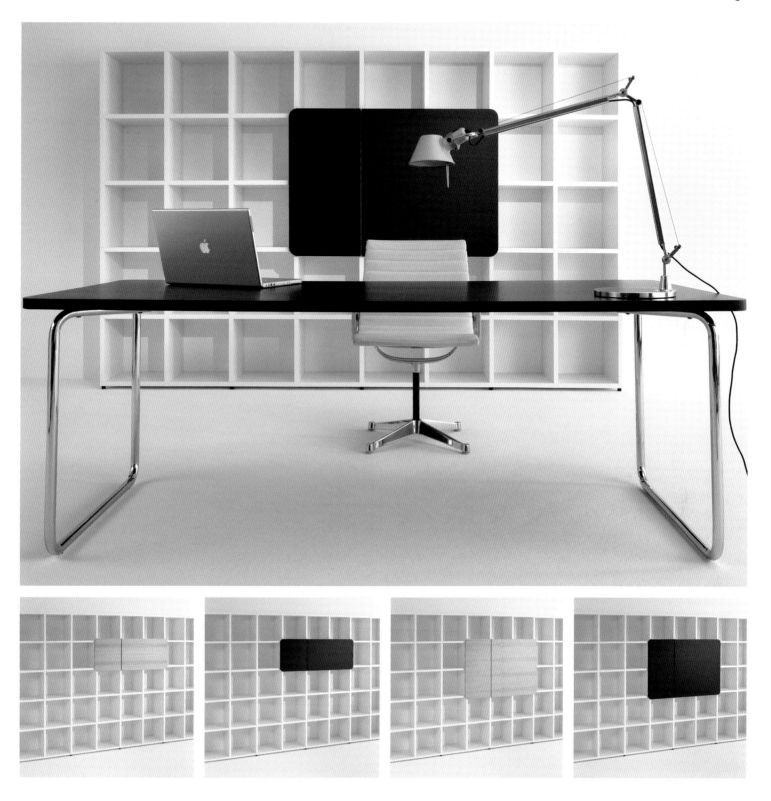

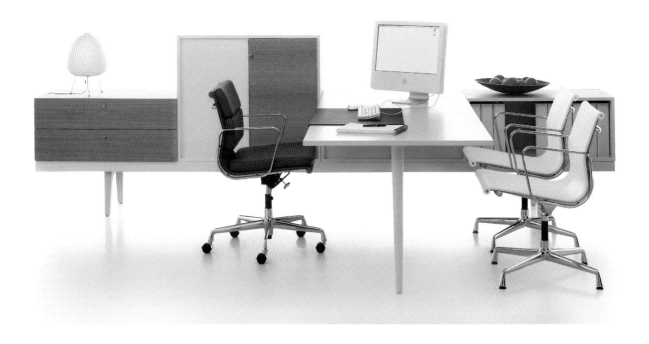

Level 34 System **Design:** Ronan and Erwan Bouroullec **Manufacturer:** Vitra

○ Level 34 is the basic element for containers, cupboards, shelving, tables, chairs, and wires, making everything more accessible. It consists of a variety of elements that are positioned on the bench for carrying out a specific task. The generic elements form many combinations with different functions, and can be easily transformed.

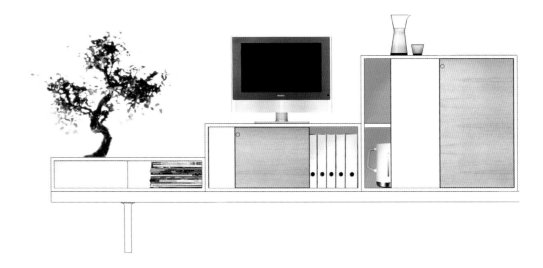

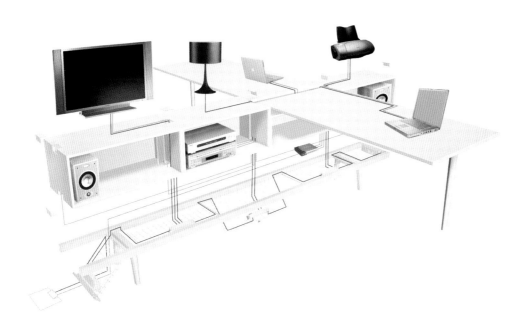

○ The Level 34 bench acts as a spinal column for electricity and data, as well as for organizational elements and a seat. The variety of elements allows for numerous applications, from individual use to large offices. The bench simplifies the management of wiring and unifies all the functional elements that are placed on it, giving the whole system a light, ethereal appearance.

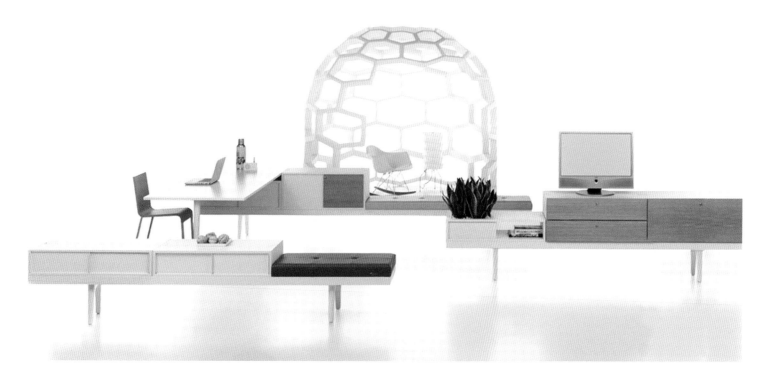

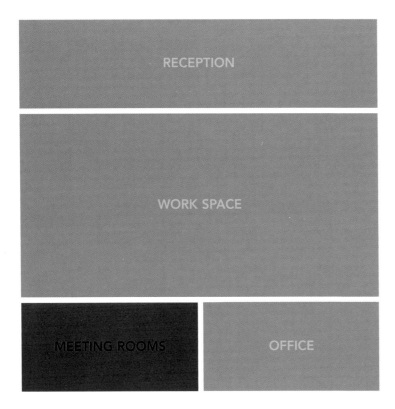

RECEPTION

WORK SPACE

MEETING ROOMS

OFFICE

03

○ The spaces designated as meetings rooms allow for multiple possibilities. The essential concept of a table with chairs around it, without being lost, has acquired new forms and greater complexity. Today, there are more and more designs for meeting tables that integrate IT connections and telephones, facilitating the use of technology and, at the same time, simplifying installations. Depending on the spirit of the company or institution, the furniture offers endless options: from neutral spaces and highly formal ones to relaxed compositions that prioritize the fluid exchange of ideas. Multifunctional furniture is often used in these environments, enhancing the transformation of work places into spaces that are more and more flexible, and where efficiency does not necessarily mean formal stiffness.

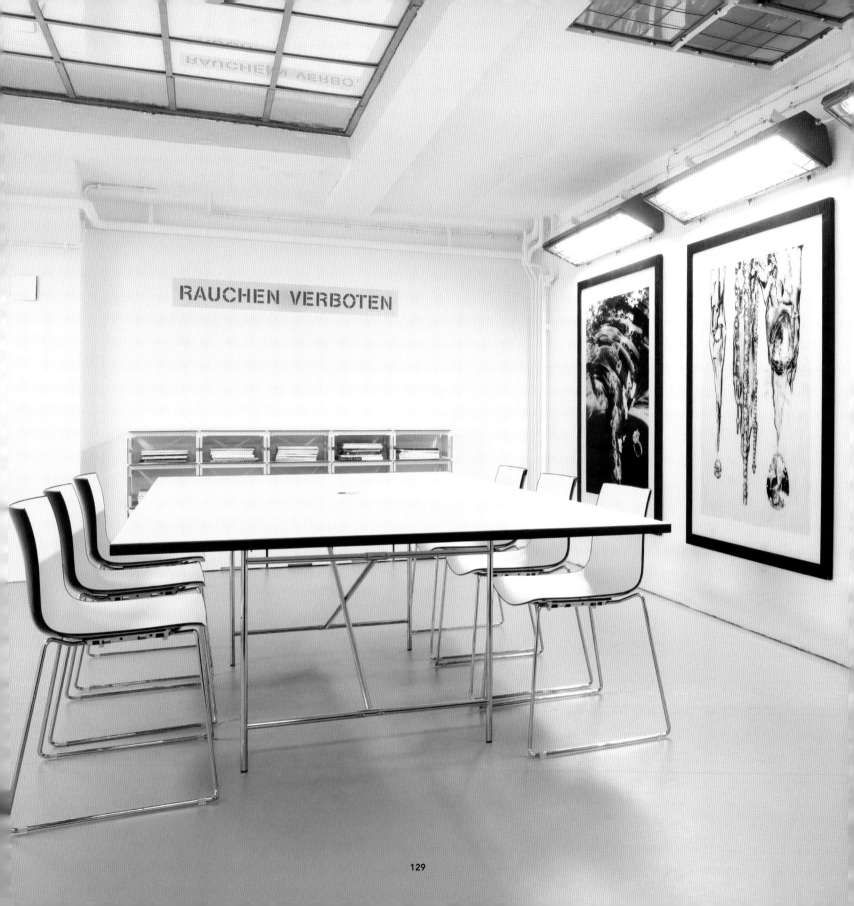

RAUCHEN VERBOTEN

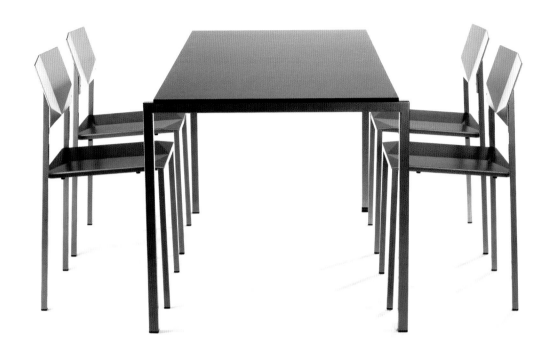

Kide Series Design: Mikko Paakkanen Manufacturer: Avarte Oy

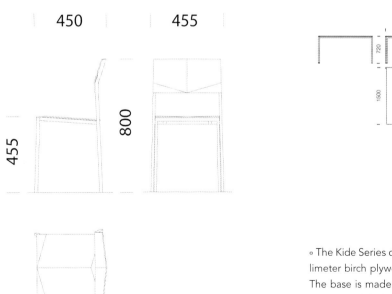

450 455

800

455

815

720

1500

∘ The Kide Series consists of five tables of different heights and sizes. Nine-millimeter birch plywood surfaces are laminated in white, gray, black, or natural. The base is made of steel covered in gray epoxy. The chairs, made from the same materials, have seats and backs that, thanks to a special fold, reflect light and shadows, creating an elegant effect.

 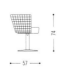 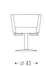 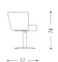

Circo Chair Design: Peter Maly Manufacturer: COR

◦ Circo is a line of rounded stools and armchairs well-suited to an informal meeting room. With a varied range, it adapts easily to almost all styles. The chairs can be made from wood or come upholstered in five different colors that can be combined: black, natural, red, dark brown, or gray. There is also the possibility of a chrome structure or one painted to match the upholstery.

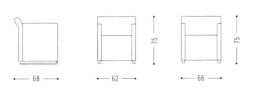
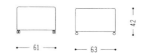

∘ Quant is a series of armchairs, sofas, and tables whose pure lines contrast with the variety that it offers, with legs, rotating bases, or sliding L-shaped legs. The pieces have a delicate appearance that integrates discretely into any environment. The sofas come in three depths, and are perfect for both home and office, providing a clear and comfortable atmosphere for any meeting room.

Quant Series Design: **Alfred Kleene and Gabriele Assmann** Manufacturer: **COR**

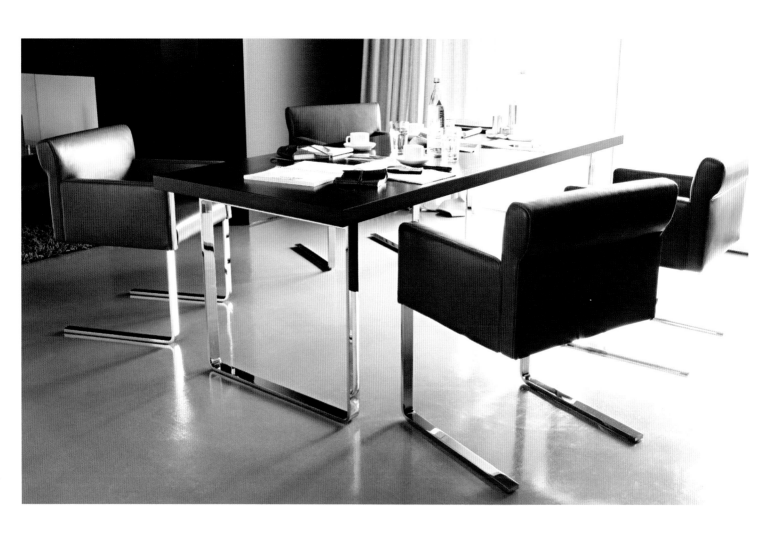

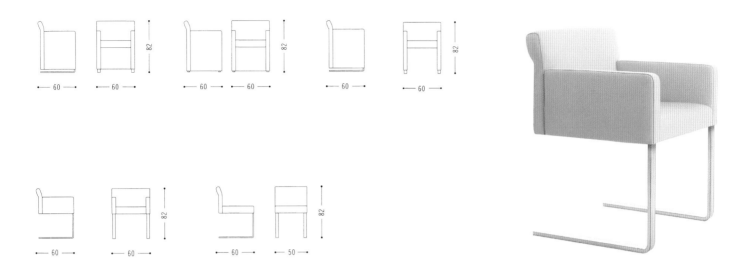

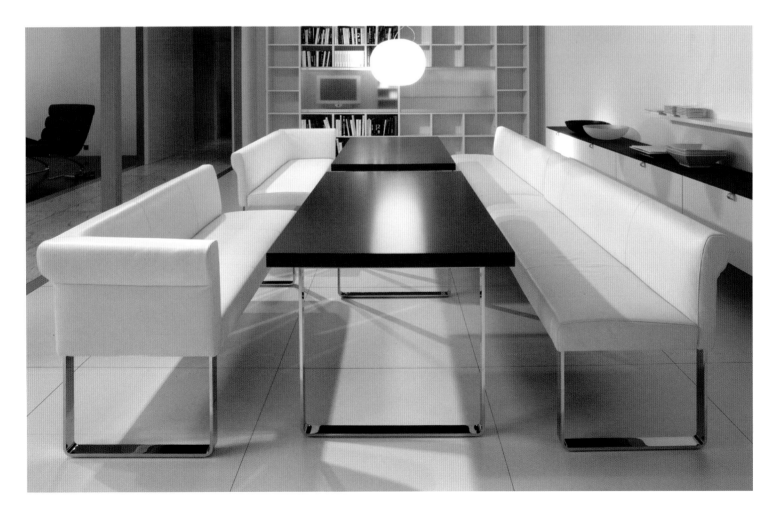

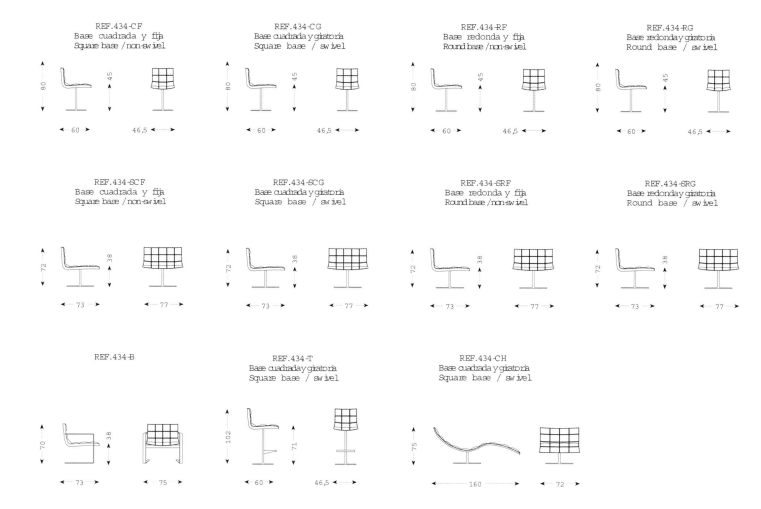

REF.434-CF
Base cuadrada y fija
Square base / non-swivel

REF.434-CG
Base cuadrada y giratoria
Square base / swivel

REF.434-RF
Base redonda y fija
Round base / non-swivel

REF.434-RG
Base redonda y giratoria
Round base / swivel

REF.434-SCF
Base cuadrada y fija
Square base / non-swivel

REF.434-SCG
Base cuadrada y giratoria
Square base / swivel

REF.434-SRF
Base redonda y fija
Round base / non-swivel

REF.434-SRG
Base redonda y giratoria
Round base / swivel

REF.434-B

REF.434-T
Base cuadrada y giratoria
Square base / swivel

REF.434-CH
Base cuadrada y giratoria
Square base / swivel

Turkana Design: **Jaime Casadesús** Manufacturer: **CYCSA**

◦ The Turkana seat has gentle and ergonomic lines that can be made with a square or rounded aluminum structure, and comes with chrome or matte finishes. With varying upholstery or in leather, the seat has a rotating system. The Tango table stands out for its transparency, which allows us to admire the balance of a metal structure that curves in its central section. The solid patina legs lend it great robustness and an exceedingly light appearance.

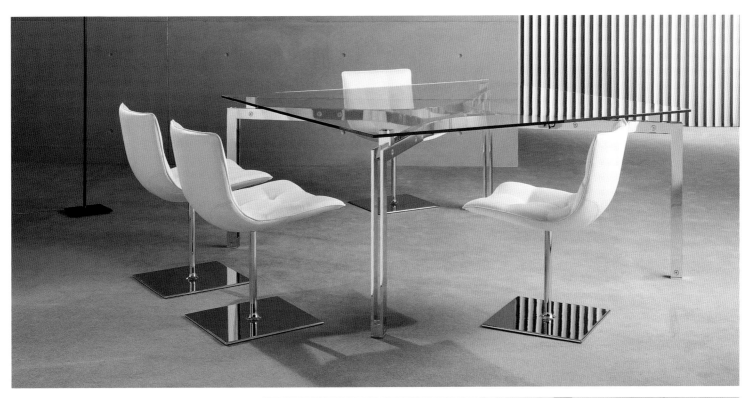

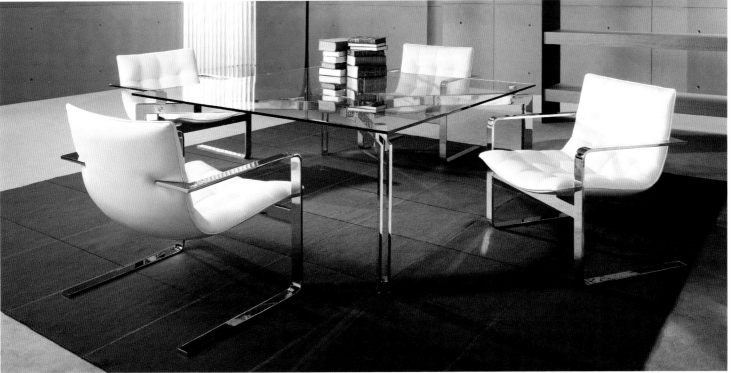

1120 Table Design: Delphin Design Manufacturer: Thonet

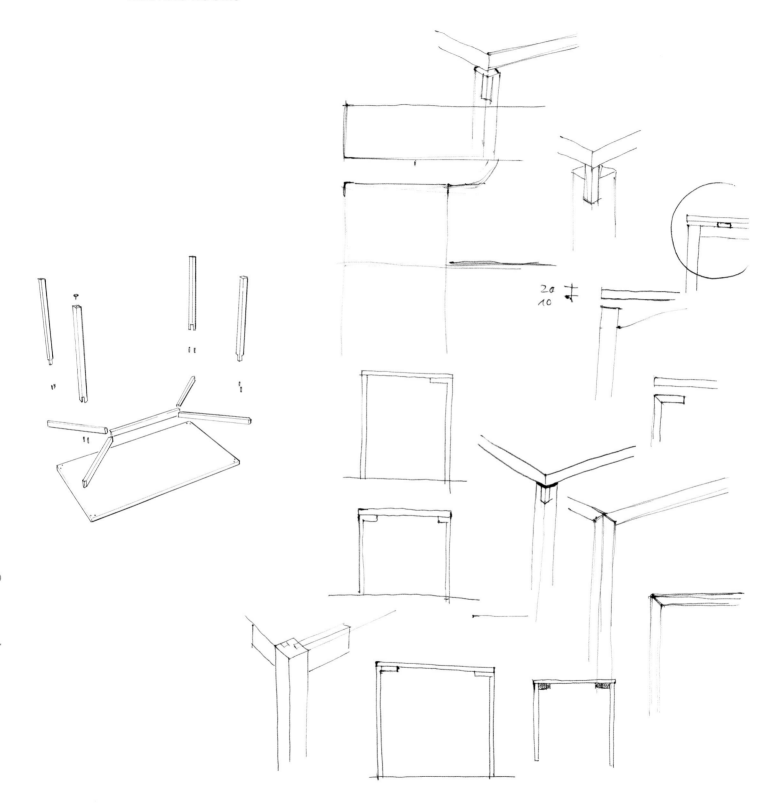

20
10

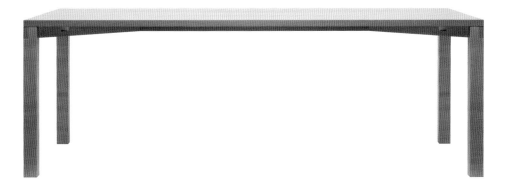

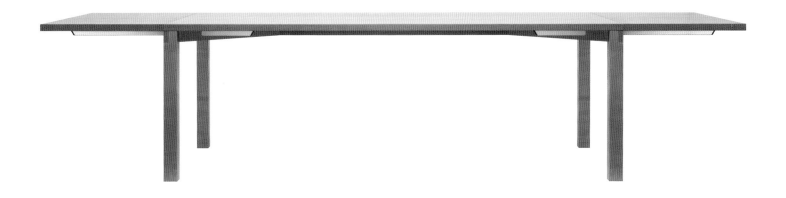

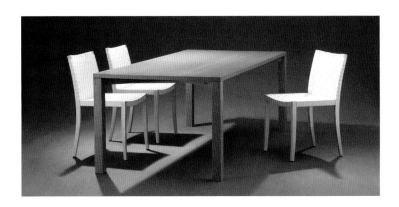

○ A solid table made from cherry wood with a firm frame, this piece's internal structure makes it highly resistant to damage. With a simple and austere design that enhances the nobility of the materials, the 1120 table has the option of a wooden laminate top. It has the added feature of being extendable by 7¾ inches (20 cm) on both sides, easily providing greater space for larger meetings.

U-Turn Table Design: Lotte Olesen and Peter Kristiansen Manufacturer: Magnus Olesen A/S

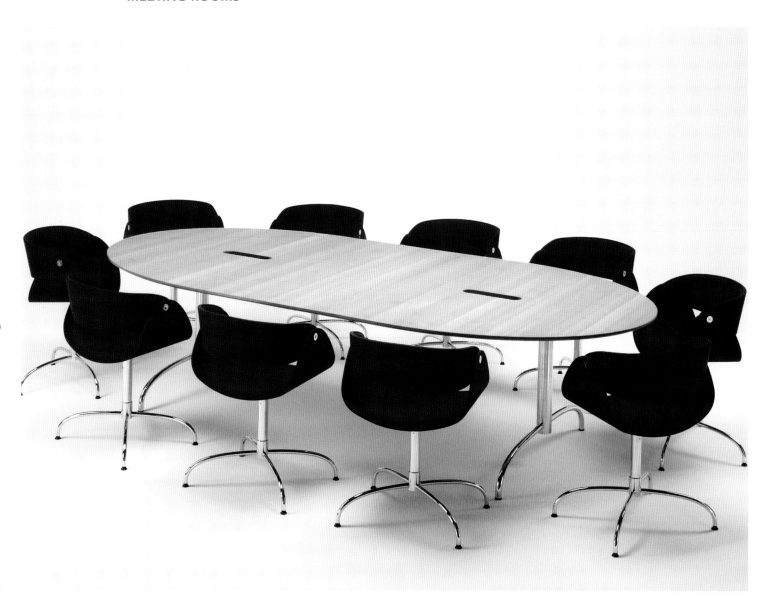

○ U-Turn presents a series of surprising innovations, both in design and its applications. It is ideal as a conference table due to an insulating material under the surface that absorbs noise, notably improving acoustics. It also has an integrated tray that handles cables and can be accessed via various perforations on the surface. It comes in lacquered laminate, maple, cherry, beech, or oak.

∘ Despite its classical design, the Session Relax Chair has a seat that is surprisingly high and comfortable as an armchair for meetings or as a seat. The chair can be piled and is built from solid wood, with an upholstered seat and back that can be taken off and put on without tools. Its ergonomics make it especially practical for users with movement difficulties, as it is easy to sit on and get up from.

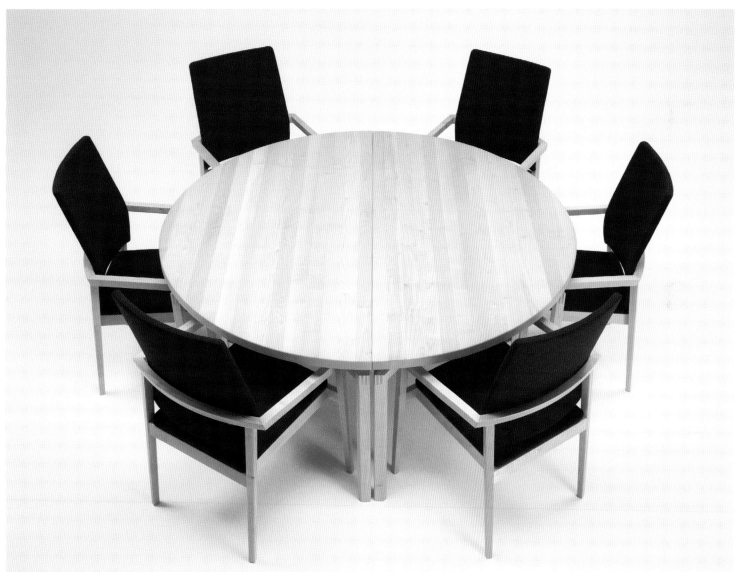

Session Relax Chair Design: Busk and Herzog Manufacturer: Magnus Olesen A/S

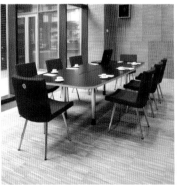

∘ In-tensive is a practical, transformable table for meetings and conferences. Light and easy to handle, different units can be assembled to form a larger surface. It offers electrical connections that facilitate the use of computers, battery recharges, table lamps, and projectors. The surfaces are made from laminated birch, and the flaps for the cable tray are made from MDF finished in aluminum or black. The standard version offers screw-on wheels.

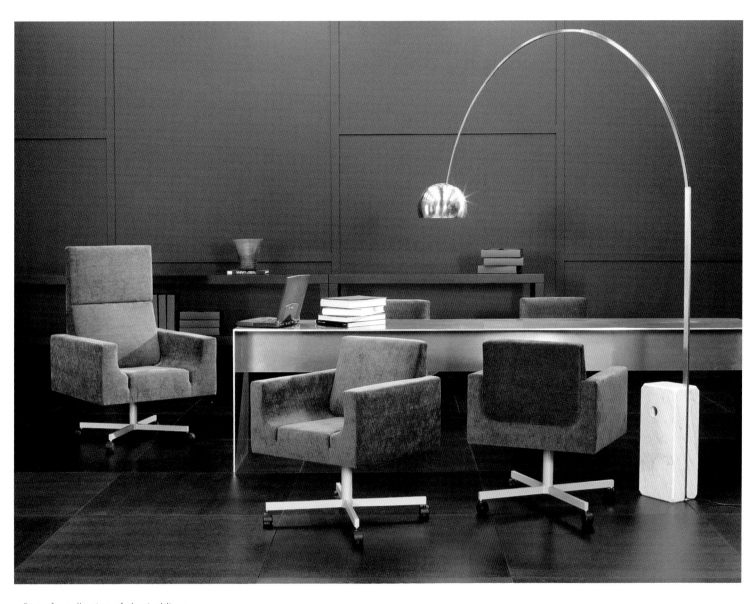

° Part of a collection of classical lines and contemporary design, this chair combines straight exterior lines with warm lines on the interior. It is made with a wooden structure, and the suspension of the seats is made from steel springs. The seat cushions and back are covered with 100 percent Terlenka polyester fiber, and are easily removed. The legs are made from steel covered in aluminum-colored epoxy.

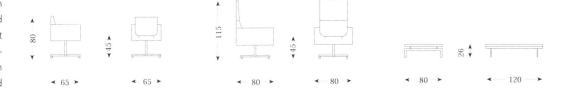

Bocaccio Chair Design: G. Vegni - G. Gualtierotti Manufacturer: CYCSA

○ An elegant conference table with a delicate appearance, Asema uses a special assembly unit, the Gotessons Powerport-unit, which connects with on-line and earth extensions. A highly resistant meeting table for daily or continual use, Asema is ideal for PowerPoint presentations. The ends are rounded, allowing nine people to comfortably sit around it. It has a steel tubular structure and a laminated MDF surface.

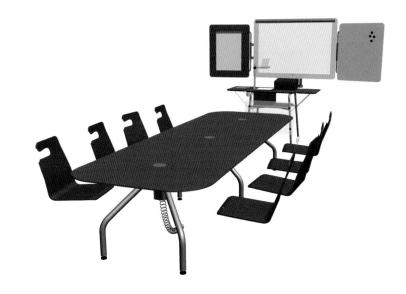

Asema Table Design: Jouni Leino Manufacturer: AVARTE

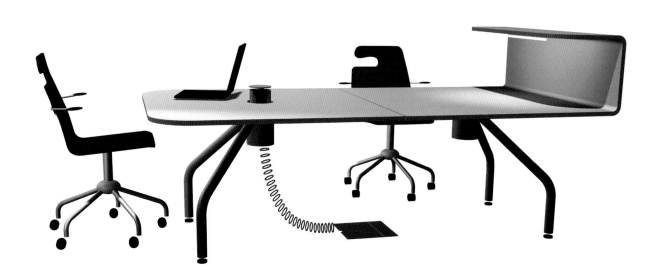

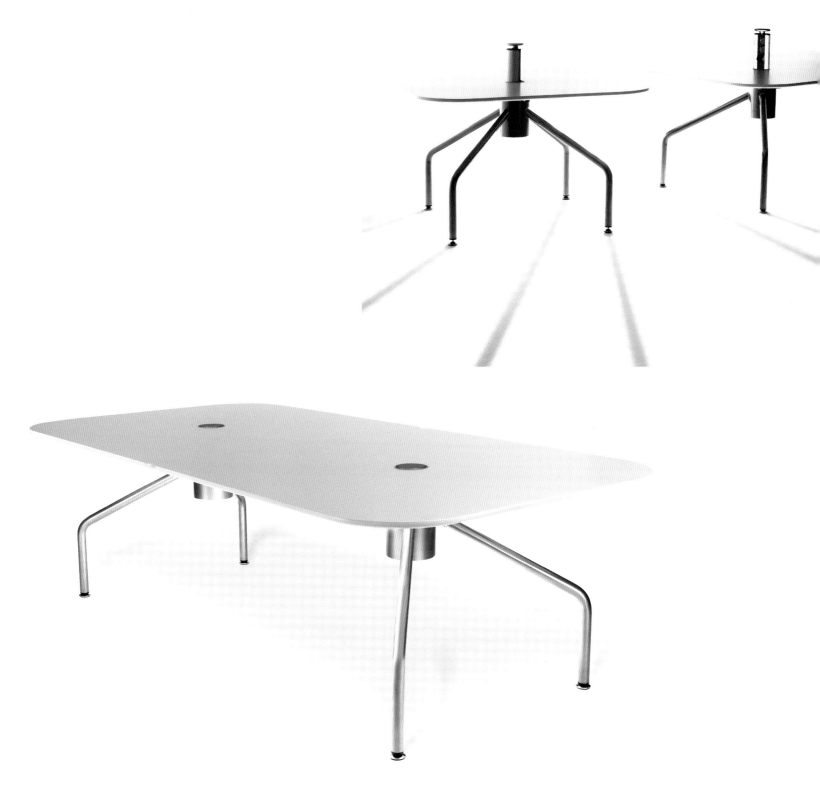

Serenissimo Table Design: David Law, Lella and Massimo Vignelli

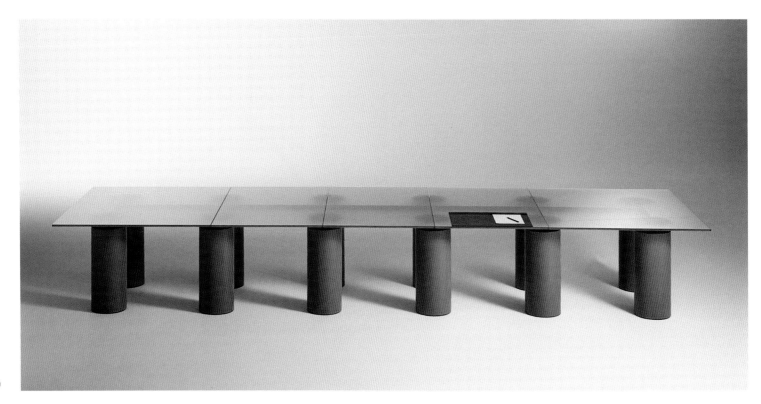

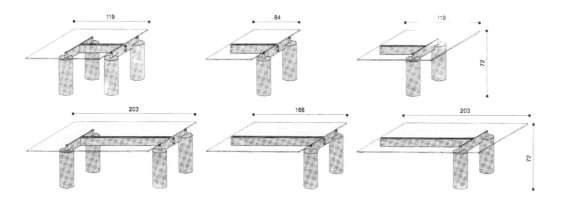

∘ The Serenísimo table, with its elegant, opalescent glass surface, presents different versions that can be adapted to a multitude of needs. The straight lines allow the assembly of various units to create an original piece, perfect for spaces designated for conferences or meetings. The distinctive element of this table is its solid metal legs, treated with Venetian plaster or in titanium varnish.

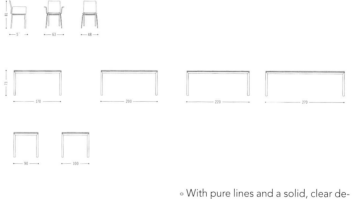

Fino System Design: Holger Janke Manufacturer: COR

○ With pure lines and a solid, clear design, the Fino chairs and table share an identity that invites relaxed use, making them perfect for work places such as the home. They can be combined differently to adapt to different spaces. The surfaces of the table are birch wood, maple or walnut, or varnished, translucent glass or granite. The frame is aluminum covered in epoxy or polished.

Model 307 Chair Design: Arne Jacobsen / Piet Hein / Bruno Mathsson Manufacturer: Fritz Hansen

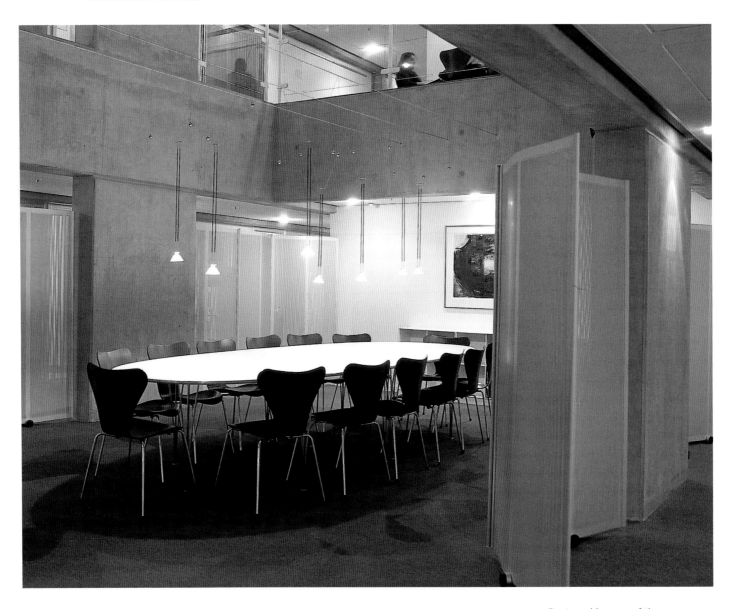

∘ Designed by one of the great masters, Series 7 is presented in an infinite range of colors. Its lines give it the possibility of a host of uses, and it has various adaptations: a lateral chair, a stool, an office chair, and also a childrens' version. Superellipse, another classic of Nordic design, is presented in the super circular, circular, square, or rectangular version and with different finishes on the surface and structure.

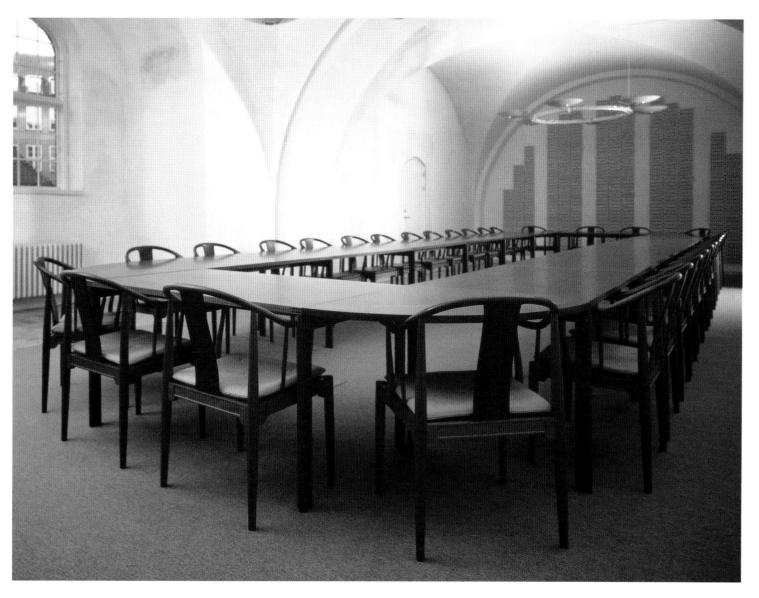

China Chair Design: Hans J. Wegner Manufacturer: Fritz Hansen

◦ Created in 1944, the China chair is comfortable, light, and durable, a perfect example of a timeless design. It is suitable for offices that want a classical style, and can be combined with contemporary pieces. It comes in mahogany or cherry, with a leather cushion buttoned to the seat.

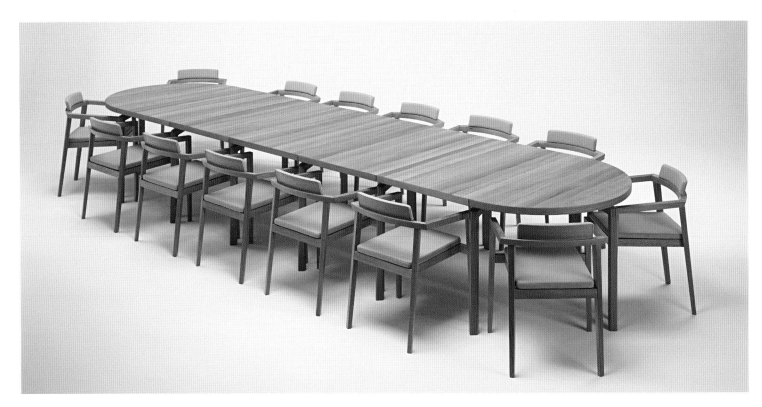

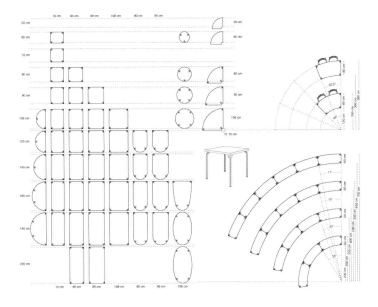

○ The Session Chair's simple and elegant lines examplify the clarity that characterizes Scandinavian design. Session offers a wide range of use, adapts to a variety of environments, and can be piled. The seat consists of a loose cushion that can be changed, rotated, and removed to facilitate cleaning and piling. It comes in different fine woods or stained black with a finish that is soft to the touch.

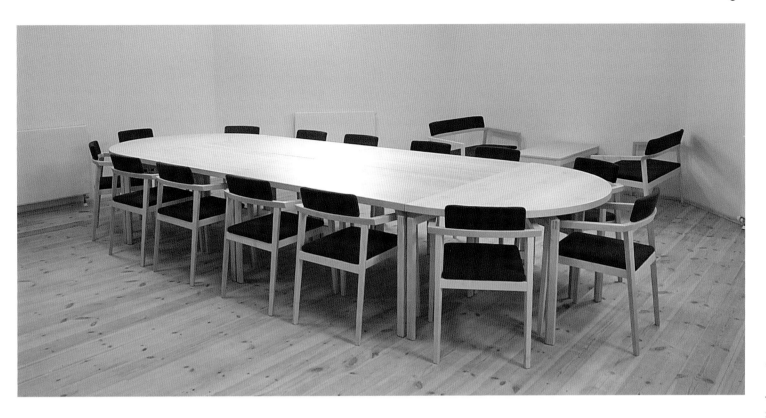

Mix Table Design: Rud Thygesen and Johnny Sorensen Manufacturer: Fritz Hansen

Cirkum Table Design: Troels Grum-Schwensen Manufacturer: Radius Møbler

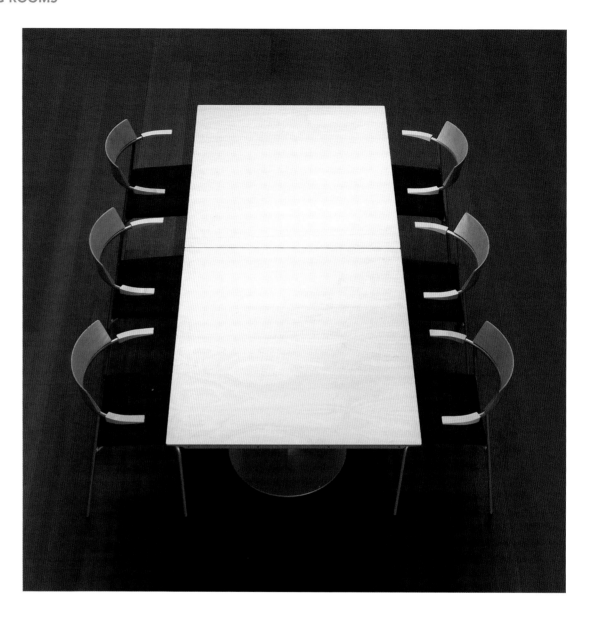

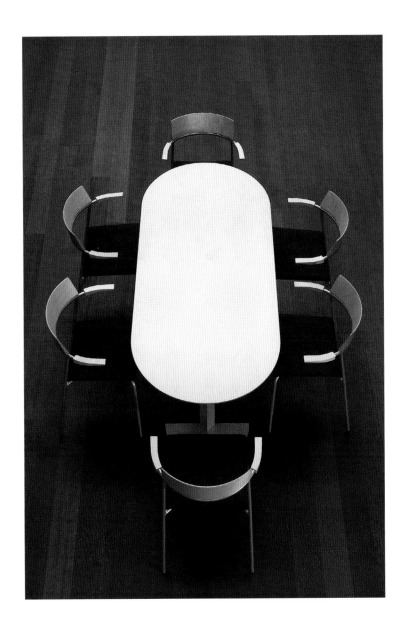

○ The Cirkum table is part of an elegant furniture system of simple lines, with a large variety of application possibilities. The concept comes from the desire to create a communicative furniture system that can vary and be combined almost infinitely, and because of that can be adapted to different spaces and carry out different functions without losing architectural character, unity, or clarity.

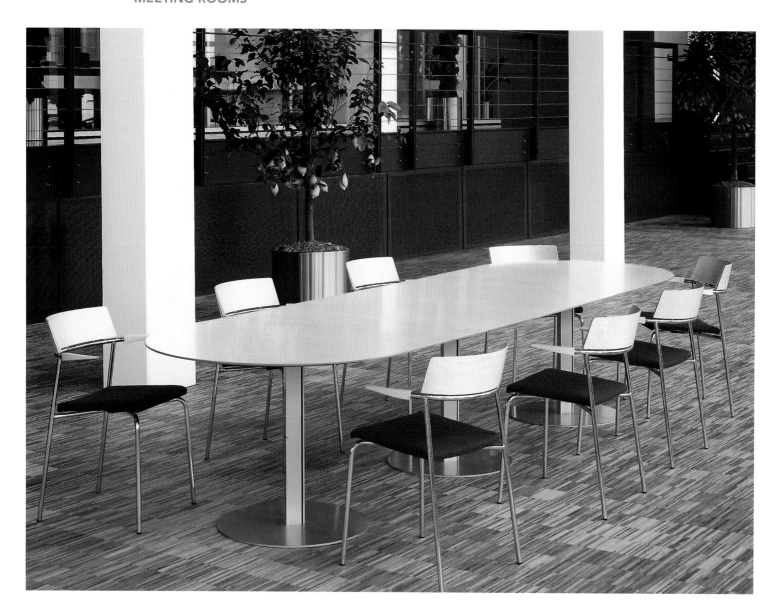

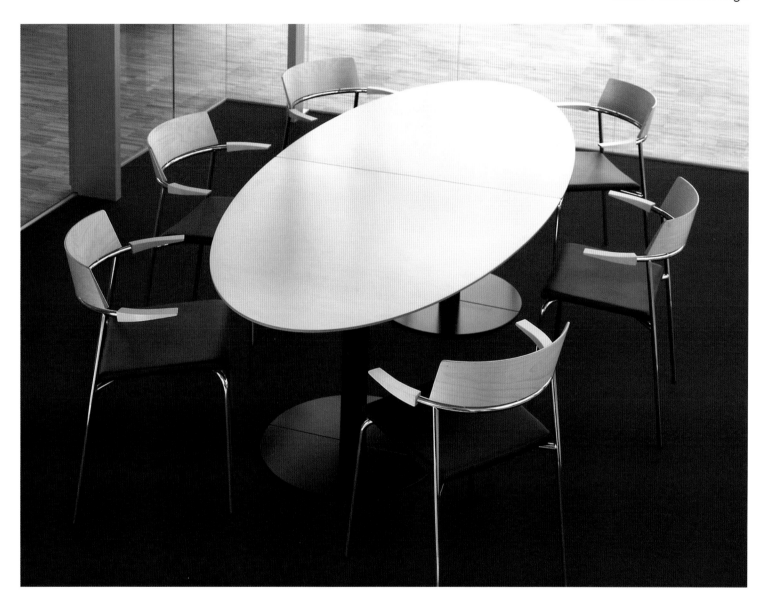

○ The fundamental concept from which the Cirkum table has developed is the semicircular base, which can be assembled to the surfaces in different ways. This makes it possible to have individual tables and also well-balanced sequences, always supported on the circular bases. Architecturally harmonious combinations can be achieved with a minimum of supports.

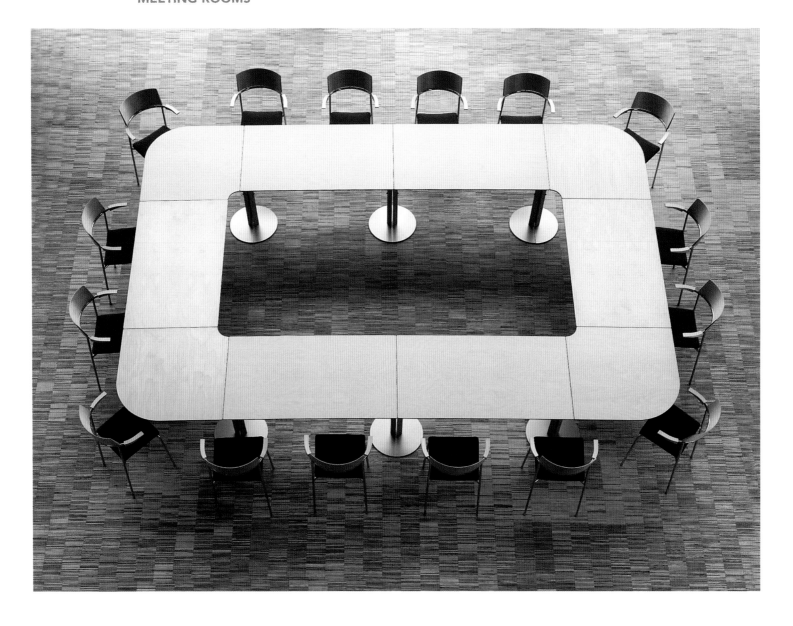

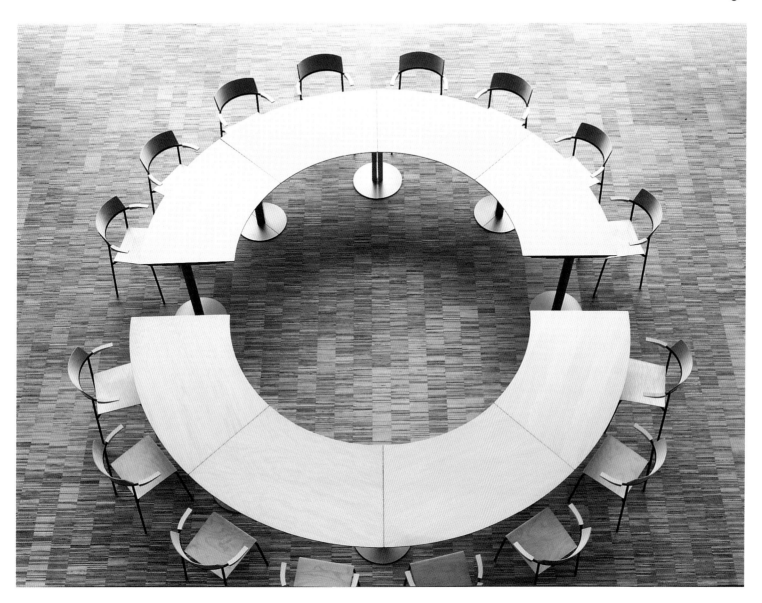

∘ Cirkum is incredibly flexible for meeting rooms and conferences, but the various sizes and shapes of the surfaces allow it also to be used in schools, bars, restaurants, reading rooms, etc. The solid or laminated birch or maple surfaces, and the bases, lacquered in different tones, offer several composition possibilities.

◦ Designed in 1960, the Nurmesniemi 001 chair is a true legend of industrial design, a timeless choice that guarantees a distinguished atmosphere. Bright chrome and soft leather upholstery constitute the basic materials. The 004 table, created in the '90s, combines the polished chrome of its legs with Oregon pine wood and stands out for its clear shapes.

800

450

525

525

Manufacturer: Piiroinen

Design: Antti Nurmesniemi

001 Chair and 004 Table

740

806

806

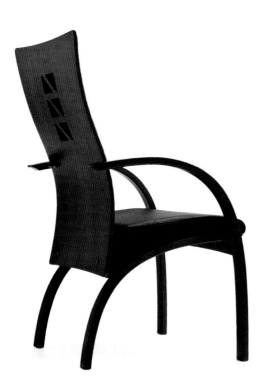

Boss Chair Design: MNIL Design Arild and Helge Manufacturer: Helland

○ The Boss chair welcomes a wide variety of proposals regarding the combination of materials to its exquisite lines. In this way, without abandoning style and comfort, it is possible to introduce it into different environments. The back can be upholstered in fabric or produced with wooden laminates. The structure, in maple or birch, comes stained in different colors of wood, from mahogany to cherry.

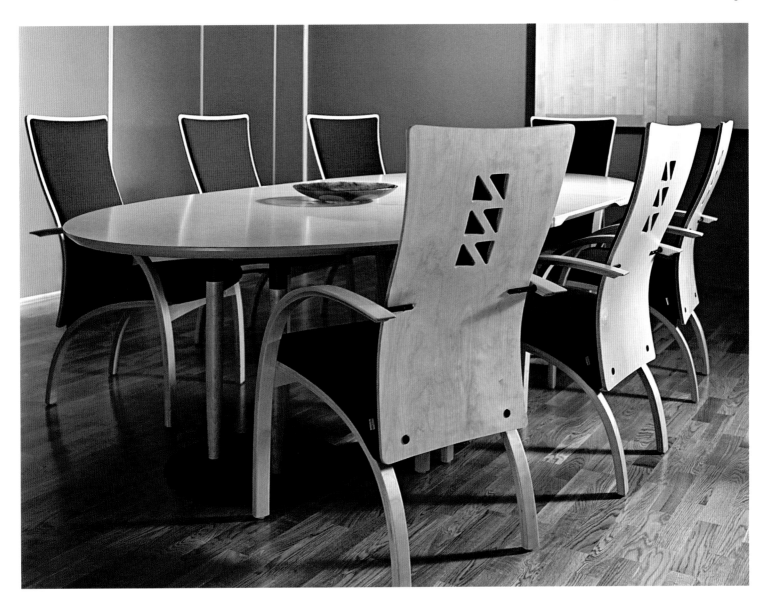

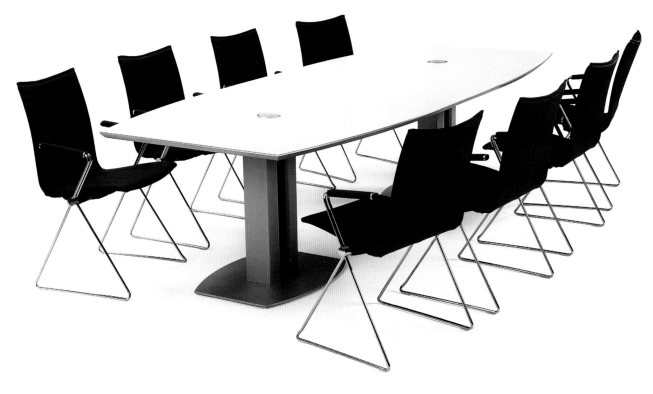

Zenit System Design: Ole Jørgen Mork Manufacturer: Helland

○ The Zenit system of chairs and tables combines lightness and solidity in contemporary lines. The chair is presented with a back, seat, and arms upholstered in fabric or black leather. The structure is made of steel covered in chrome. The foldable table offers the possibility of using one or two laminates in such a way that its size is almost doubled. The MDF surfaces can be laminated in maple or birch. The bases can be in gray or black epoxy.

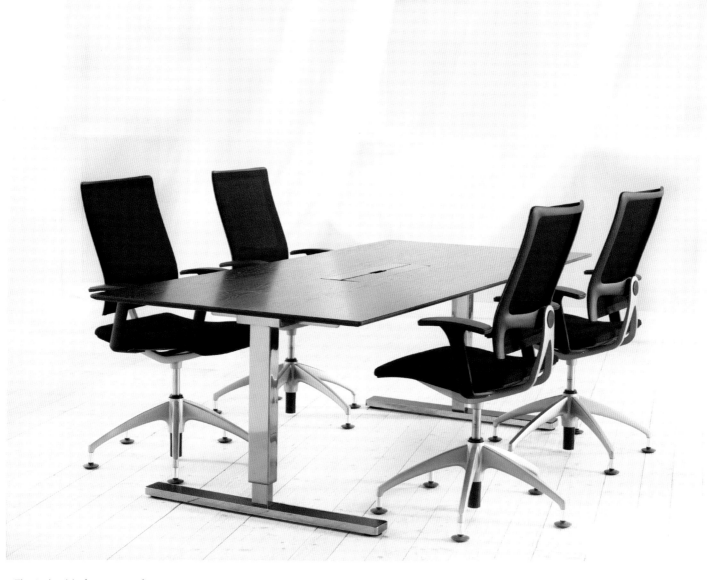

∘ The Link table forms part of a complete system of office furniture in which all the components are linked. Tables, chairs, and storage units make up an aesthetic unit, while each element maintains its personality. There is a choice of laminated wood, oak, or oak stained black or white for the table tops. The legs, with a T-shaped electric connection, allow the height to be regulated.

Link Table Design: Morgan Rudberg and Lars Petterson Manufacturer: Horreds

RECEPTION

WORK SPACE

MEETING ROOMS

OFFICE

◦ Within the spaces designated for work, individual offices acquire special importance. It is essential to provide individual work spaces with necessary equipment and still achieve an atmosphere in keeping with the responsibilities and functions of the occupant.

In this section, current design has focused on integrating technology with specific furniture and emphasizing the use of fine materials, such as wood or glass, which are enhanced by more generous proportions. The more vanguard, flexible, and durable materials are often used in open work spaces, but private offices can, without abandoning a modern style, combine it with an elegance belonging to more classical pieces.

04

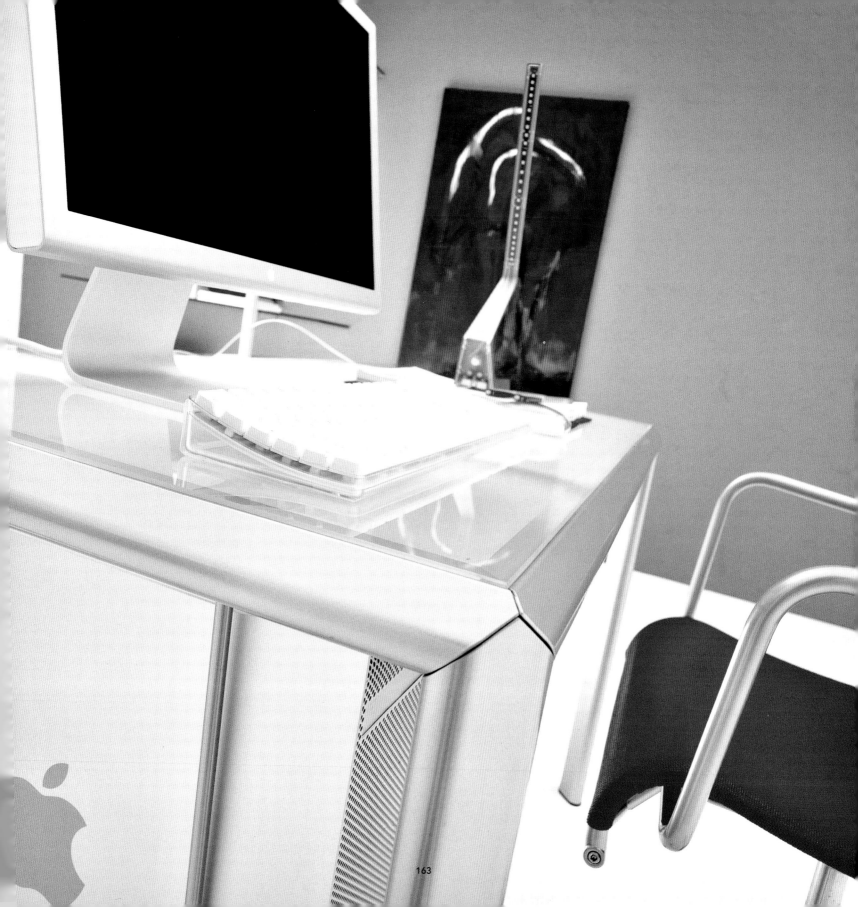

○ Spin is a small chair, whose comfortable lines are complemented by the lightness and freshness of the breathable micro fiber of its seat and back. The soft rubber wheels make it easily transportable, allowing the user to move easily between the different modules of his workstation. The base is made of lacquered glossy steel. Spin proposes a modern and versatile style, which is also adaptable to any space.

Spin Chair Design: Edi and Paolo Ciani Manufacturer: Calligaris

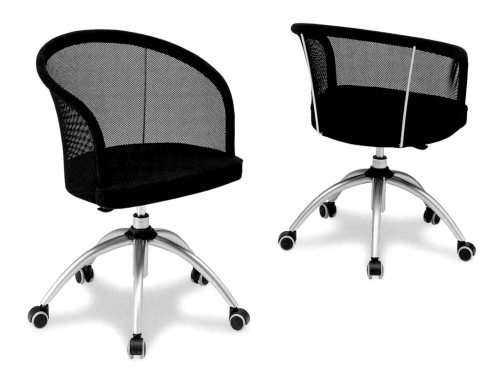

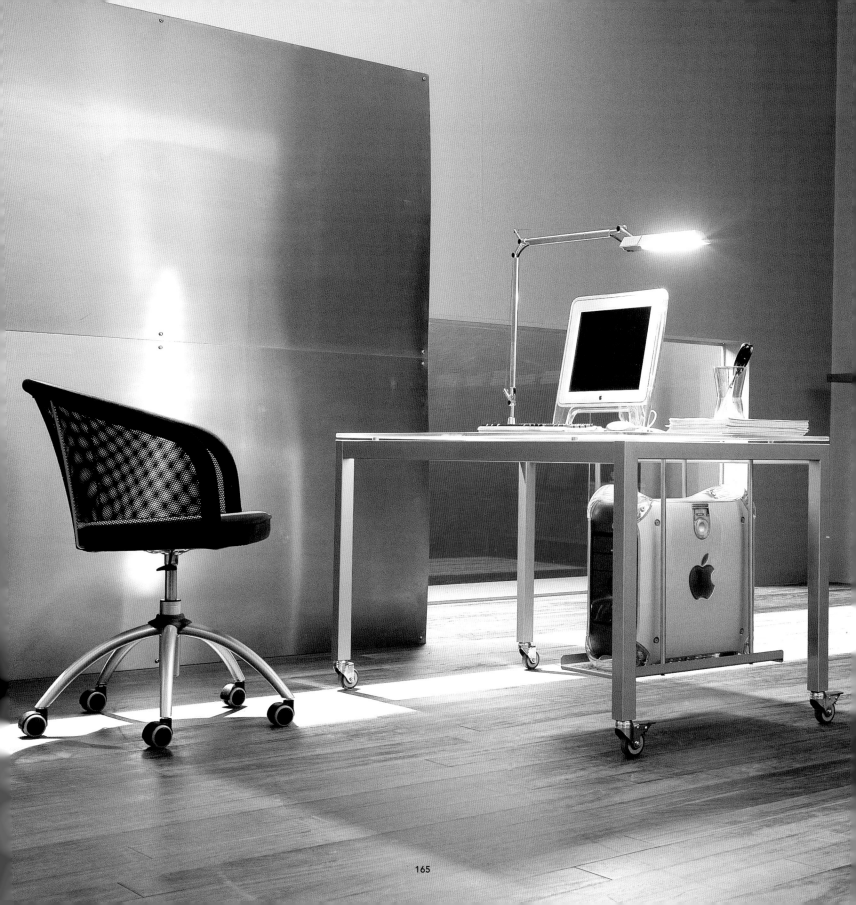

○ The attractive and comfortable Tend Soft chair adds a contemporary touch to the environment, whether it be an office, for which the version with wheels is most practical, or the home. The seat and back have rounded forms and are lightly concaved. It comes in vibrant colors, with synthetic, non-stain Teflon upholstery and a steel structure. The Stealth table is another example of a piece that functions perfectly well in private or working environments.

Tend Soft Chair Design: Edi and Paolo Ciani Manufacturer: Calligari

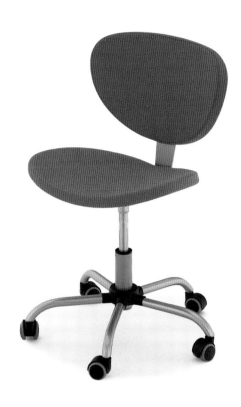

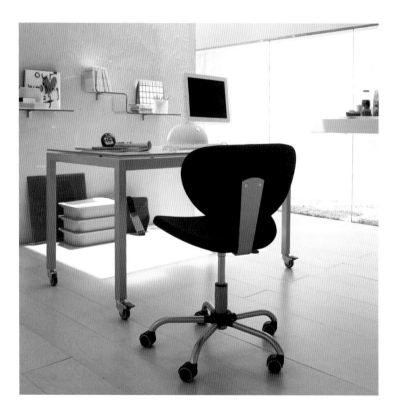

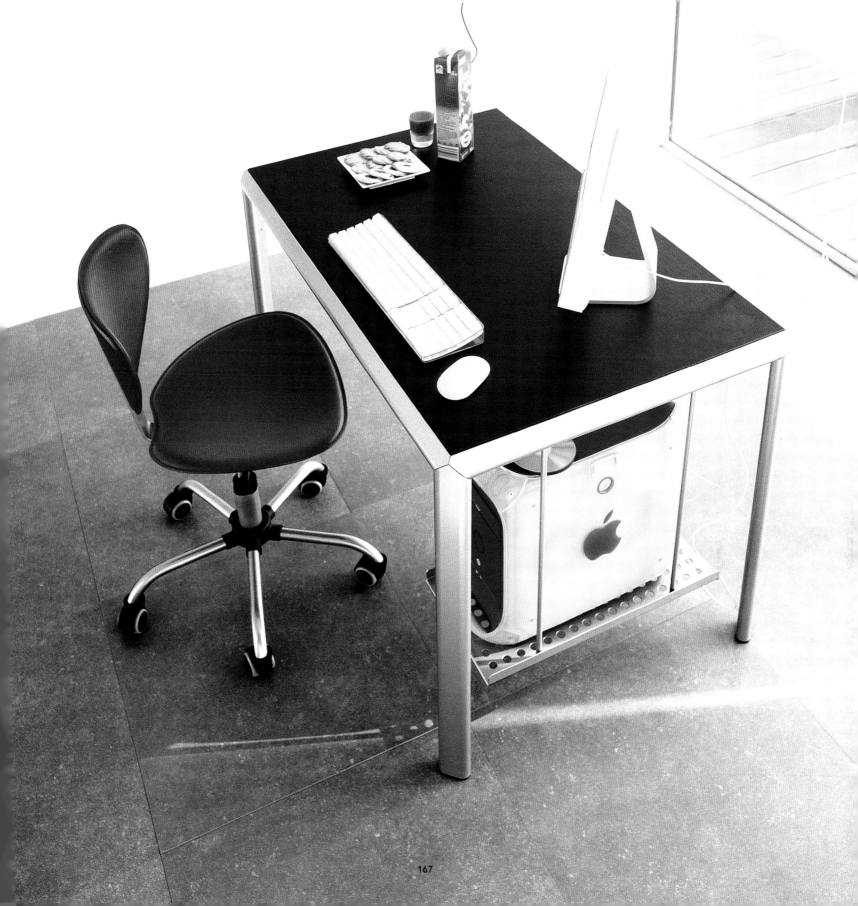

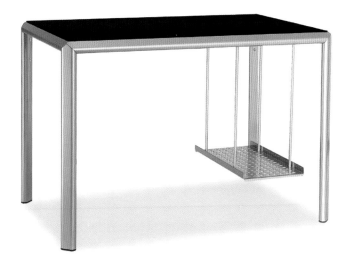

° Stealth optimizes its office use thanks to the CPU support that adjusts to the back part of the table top. With an aluminum structure and covered in semitransparent glass or maple wood laminated in diverse colors, Stealth comes in various heights and sizes, and is a versatile model perfectly apt for a variety of environments.

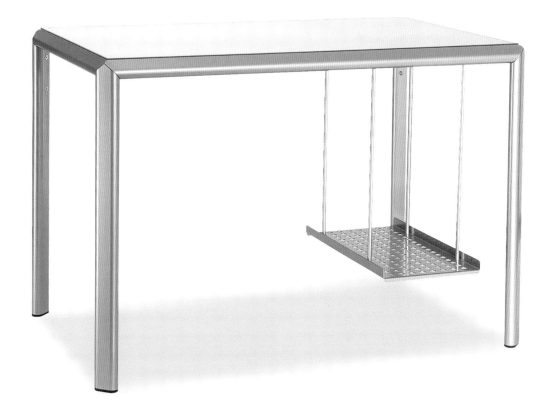

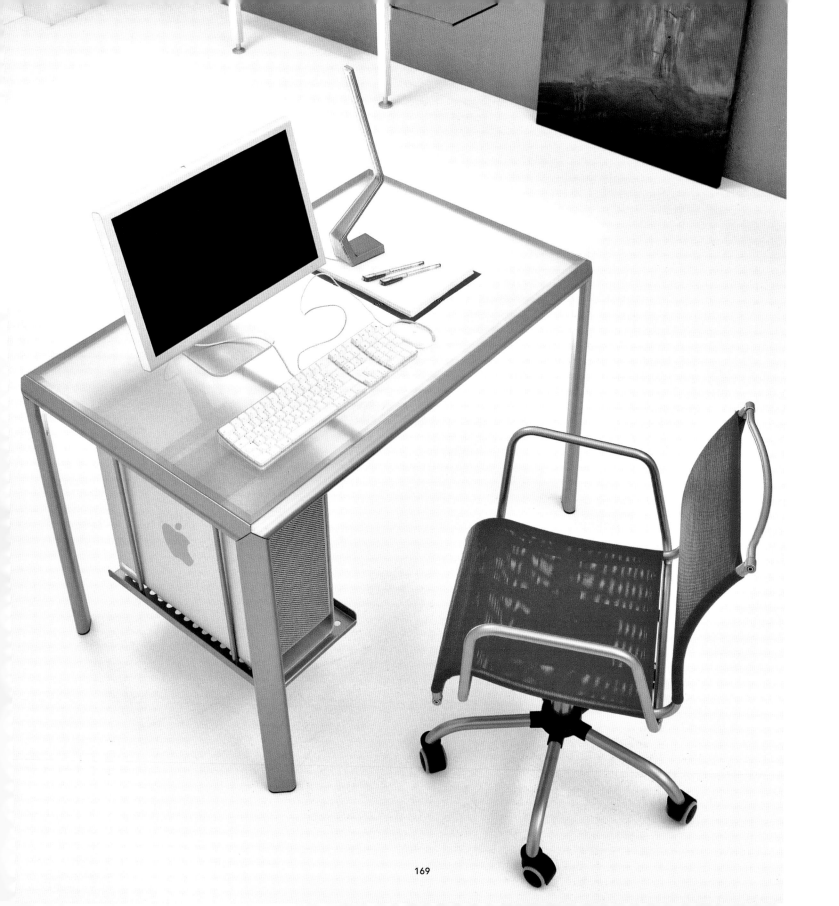

○ Tri.Be.Ca is an aluminum seat that can be piled, which uses a ductile material with great plasticity and special luminosity that reflects and absorbs the environment. Tri.be.ca is adaptable to numerous spaces and offers a variety of uses. Above all, it presents the great advantage of being long lasting, in brushed or gloss aluminum.

TRI 001
L 47 H 82 P 42

TRI 003
L 55 H 82 P 42

TRI 005
L 47 H 82 P 42

TRI 007
L 55 H 82 P 42

TRI 010

Tri.Be.Ca Chair Design: Luciano Bertoncini Manufacturer: Bellato

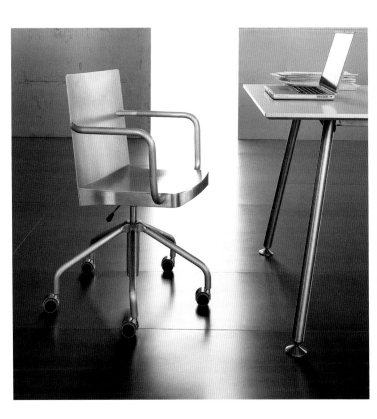

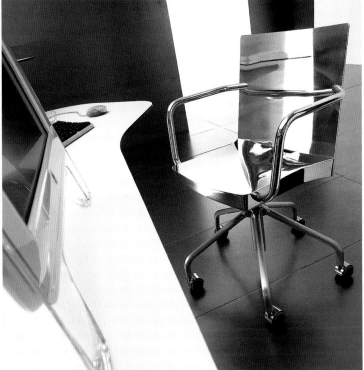

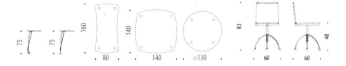

° The Axel table has three possible surface shapes—round, square, or rectangular—that always show curved lines of sand-etched glass in dark gray, red, or blue. Its chrome legs are secured by two reinforcing parts that form part of its surprising line. The Vedette chair is light, rotating, and has an adjustable structure with an adjustable height. Any one of twenty-seven different tones can be chosen for its leather seat.

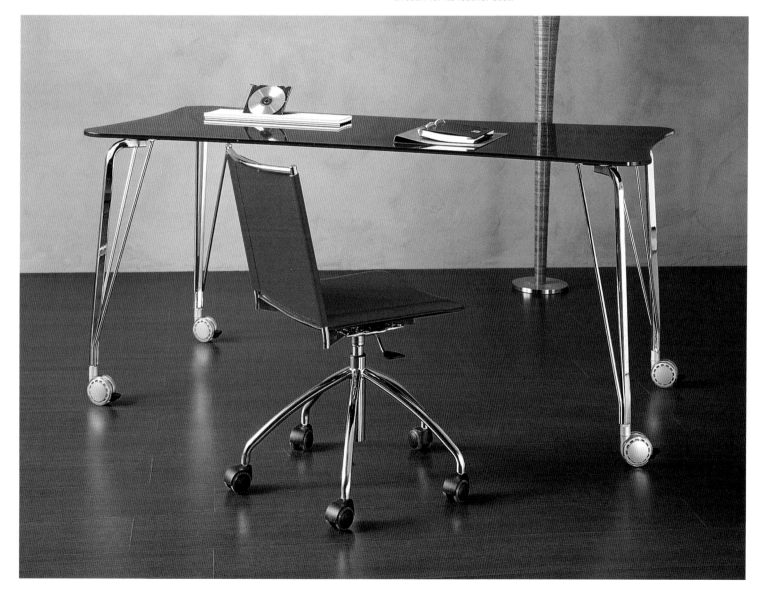

Vedette Office Chair Design: Andy Ray and Emilio Nanni Manufacturer: Fly Line

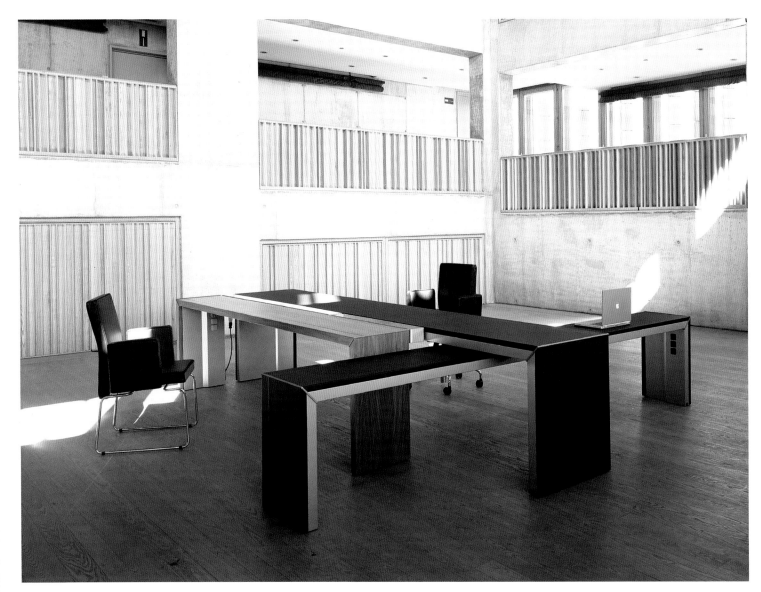

Double You Table Design: Hannes Wettstein Manufacturer: Bulo

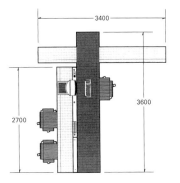

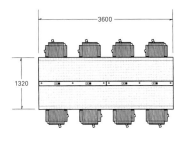

○ The Double You Table is an innovative design, primarily but not exclusively for collective use, whose size and use can be flexible depending on the creativity of the users of the furniture. Starting from a "bench," a long, narrow table in different sizes and heights can form different configurations by combining the various accessories that the series proposes.

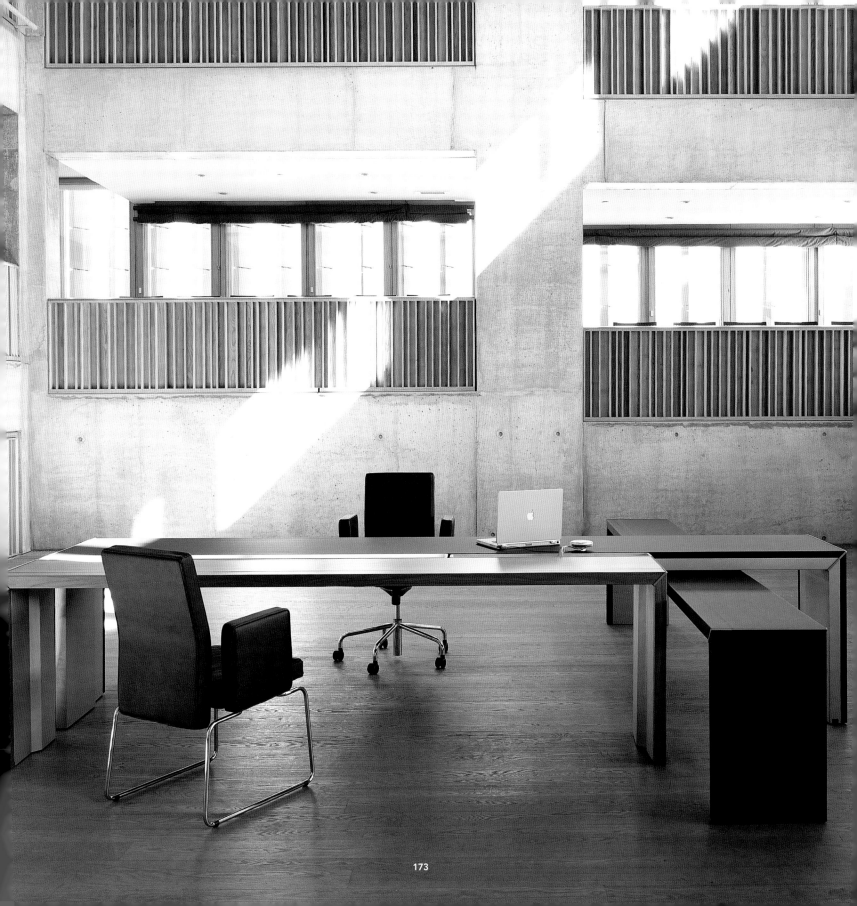

Uniqua Chair Design: Paolo Favaretto Manufacturer: Favaretto and Partners

∘ This design guarantees correct posture and maximum comfort. Its original patented back adapts to the position of the spinal column and muscles in the back, providing the body with a relaxing massage. It is breathable and hygienic, and has eleven different positions that synchronize the seat with the back. Its structure is made of resistant aluminum, and the seat and back are cushioned with polyurethane foam.

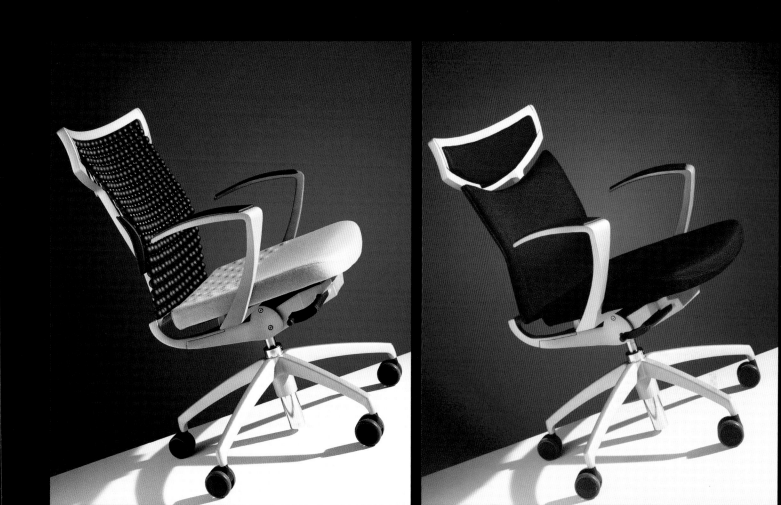

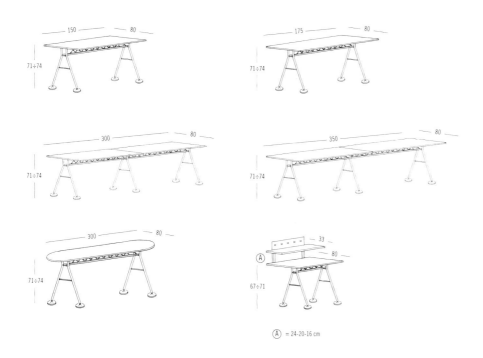

○ This series of tables, with surfaces of different shapes and sizes in high-pressure white laminate or natural maple, offers various usage options. The tables can be used individually or modularly and include numerous accessories and supports. The Orquídea chair draws on the lines of nature and can be used anywhere. It is a rotating, reclining chair for relaxation and has character. The light is gradable for reading or rest.

Orquidea Office Table / Chair Design and Manufacturer: Studio D'Urbino Lomazzi

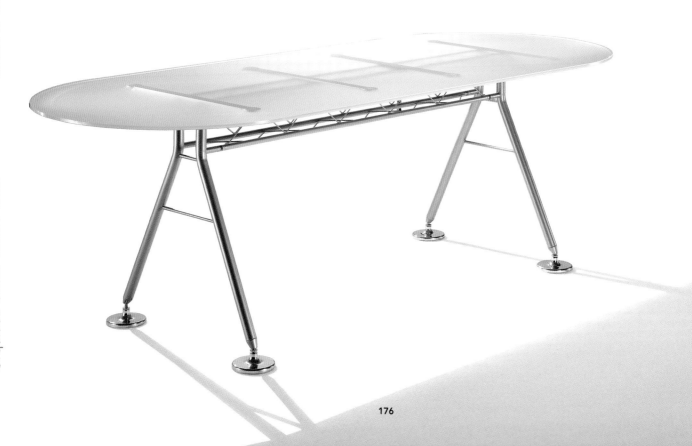

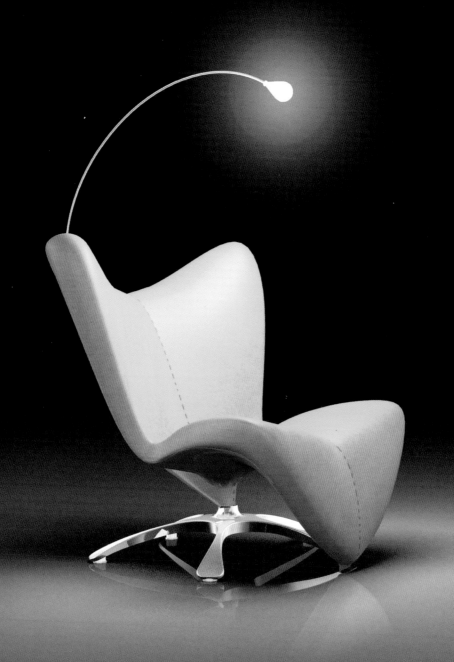

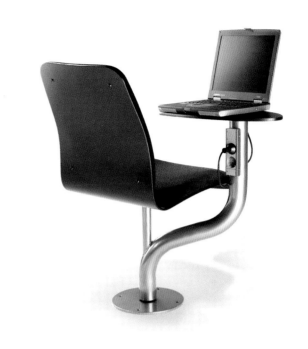

Alfa Chair Design: Jouni Leino Manufacturer: Avarte

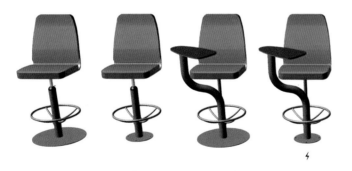

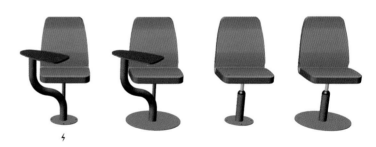

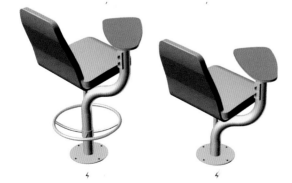

◦ Alfa is not a traditional auditorium chair, but is designed for the interactive needs of life today. It rotates and is fixed to the ground via a support that integrates electric cables and a computer connection. The chair was conceived for workspaces but is also ideal for other spaces like conference halls or Internet cafés. The seat is made of folded birch plywood with a tubular steel structure covered in epoxy.

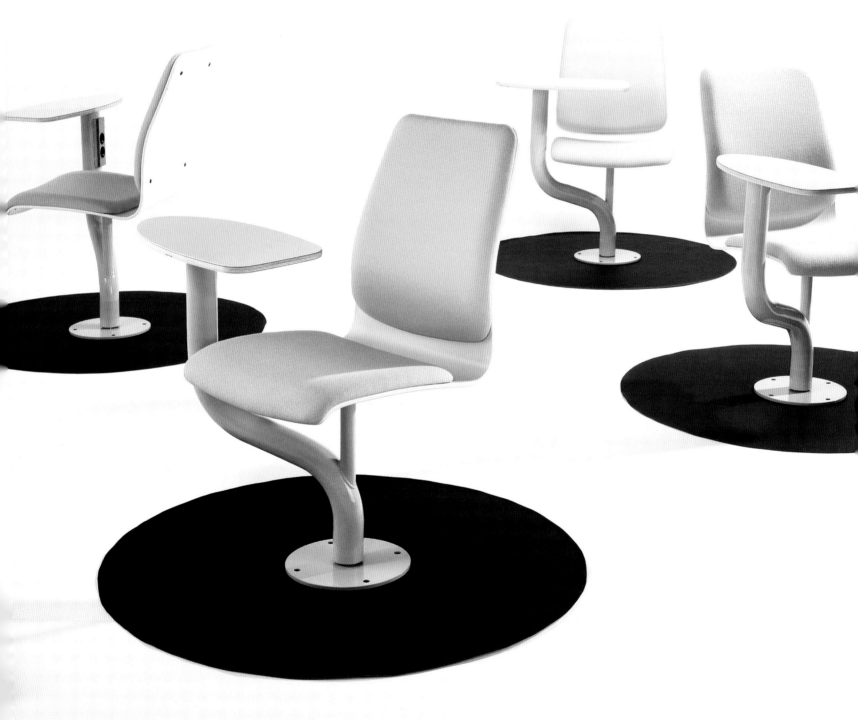

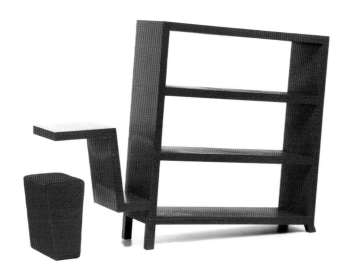

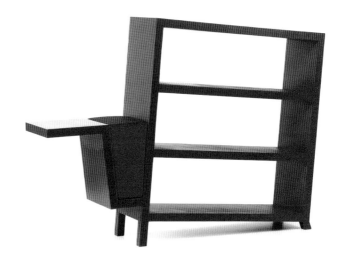

Anubis Series Design: Bram Boo

○ The Anubis series relates to the concept of flexibility in use. The objects adapt to the needs of the user and the environment, achieving a high level of mobility. The objects in this series connect to each other and have surprising forms and colors, from the lounger whose back incorporates a shelf to the chairs whose arms can become a table for another user.

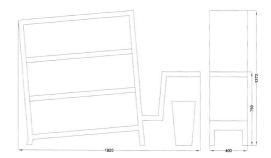

180

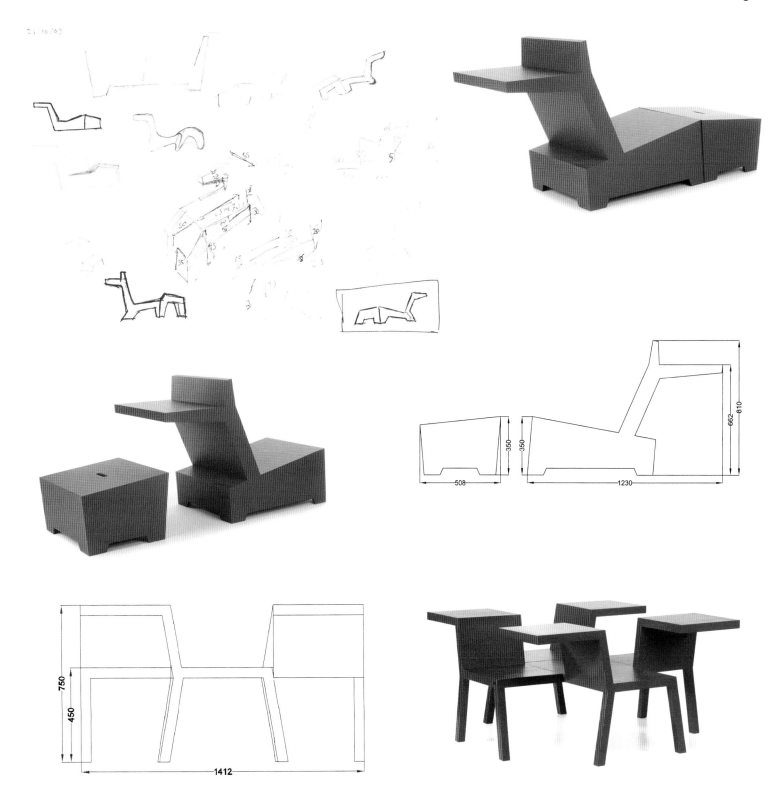

∘ The Normal series has been used by the designer Jean Nouvel as a message to express rationality—not a conventional rationality, but one loaded with common sense and not at all lacking in sensuality, thanks to the nobility of its size and materials. Made from four classes of wood, Normal has a moveable surface that amplifies the work space creating a temporary shelf.

Normal Table Design: Jean Nouvel Manufacturer: Bulo

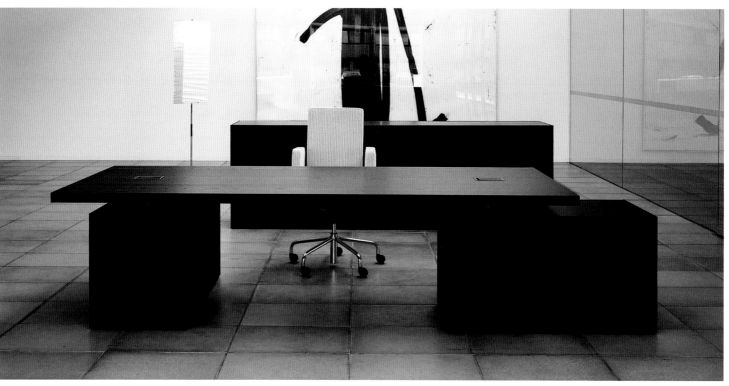

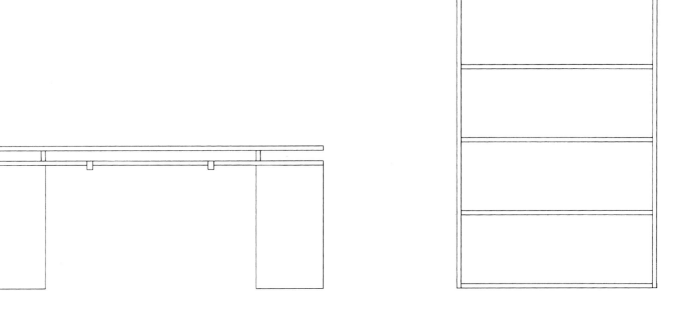

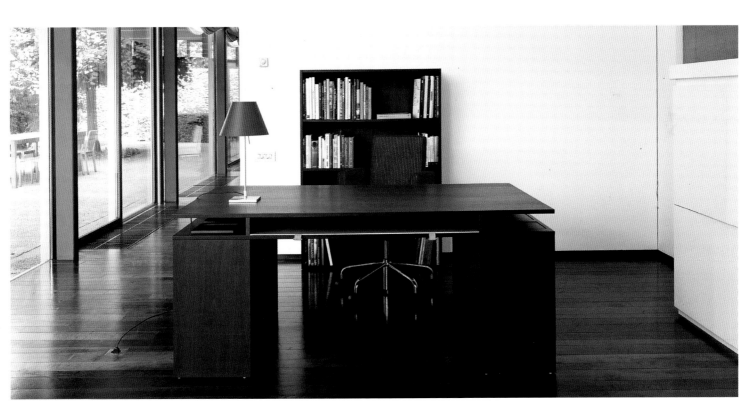

Studiolo Table Design: Annabelle d'Haurt

∘ This table system stands out for its formal rigor, technological research, and impeccable execution. It has a steel structure finished in arctic gray, black, or chrome. The surfaces are of transparent, tempered glass bathed in acid, clear glass, black veneer, or white laminate. Some versions can be accompanied by accessories such as supports for Hi-Fis or CPUs.

Table Helsinki Design: Caronni and Bonanomi Manufacturer: Desalto

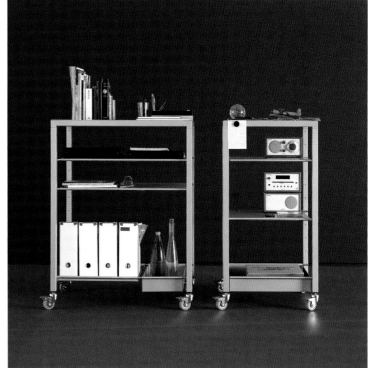

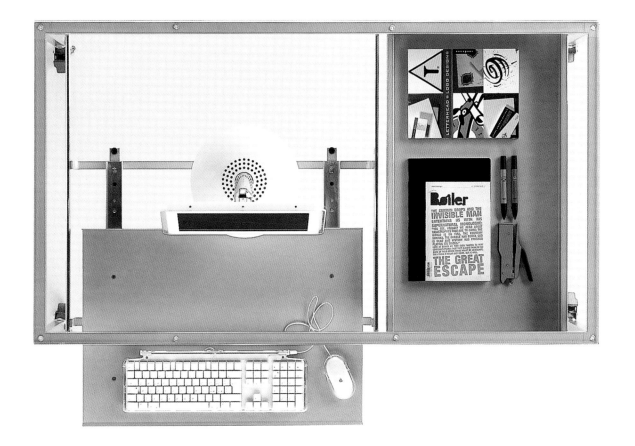

° This shelving, with a simple and essential design, has steel edging in different tones. It is fixed to the wall or ceiling, which allows the possibility of being used from both sides, functioning also as a space divider. There are various finishes, such as glass, laminate, or natural wood. The Stilt table, with a timeless design and made from wood, steel, and glass, possesses an inimitable extension mechanism that gains a large amount of surface area without occupying much permanent space.

Armida Stilt Shelving Design: Caronni and Bonanomi Manufacturer: Desalto

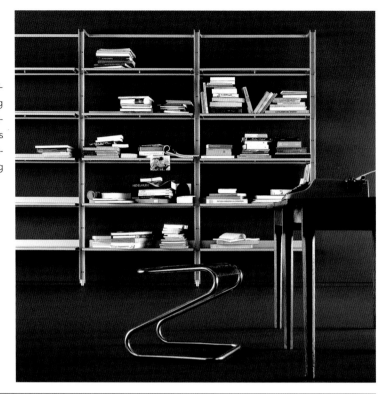

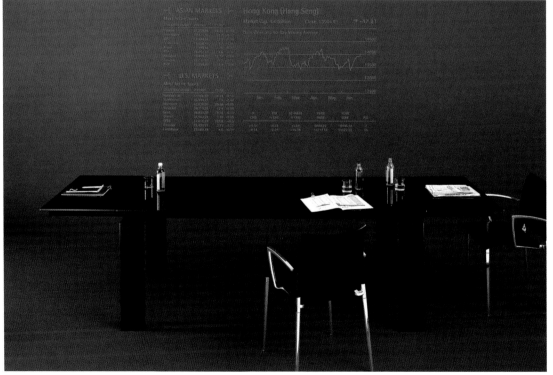

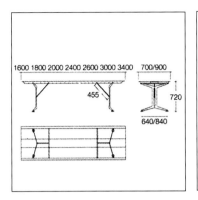

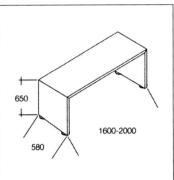

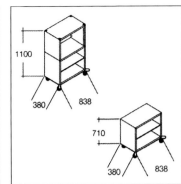

○ The Push-In Table presents two modules, one of which serves as the legs, and can be slid out to provide a new work surface allowing various configurations. Bridge is a chair composed of two curved bars joined by a silver aluminum structure. It comes in two versions: with four legs, pilable; or with a rotating base and adjustable height.

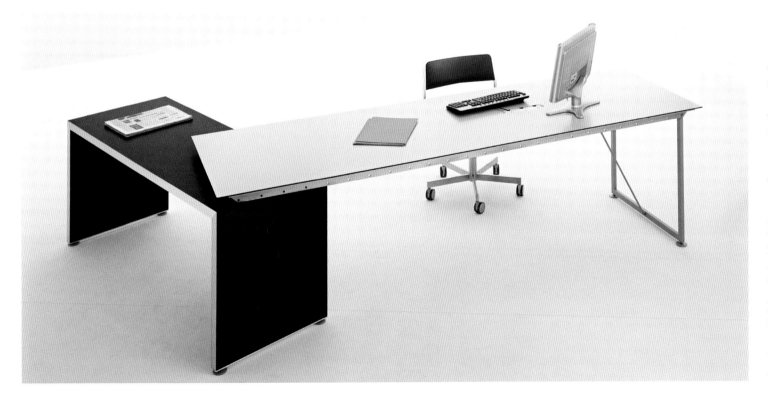

Push-In Table Design: Ueli Biesenkamp Manufacturer: Pallucco

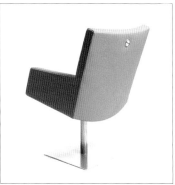
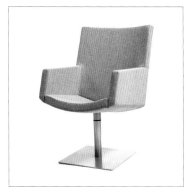
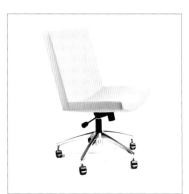

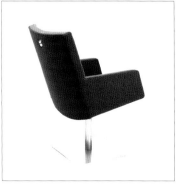
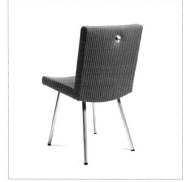
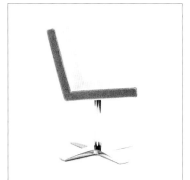

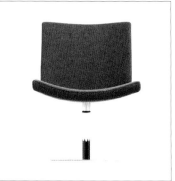
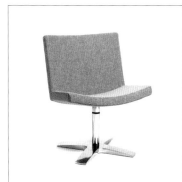

Manufacturer: Inno Interior Oy

Select Series Design: Harri Korhonen

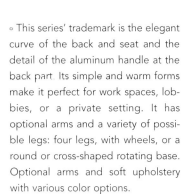

○ This series' trademark is the elegant curve of the back and seat and the detail of the aluminum handle at the back part. Its simple and warm forms make it perfect for work spaces, lobbies, or a private setting. It has optional arms and a variety of possible legs: four legs, with wheels, or a round or cross-shaped rotating base. Optional arms and soft upholstery with various color options.

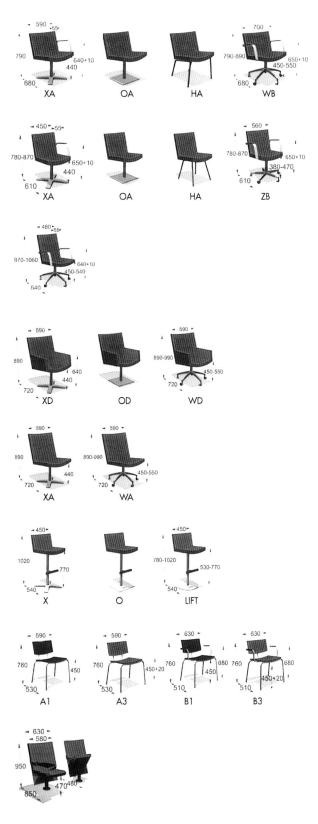

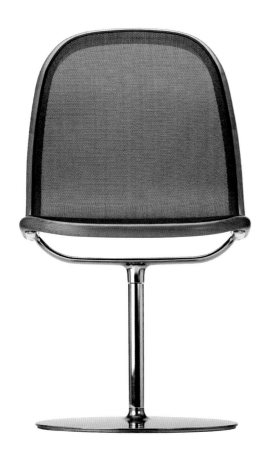

° The A660 is a classic design with curved forms. Its folded maple wood frame can be natural, varnished, or stained black. It has a circular star-shaped base, made from polished aluminum. The seat rotates, and the interior of the seat is a synthetic mesh in black, habana, or silver. It comes with or without arms and its ergonomic, light, and timeless design make it perfect for work and the home.

A660 Chair Design: James Irvine Manufacturer: Thonet

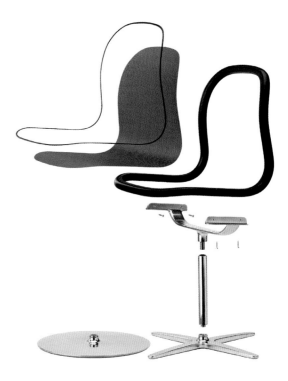

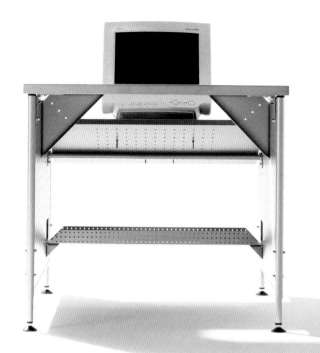

∘ This table has been developed around the ergonomic concept of the gaze at rest after looking at the computer screen from a higher position. For this reason, the monitor is below the surface of the table. That way, the keyboard and screen are closer to the user's field of vision. The table has small dimensions, made from steel and maple wood, and has a back support for a CPU, leaving the surface free.

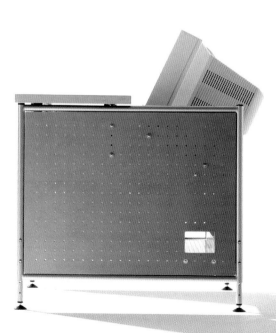

Minic Computer Table Design: Otto Sudrow Manufacturer: Richard Lampert

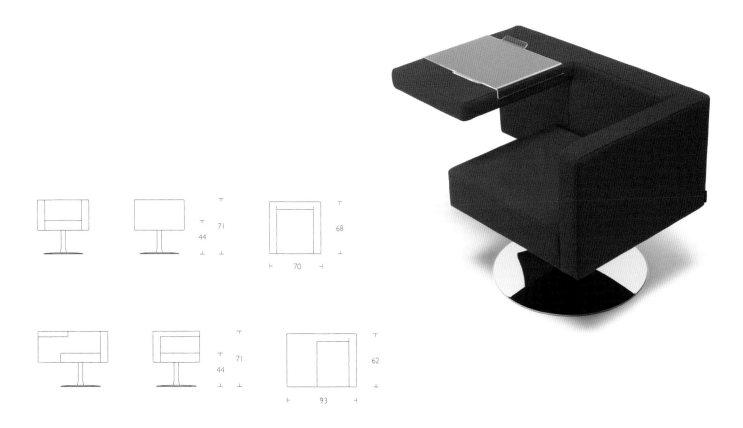

71
44
68
70

71
44
62
93

Solichair Design: Alfredo Häberli Manufacturer: OFFECCT

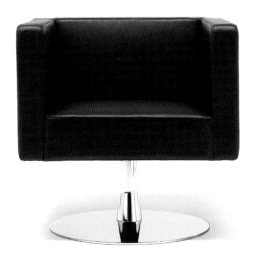

∘ Solichair is a design with simple organic forms, made from a single piece. It is upholstered in fabric or leather of different bright colors, and has a circular base of chrome metal or metal lacquered in silver. Its materials make it highly comfortable, and it also presents the option of a lateral surface for reading or writing. It is a piece which is perfectly apt for both the home and dynamic places of work.

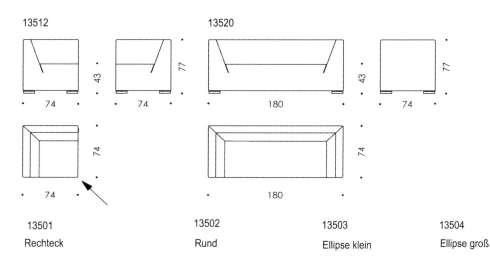

13512

13520

43 77 74 74 180 74 77

74 180 74

13501

Rechteck

13502

Rund

13503

Ellipse klein

13504

Ellipse groß

26 75 75 3 links rechts

38 40 40 3 links rechts

42 43 43 3 links rechts

27 75 75 3 links rechts

° The future is here, but it is not as we imagined it. The 21st century utopia suggested an unattainable reality with flying cars. However, only a few details, such as functional changes within the home to meet new needs, have been attained.

Basilea Design: John and Samantha Ritschl-Lassoudry Manufacturer: Wittmann Moebelwerkstaetten

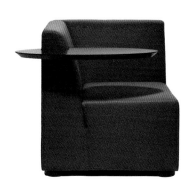
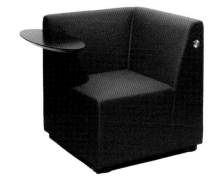
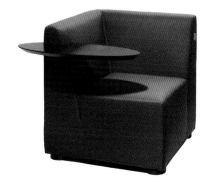

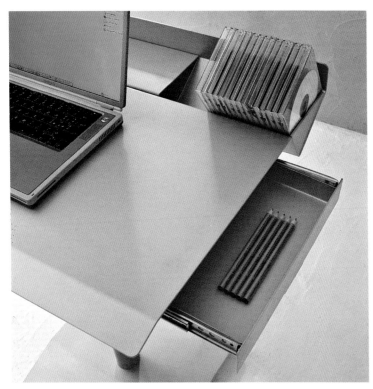

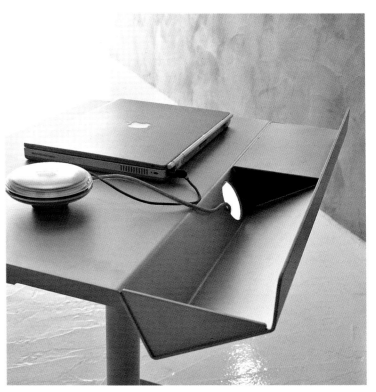

Bit Computer Table Design: Davide Varotto Manufacturer: Bellato

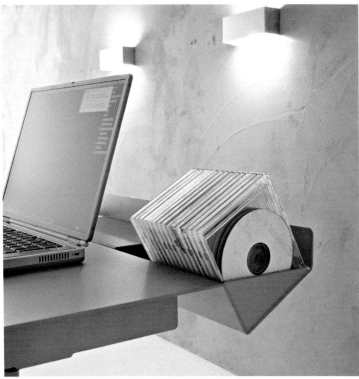

∘ The Bit table has a structure conceived for individual use and stands out for its storage capacity, despite its small size. Its height is adjustable and can house the agenda or computer. It is perfect for a laptop. It has a space for CDs, one for paper, a hole for cables, and a drawer. Bit is mounted on wheels and the base can be equipped with a space to support a CPU and printer.

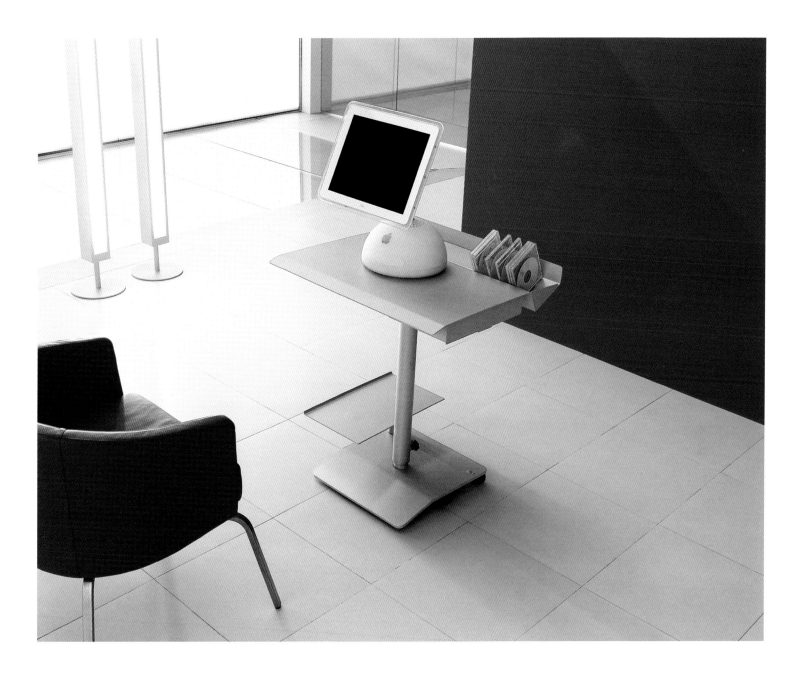

Navigator Computer Table Design: Carniato, Matta, Varaschin Manufacturer: Bellato

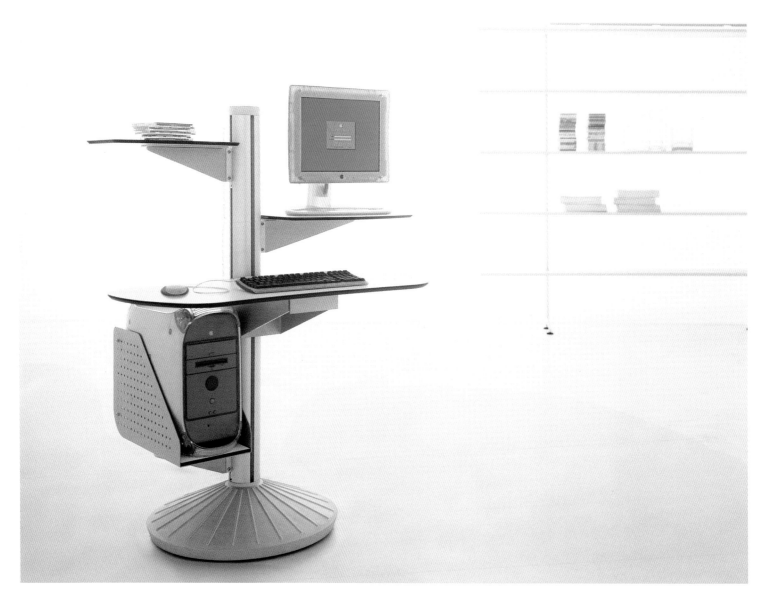

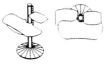

NAV 002
L 102 H 73 P 132

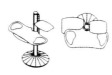

NAV 005
L 102 H 73 P 132

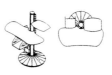

NAV 009
L 102 H 73 P 132

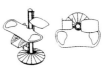

NAV 001
L 102 H 73 P 132

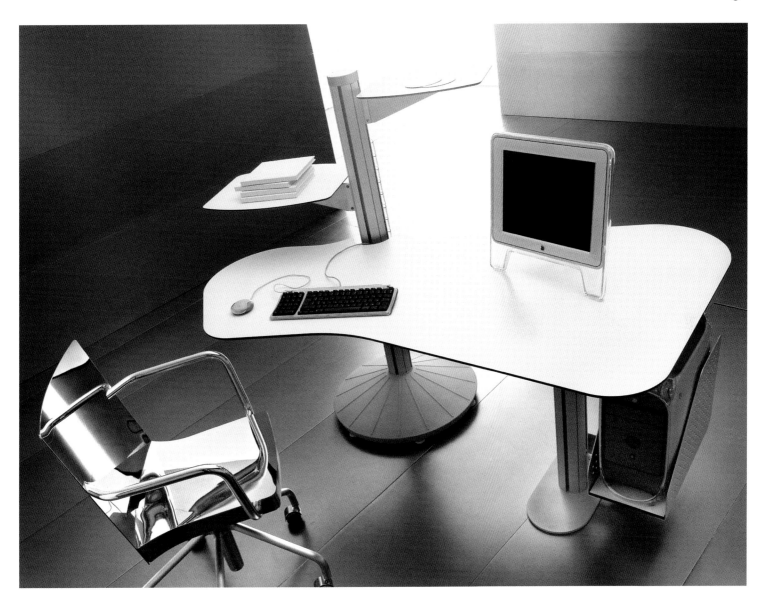

L 170 H 73 P 68-90 L 170 H 73 P 68-90

° The Navigator consists of an innovative, mobile workspace that occupies a minimal area. All the elements have been carefully studied and tested in terms of ergonomics and function: The main table top is extractable, and can be positioned to the right or left of the Navigator structure.

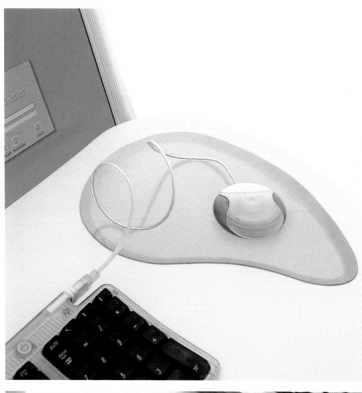

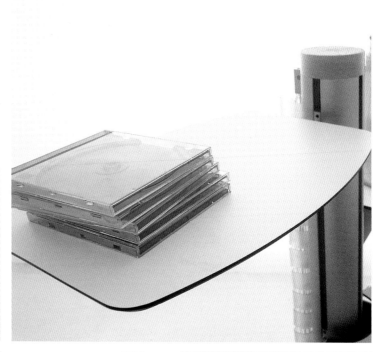

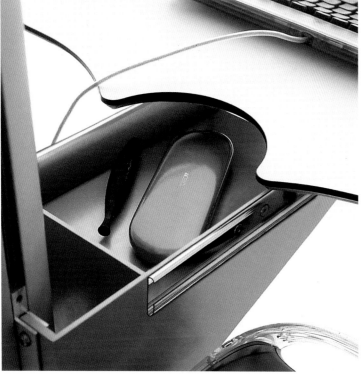

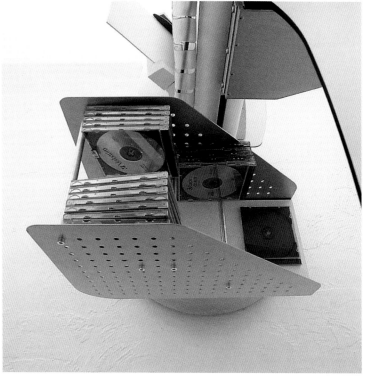

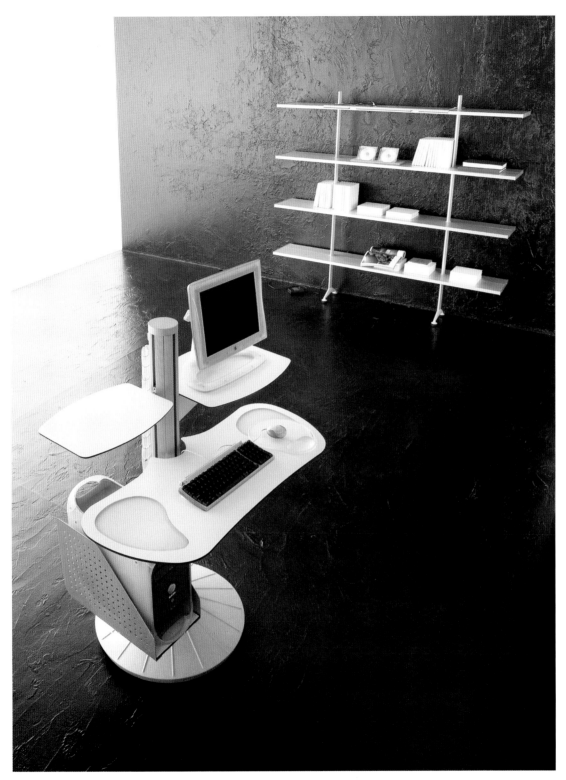

◦ In Navigator, all the surfaces are of varying dimensions and are moveable. The table top functions as a desk, and the sides can house a scanner and printer. The back support can house a CPU, CDs, paper, or documents. It also has an automatic cable retractor and four plug sockets. The "Large Top" version has a big work surface, with a column to which supports or a tower support can be applied.

° This is a modular system composed of two main elements: the work surface and the vertical containers that act as supports for the surface and can be moved, thanks to the wheels. The versatility and generosity of the proportions have made Push-In the ideal system both for the domestic and work setting. The version with legs presents a metal structure covered in matte epoxy.

Push-In System Design: Ueli Biesenkamp Manufacturer: Pallucco

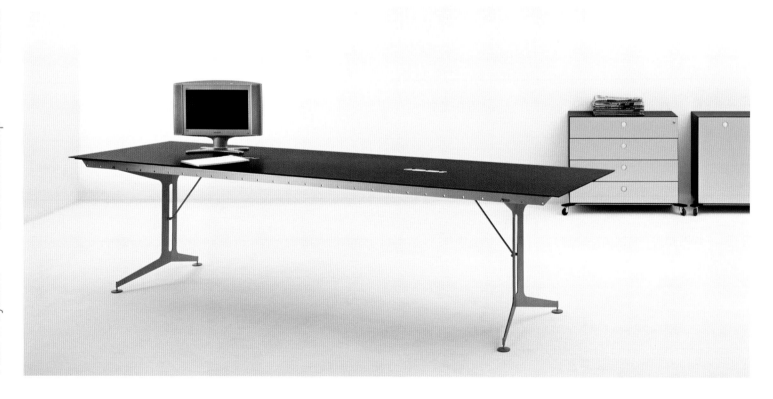

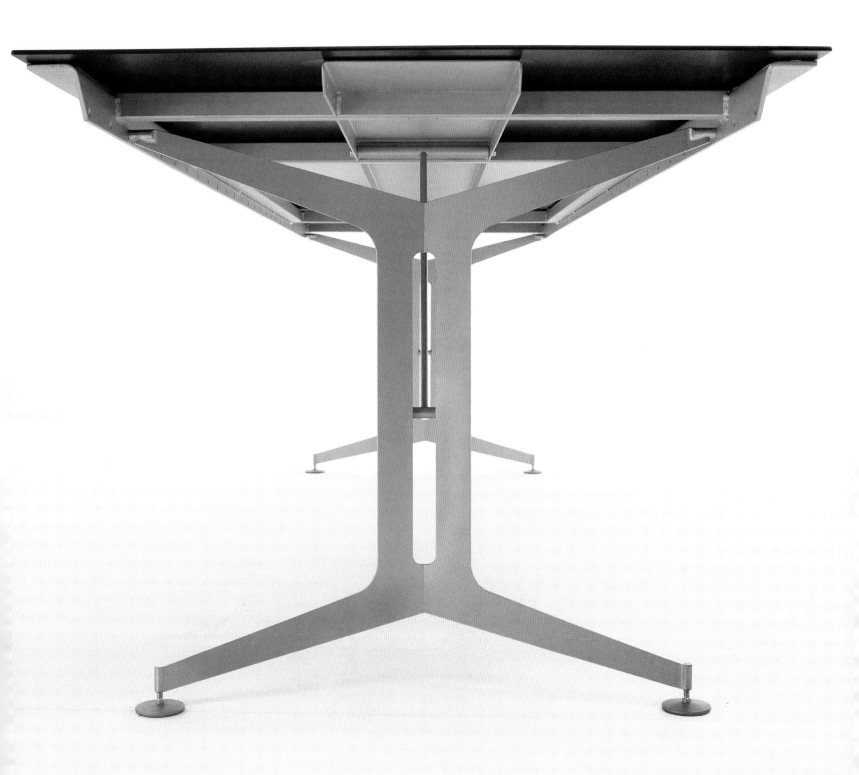

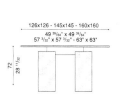

126x126 - 145x145 - 160x160
49 $^{38}/_{64}$" x 49 $^{38}/_{64}$"
57 $^{3}/_{32}$" x 57 $^{3}/_{32}$" - 63" x 63"

72
28 $^{11}/_{32}$

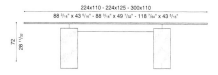

224x110 - 224x125 - 300x110
88 $^{3}/_{16}$" x 43 $^{5}/_{16}$" - 88 $^{3}/_{16}$" x 49 $^{7}/_{32}$" - 118 $^{7}/_{64}$" x 43 $^{5}/_{16}$"

72
28 $^{11}/_{32}$

∘ The elegant Serenissimo table offers transparent or opalescent glass surfaces in different shapes and sizes, supported by thick columns that have a special treatment of Venetian plaster in various tones, or a titanium colored varnish. It is ideal for an office or for private use. The chair stands out for its balanced contrast of volumes and for the strength and texture of the curved back, in different lengths, inspired by the spinal column.

Ø145 - Ø160 - Ø180
Ø57 $^{5}/_{32}$" - Ø63" - Ø70 $^{7}/_{8}$"

72
28 $^{11}/_{32}$

Serenissima Chair Design: David Law, Lella and Massimo Vignelli Manufacturer: Acerbis

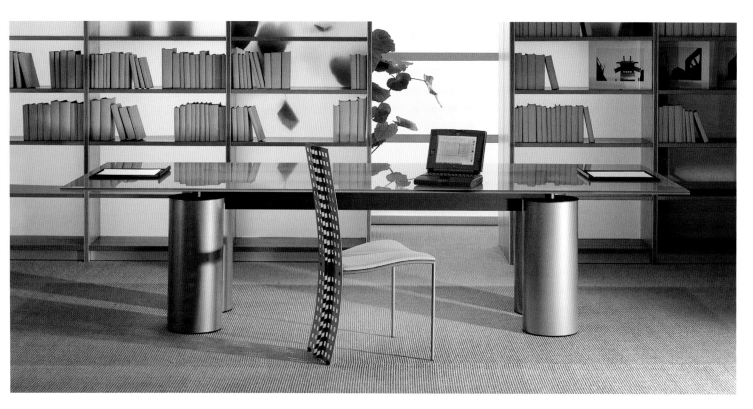

Tavolo a sella

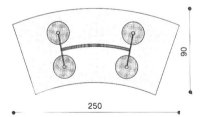

250

90

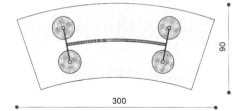

300

90

Tavolo convesso

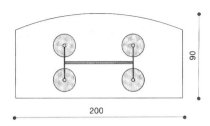

200

90

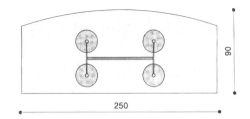

250

90

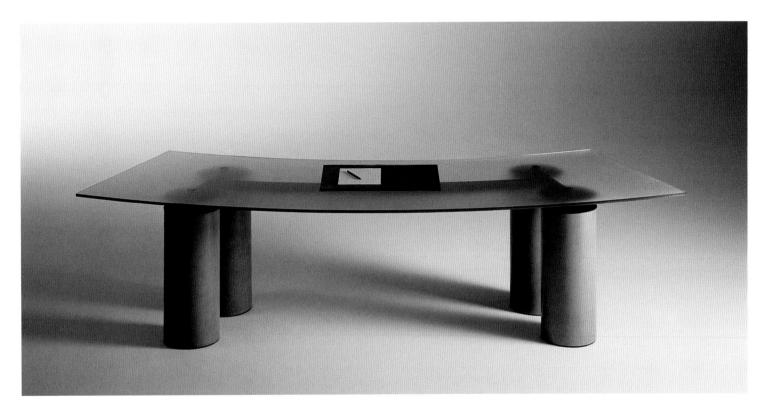

∘ This table with slim and balanced lines is composed of an entirely aluminum base with legs built from solid wooden molds. The gloss finish contrasts with the wooden drawers and the CPU support, also made of wood, that has a cable retractor and can be positioned at different heights, combining the different volumes. The surfaces can be steel, opalescent, white, or cherry wood.

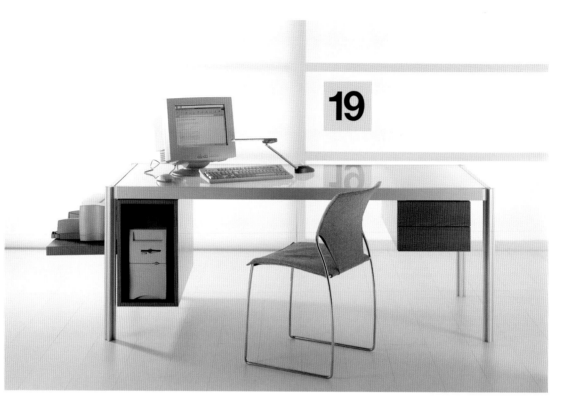

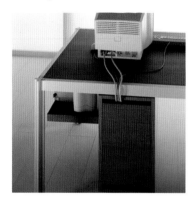

Kent Office Table Design: George Ciancimino Manufacturer: Acerbis

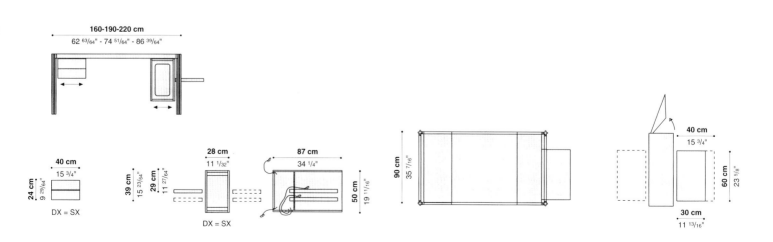

160-190-220 cm
62 63/64" - 74 51/64" - 86 39/64"

40 cm
15 3/4"

24 cm
9 29/64"

DX = SX

39 cm
15 23/64"

29 cm
11 27/64"

28 cm
11 1/32"

DX = SX

87 cm
34 1/4"

50 cm
19 11/16"

90 cm
35 7/16"

40 cm
15 3/4"

60 cm
23 5/8"

30 cm
11 13/16"

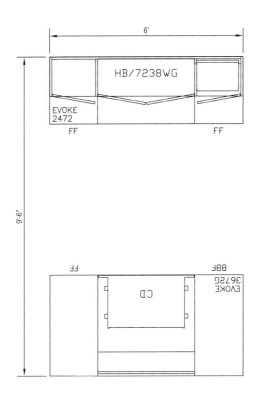

HB/7238WG

EVOKE
2472

FF

FF

6'

9'-6"

FF

BBF

EVOKE
3672G

CD

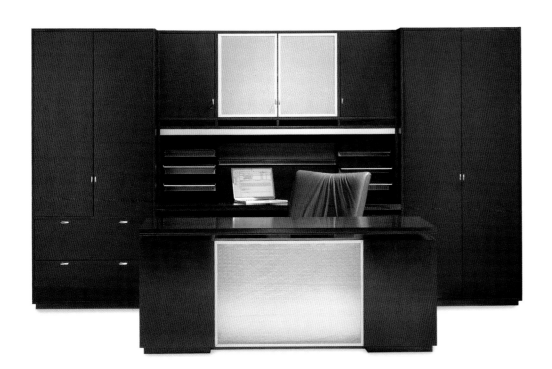

○ Conceived for an independent office, the elegant Evoke system raises the design of modules to a new level, presenting a table with a surprising floating surface and a wide range of possibilities to combine details in steel, wood, and glass, adapting to a variety of environments. This unique design has multiple storage spaces and is presented in three different woods with seventeen different possible finishes.

Evoke System Design: Peter Wooding and Associates Manufacturer: Kimball Office

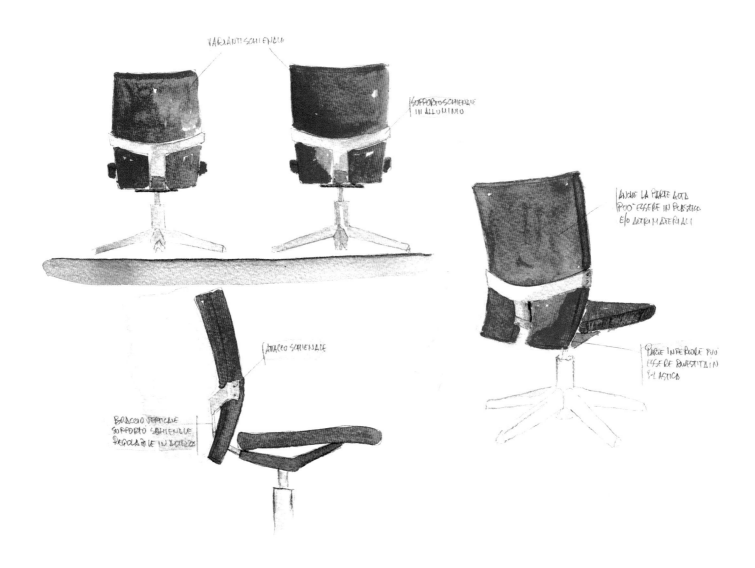

System 39 Design: Paolo Favaretto

○ System 39 is the perfect combination of Italian design and sophisticated technology. With its mesh back, it represents a modern alternative to office design. Permeability and comfort offer the user optimum lumbar support. Its light forms provide a touch of elegance for the work place. The chair can be rotating or with four legs, and proposes multiple options of mesh or upholstery and varying positions of the back and seat.

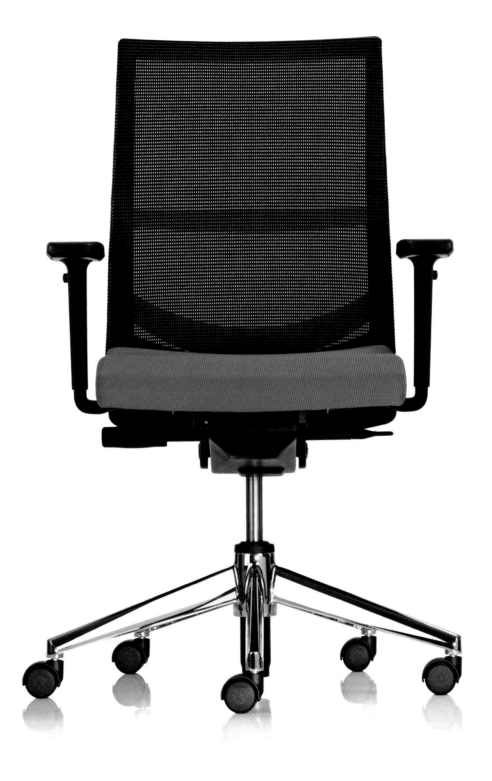

Xsite Structure Design and manufacturer: Keith Metcalf and Kimball Office

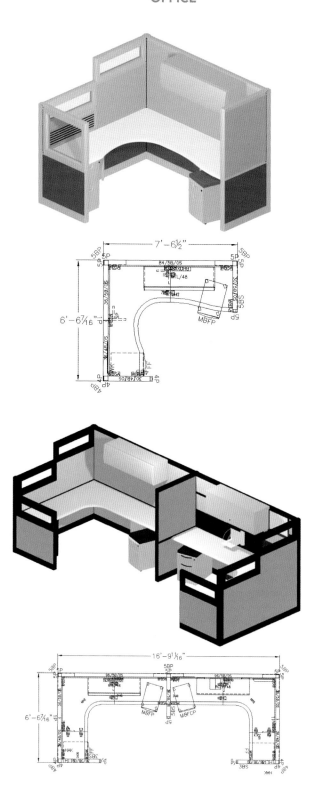

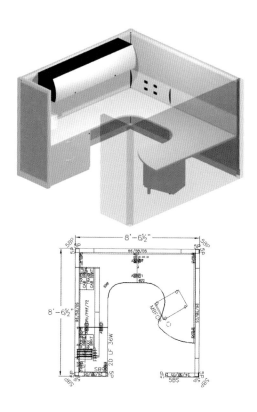

○ This system starts from the basic concept of panel and frame and recreates it in an innovative way. It can be situated in any environment, and the panels can be positioned with great freedom so that each side of the same structure can accommodate different functions. The result is a seamless, homogenous join. The components of the system are supported, and the work surfaces, storage spaces, and composition can be easily altered.

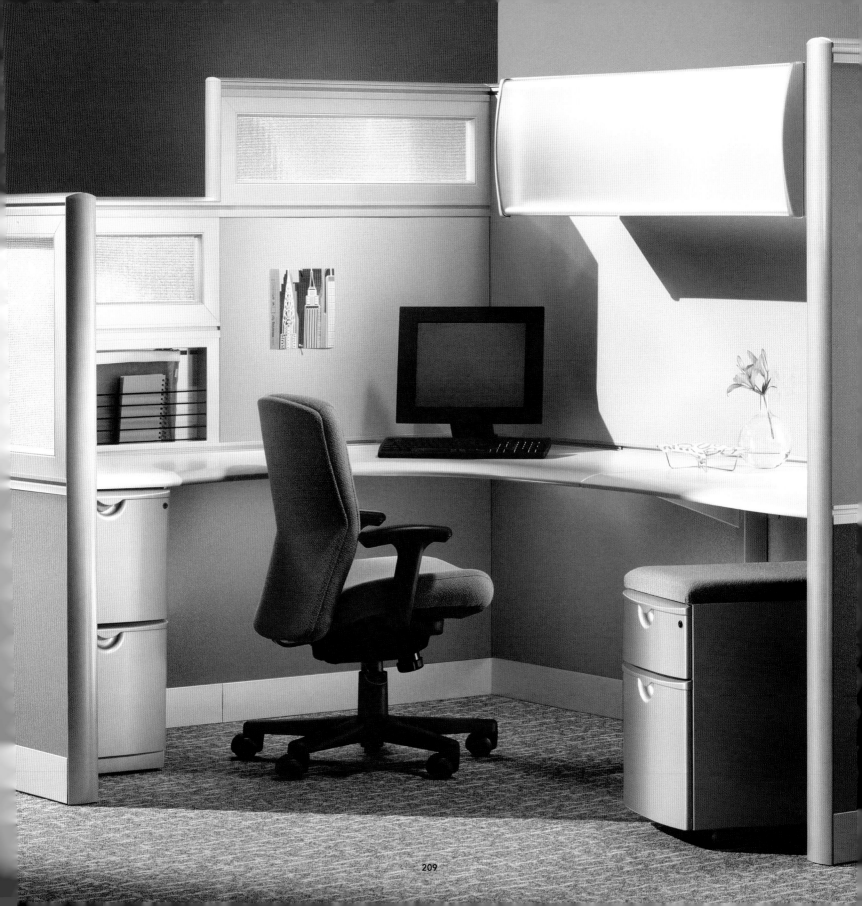

Little Friend Table and Oxford Chair Design: Kasper Salto, Arne Jacobsen Manufacturer: Fritz Hansen

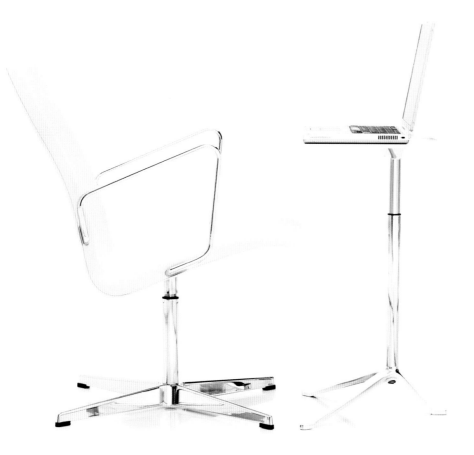

○ Little friend is a small, foldable table whose fine white laminate surface has a perforated handle, making it easy to transport. The base is made of polished, chrome aluminum, and has an adjustable height using a button.

The legendary Oxford chair, upholstered in leather or print fabric, offers the possibility of arms. It can be rotated and slid, and the height of the back is variable. It is perfect for work and rest, thanks to the new foot rest accessory.

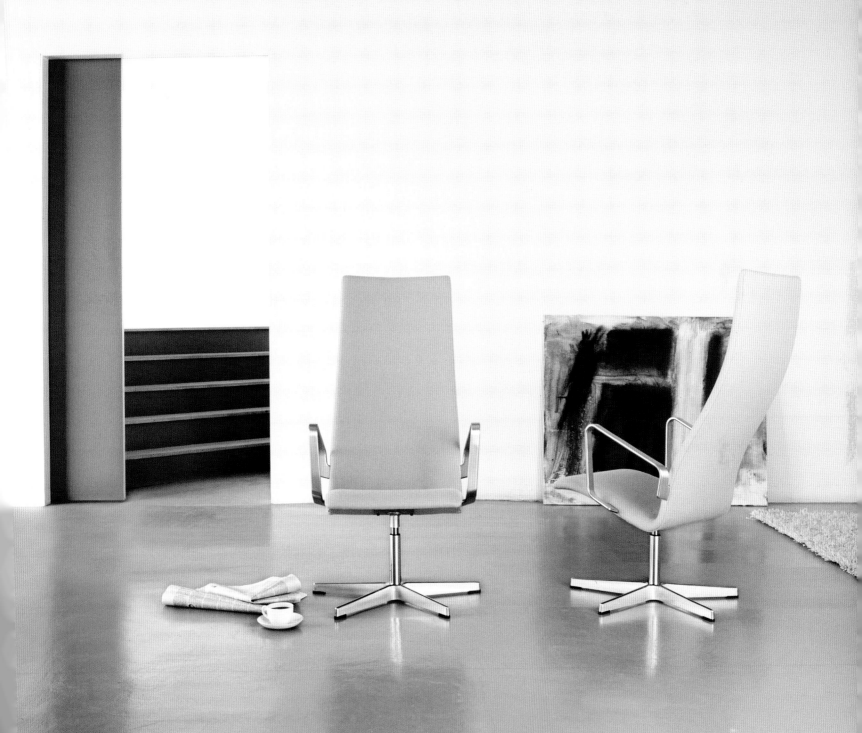

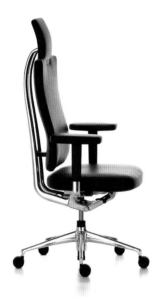
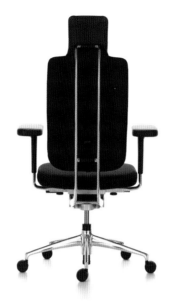
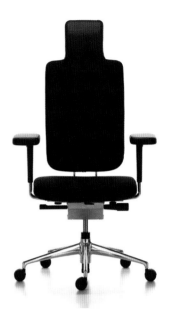

Headline Office Chair Design: Claudio Bellini Manufacturer: Vitra

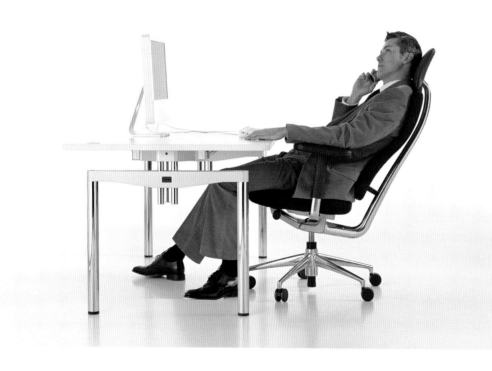

◦ This extremely comfortable, rotating chair features flexible construction that allows both the back and the seat to adapt to movement. It is also adaptable in height and depth to each user. The chair is distinctive for the special form of the headrest. Tried and tested for their ergonomics, the materials used in the construction provide comfort, and adapt to body temperature. The chair has two options of wheels for carpeted or hard floors.

Link Design: Morgan Rudberg and Lars Pettersson

DIRECTORY

ABR
Corcega 195-197
08036 Barcelona
Spain
www.abrproduccion.com
info@abrproduccion.com

Acerbis International SPA
Via Brusaporto 31
24068 Seriate (Bergamo)
Italy
info@acerbisinternational.com
www.acerbisinternational.com

Ateliers Jean Nouvel
10, cité d'Angoulême
75011 Paris
France
chuisman@jeannouvel.fr
www.jeannouvel.fr

Avarte Oy
Lemuntie 3-5 C
FIN-00510 Helsinki
Finland
www.avarte.fi

Bellni Studios
Piazza Arcole, 4
20143 Milano
Italy
www.bellini.it

Bluesquare
P.O. Box 4235
Richmond East
Vic 3121
Australia
www.bluesquare.net
matt@bluesquare.net

Bluepoint as
Ostensjoveien 36
0667 Oslo
Norway
mail@bluepoint.no
www.bluepoint.no

Bram Boo
Basiliekstraat 14
3800 Sint-Truiden
Belgium
www.bramboo.be

Bulo
Industriezone Noord B6
2800 Mechelen
Belgium
www.bulo.com

Calligaris S.p.A.
Viale Trieste, 12
33044 Manzano (Udine)
Italy
www.calligaris.it

Casadesus - Cycsa
Pol ind rosanes - C/ Luxemburg
19/23
08769 Castellví de Rosanes
Barcelona
Spain
www.cycsa.es

Cor Sitzmöbel,
Helmut Lübke Gmbh & Co.
Nonenstraße 12
D-33378 Rheda-Wiedenbrück
Germany
info@cor.de
www.cor.de

Delphin Design
Heynstrasse 5
13187 Berlin
Germany
www.delphin-design.de

Desalto S.P.A.
Via Per Montesolaro
22063 Cantù (Co)
Italy
Info@Desalto.It
www.Desalto.It

Design Studio
Jouni Leino Ky
Merimiehenkatu 30
FI-00150 Helsinki
Finland
studio.jouni.leino@kolumbus.fi
www.jounileino.com

Elmarflototto Gmbh
Am Ölbach 28
33334 Gütersloh
Germany
verkauf@elmarfloetotto.de
www.elmarfloetotto.de

Engelbrechts
Skindergrade 38
1159 Kobenhavn
Denmark
info@engelbrechts.com
www.engelbrechts.com

Fantoni Spa
Z. I. Rivoli
33010 Osoppo (UD)
Italy
r.venturini@fantoni.it
www.fantoni.it

Favaretto & Partners
Via Gabriele Falloppio 39
35121 Padova
Italy

Fly Line Srl
Via Terrenato 7
36010 Carrè (Vicenza)
Italy
info@flyline.it
www.flyline.it

Formstelle
Hans-Sachs-Str.5
80469 München
Germany
mail@formstelle.de
www.formstelle.de

Fritz Hansen A/S
Allerødvej 8
DK-3450 Allerod
Denmark
www.fritzhansen.com

Helland Mobler AS
Postbox 10
N-6259 Stordal
Norway
www.helland.no

Horreds Möbel AB
Box 54, Varbergsvägen 448,
519 21 Horred
Sweden
www.horreds.se
info@horreds.se

Inno Interior OY
Tähdenlennontie 9
fin - 02240 Eepoo
Finland
inno@innointerior.fi
www.innointerior.fi

Kimball International
1600 Royal Street
Jasper, Indiana 47549
USA
info@kimball.com
www.kimball.com

Magnus Olesen A/S
Agertoft 2, Durup
DK-7870 Roslev
Denmark
www.magnus-olesen.dk

Meubelfabriek Gebroeders
van der Stroom B.V.
3e Industrieweg 5
NL-4147 CV Asperen
Netherlands
www.dutchoriginals.nl
info@dutchoriginals.nl

Nils Holger Moormann
GMBH
Festhalle
D-83229 Aschau im Chiemgau
Germany
info@moormann.de
www.moormann.de

Thonet GmbH
Michael Thonet
Strasse 1
35066 Frankenberg / Eder
Germany
www.thonet.de

OFFECCT AB
Box 100, SE-543 21
Tibro
Sweden
info@offecct.se
www.offecct.se

Ontwerpersgroep Yksi
Havenstraat 1
5611 VE Eindhoven
Netherlands
www.yksi.nl
yksi@yksi.nl

Pallucco - Bellato Italia Spa
Via Azzi, 36
31040 Castagnole di Paese (TV)
Italy
www.palluccobellato.it

Peppermind
Jacobastraat 132
2512 JC Den Haag
Netherlands
vincent@pepper-mind.nl
www.pepper-mind.nl

Piiroinen
Tehdaskatu 28
24100 Salo
Finland
www.piiroinen.com

Quattrocchio srl
Zero Division
122, via Piacenza
15050 San Giuliano Vecchio
Alessandria
www.zero-system.com
info@zero-system.com

Richard Lampert Gmbh & Co KG
Gaisburgstrasse 12 b
D-70182 Stuttgart
Germany
mail@richard-lampert.de
www.richard-lampert.de

Studio Aisslinger
Oranienplatz 4.
10999 Berlin
Germany
studio@aisslinger.de
www.aisslinger.de

Troels Grum-Schwensen
Rosenvængets Hovedvej 42 st.tv.
DK 2100 Kobenhavn
Denmark
www.troelsgrum-schwensen.com
Troelsg-s@mail.tele.dk

UNStudio
Communication
Stadhouderskade 113
Postbus 75381
1070 AJ Amsterdam
Netherlands
info@unstudio.com
www.unstudio.com

Vitra GmbH
Pfeilgasse 35
A-1080 Wien
Austria
www.vitra.com

Wilkhahn
Wilkening + Hahne GmbH + Co
Fritz-Hahne-Straße 8
D-31848 Bad Münder
Germany
info@wilkhahn.de
www.wilkhahn.de

Wittmann Moebelwerkstaetten
Obere Marktstrasse 31
A-3492 Etsdorf
Austria
www.wittmann.at

Zed ag
seefeldstrasse 303
ch-8008 Zuerich
Switzerland
studio@zednetwork.com
www.zednetwork.com

i29 Office for Spacial Design
Industrieweg 29
NL-1115 AD (Duivendrecht)
Netherlands
info@i29.nl
www.i29.nl